HEAVEN

An Exhibition That Will
Break Your Heart

HEA

HATJE CANTZ PUBLISHERS

VEN

DOREET LEVITTE HARTEN

SYLVIE BLOCHER · RALPH BURNS · JAKE & DINOS CHAPMAN
ART STUDIO DEMETZ · JESSICA DIAMOND · SYLVIE FLEURY
KIRSTEN GEISLER · GILBERT & GEORGE · MAJIDA KHATTARI
KAREN KILIMNIK · KATJA KLOFT · JEFF KOONS · JUSTEN
LADDA · INEZ VAN LAMSWEERDE · MARIKO MORI
RON MUECK · THIERRY MUGLER · SHIRIN NESHAT · ORLAN
JEAN-MICHEL OTHONIEL · TONY OURSLER · QIN YUFEN · ED
RUSCHA · MICHAEL SCHIRNER · GIL SHACHAR · JEFFREY
SHAW · YINKA SHONIBARE · GARY SIMMONS · HAIM
STEINBACH · EDDO STERN · OLGA TOBRELUTS · JEFFREY
VALLANCE · ANNEKE IN'T VELD · VIKTOR & ROLF · WANG FU

HEAVEN is an exhibition of contemporary art with a clearly defined theme, the latest in a long-running series of exhibitions in the Kunsthalle Düsseldorf. As well as presenting outstanding artists and renowned names from the international art scene today, it also opens up the discussion in an area that is currently of great interest and which fascinates media specialists, sociologists, anthropologists and art historians alike—that area is religion, and more particularly how religion manifests itself in a society that is formed by fashions and markets, a media-soaked society that craves networks of all kinds and which no longer pays allegiance to traditional notions of truth and reality but which has yielded to 'spectacle' for its own sake. This exhibition brings together works by 35 different artists in order to look at the role that religion is granted in a world of this kind, to discover how

FOREWORD AND ACKNOWLEDGEMENTS

religion finds expression in our culture and what religious or cult practices we devote to the idols and the gods of the 90s.

As Doreet LeVitte Harten, the curator of the exhibition, has put it: "Whether they want to admit it or not, people are and always will be religious beings, even in secular times, and even when they call themselves atheists. Wherever and whenever people have formed into communities there have always been religious rituals, institutions and doctrines. Although the great project of the Enlightenment was to liberate individuals from theological constraint, nevertheless religion survived, just as though it were a biological component in its own right and a significant element in a system which makes humans into sentient beings. But in order to survive the secularisation of modern society, those same religious ingredients had to undergo some kind of transformation."

It is this transformation of different aspects of religion which is at the heart of the exhibition HEAVEN. Is religion behind the current belief in the art of the sublime, does it play a part in the devotion lavished on film stars and in the euphoria which music fans succumb to, can it explain the willing self-sacrifice of those who choose cosmetic surgery, or of the asceticism of certain models? Has religion descended to Earth from Heaven and is it now operating—setting moral values—within our everyday lives? What form does the transfer of worship from divine to human idols take? And what are the consequences of this transfer for the contents of what we call religion?

Doreet LeVitte Harten has been the moving force behind the idea, the concept and the organisation of HEAVEN, and I should like express my deep gratitude to her and to her project manager, Markus Mascher, for the many months of friendly cooperation we have shared. I should also like to thank all the authors who have contributed texts to the catalogue. Far from shrinking from the complexity of the questions raised by this exhibition they have rather extended its scope by proposing cross-connections to art theory, mythology and philosophy. We are most grateful to the artists for lending such a wealth of important exhibits and for all the works that have been created specifically for this exhibition.

We should also like to express our sincere gratitude for the loans from Jeffrey Deitch of the Deitch Project Gallery, Tom Heman of Metro Pictures, Adriaan van der Have of the Torch Gallery, Nigel Hurst and the Saatchi Gallery, Nora Tobbe in the 303 Gallery, and the Stephen Friedman Gallery, the Anthony d'Offay Gallery and the Galerie Philomene Magers, Fondazione Prada and the Arts Council of England.

Above all our sincere gratitude goes to the Igedo Company and specifically to Manfred Kronen for the generosity of his financial support. The Igedo Company, which celebrates its 50th anniversary this summer, has provided funds both for the realisation of this exhibition and other events in Düsseldorf.

At the same time this exhibition would have been impossible without the additional help of the Stadtsparkasse Düsseldorf, the Klaus Harren GmbH & Co KG, the Trowe Düsseldorf GmbH, the Treumerkur, Dr. Schmidt & Partner KG, the Laser Litho, the Hoffmann u. Stenmans GbR, the Erberich GmbH, and the Verkehrsverein der Stadt Düsseldorf e.V.

Furthermore, we should also like to express our sincere thanks to Conzen Glas GmbH, Dieter Cronenberg GmbH & Co KG, Oliver Drewes and carhartt, VIVA ZWEI and the Volkswagen Sound Foundation, W. Pelz GmbH, Lange + Ritter GmbH, Klaus Haar and KS Druck, Hans-Reiner Trautvetter and Gahrens & Battermann GmbH, Michel-Bernard Brossard and Philips France, Josef Roggendorf International Fine Art Service, Markus Schüßler, Lars Wilbert and the Michael Schirner Werbe- und Projektagentur, Oliver Sieber and Bastian Bertemes as well as the KOMED GmbH and the Hair Club France GmbH. All of these were generous with their time, energy and materials and were always on hand with professional advice when we needed it. For help and assistance in the realisation of individual works, we are most grateful to Damiano Dinelli, to Yadi Yilmaz, Mounir Hammouda, Nadia Saouei and to Stephanie Kloft.

We are also most grateful for support for individual projects from the AFAA, l'Association Française d'Action Artistique, Ministère des Affaires Etrangères, the British Council, the Royal Netherlands Embassy and from Pavel Choroshilov, the Deputy Russian Minister of Culture.

The exhibition design was undertaken by a student team from the Staatliche Hochschule für Gestaltung in Karlsruhe: the members of the HEAVEN project group were Johannes Fischer, Matthias Gommel, Volker Roos, David Schäfer and their teacher, Volker Albus. Jochen Saueracker, Julia Höner and Heike Rosenbaum carried out the necessary research and were generously on hand to solve technical problems. We should also like to thank the Colopic Restaurant for their generous and culinary support.

Finally, I should like to express my heartfelt thanks to all the staff of the Kunsthalle Düsseldorf who have been involved with this exhibition: Michael Bützer, Wolfgang Topel, Angela Hardt, Heidi Steger, Hiltrud Eichelmann, Sabine Krohm-Steinberg, Bettina Kratzsch, Hans-Jürgen Künzel, Jürgen Fritzke and Hilmar Sauer.

It gives me great pleasure that this exhibition will travel to the Tate Gallery Liverpool and I would like to take this opportunity to thank Lewis Biggs and Victoria Pomery for their wonderful help and commitment.

Marie Luise Syring
Kunsthalle Düsseldorf

Ernest: Life then is a failure?
Gilbert: From the artistic point of view, certainly.

Oscar Wilde, *The Critic as Artist I,* 1891

Heaven is not built on cloud nine, but on the firmer foundations of suffering. Oscar Wilde acknowledges that if life were perfect we would have no need of art (or the heaven promised by religious faith). The consolation of art, like that of religious faith, is to bring us some of the certainty that life denies us. This is an exhibition to break our hearts because Heaven is by definition elsewhere: the image of perfection returns us to our state of imperfection.

HEAVEN IN THE TATE GALLERY LIVERPOOL

Religion has not disappeared, as Wilde thought it would, in the wake of Darwin and Renan. People visit art galleries with a hunger for experience, a thirst for refreshment, a desire to get a perspective on "real life", that is far more than idle curiosity. The religious impulse, and certainly the artistic impulse, seem to be finding ever less celestial and more mundane objects. The multiplication of the objects of our faith is the mirror image of our diversification as individuals. As the essays in this publication say in so many ways, to be human is to be idolatrous, and in the century of Marcel Duchamp and Joseph Beuys none of us can escape the possibility that he or she is an artist. The exhibition's presentation in Liverpool will straddle two millennia: a kind of high place from which to review the extent to which art has been made the property of the individual conscience in the way that Luther proposed the Christian faith should be.

"HEAVEN, an Exhibition that will Break Your Heart" has two great strengths. One is its content, the enquiry into the nature or image of heaven in our time and the process of art in representing it to us for our consolation. The image is in many ways what it has always been: magic, impossible beauty, glamour, the sublime, the absolute, the distinct, the different—the qualities that have always been ascribed to the saints or the multiple manifestations of divinity. The engagement we bring to the image (dialogue, contemplation, meditation, prayer, devotion) is the process through which we release from the image and gain for ourselves our reward: renewal, consolation, insight, rejuvenation, a sense of self purified in the fire of emotion. As Thierry de Duve writes so eloquently in his essay, the image remains untouched, but in reaching out to touch it we find ourselves touched.

The second strength of the exhibition is in its challenge to art conventions. You may suppose that there are no longer any conventions to challenge. But the scope and variety of images presented here is very great. Clothing and other relics carrying the magic of celebrity jostle for place alongside objects conceived and created specifically for the frame of "art". The art world does have its tenets of faith, and however fluid those tenets may be, there are aspects of this exhibition that are nevertheless provocative. Can the curator take on the mantle of the artist? In other words, can the intention of the curator—that an artefact (made within the conventions of artisanship) be seen as "art"—can this intention carry conviction? Does this leave the "professional" artist financially threatened or even redundant? Any faith contains within it the seeds of doubt, and its capacity to carry this doubt is a sign of its strength.

I would like to thank Doreet LeVitte Harten, the curator of HEAVEN and Markus Mascher, its project manager for approaching us with the suggestion that Tate Gallery Liverpool collaborate with them to realise the project in England. Their enthusiasm and professionalism have been a blessing. Marie Luise Syring and her colleagues at the Kunsthalle Düsseldorf have been most helpful and accommodating, and we owe a debt of thanks also to those individuals and companies mentioned by her whose permissions, financial or other support have made the exhibition possible. The essays in this publication are remarkable for their scope and their insights, and we thank the authors for con-

tributing so much to the depth of experience afforded by the exhibition.

In Liverpool, the exhibition has been designed and managed by Victoria Pomery supported by David McNeff, Natalie Rudd and Lindsay Taylor, and the installation carried out by Ken Simons and his team. Sadly, pressures of space and architectural characteristics of the Gallery have forced us to leave out some of the exhibits shown in Düsseldorf: we apologise to those artists whose work we have had to exclude. We are the poorer for not hosting their work, but we believe the thesis and experience of the exhibition are no less strong and we are happy that their work is represented in the catalogue. We are immensely grateful to all the artists for making this little bit of heaven on earth and for breaking our hearts.

Lewis Biggs
Director, Tate Gallery Liverpool
May 1999

The art of the sublime in this century has been articulated by a clear grammar. The founding fathers, Kasimir Malevich, Wassily Kandinsky and Piet Mondrian, and later, those on the far shores of America, Barnett Newman and Mark Rothko, laid down the etiquette and court manners by which the sublime in art should be revered and canonised. The sublime was to be abstract, devoid of all signifiers, so that which is signified will appear in all its decorum: that is, by stating its not being there it will have the appropriate Parousia, the manifestation of the hidden essence.

Of course, religious feeling had other genealogical lineages, expressed in the works of artists like Max Beckmann, Emil Nolde or Georges Rouault, and later in the works of Joseph Beuys and Anselm Kiefer, but if a difference is to be made between the sublime and the religious and this difference is

CREATING HEAVEN

Doreet LeVitte Harten

to be on a scale that goes from popular to aristocratic, then it was the annihilation of signifiers which won the sublime its patrician place in the middle of the 20th century.

This application of a negative theology in the arts, a theology which is based on the idea of aphairesis (the coming to the essence by way of abstraction), haunts us still. It is therefore difficult for the catechist to see the sublime in a popular or figurative form. For the equation of the holy with the monochrome, the sacred with the abstract is combined with another doctrine of art which states that depth is of value, and that one of the conditions by which depth is manifested is through the mechanism which throws the signifier out of the spiel: an endless theoretical field sustains the weakness of the image, chased out of pictorial paradise.

The idea of depth is important for works of art which designate the sublime. Depth is not meant here as a dimension of material space, nor does it only stem from the narrative of the work. It has "aura" and as such transfers the value of the work into an insubstantial realm and by doing so re-invests the phantasm of the artefact with a value in the physical world. This process of re-materialisation was doubly complicated in matters of representing the sublime, for here the work had to be transubstantiated not only in order to gain its value but its narrative as well. If the work of art was to gain its "aura" as a religious object, and if the sublime was to be made incarnate and described through a field devoid of signifiers, there was a danger of total annihilation of meaning: for how could a spectator make a connection between exalted nothingness and its tokens, if icons were not to be used?

To avoid such a calamity the old device of an interpretative and scholastic web had to be put to use. Depth, or the hidden element, would act here as the fourth dimension. It is usually achieved through the cultural patina of the work, that is, by a process of time, but it could also be gained by turning time into a factor of speech. Benjamin's "aura", which is generally accomplished by the action of time on the work, could then be accomplished through a contemplative verbal field.

The verbalisation of the field surrounding a work of art in order to sustain its declared religious meaning is understood in our time as an inherent quality of the work itself, emanating from its very essence, thus adding to the myth of authentic and autonomous existence. But we should not forget that such a response was a learned process which took time. Only by depending on the metaphorical depth, acting as if it knew more about the work than the work knew about itself, could the iconoclastic sublime of this secular time be described as being here and now.

But depth is not what it used to be and for that matter, neither is religion nor religious feeling. In post-modern times (and I take it these are still post-modern times for want of the next sonorous terminology), depth is to be regarded with a suspicious eye because it is in the process of losing its absolute hegemony over the concept of value. Rhetorical depth gives way to works of art which either use recognisable icons and words, or in the case of a religious manifestation bring the sublime, in all its transformations, to the surface. A revival of iconic figures, by means of different media, and whose eternal state is sustained through their capacity to sell and to be sold, is almost equivalent to the revival of mythological images in the Renaissance. The laconic, pure attitude of

the modern sublime, mistakenly considered as a monotheistic dictum and therefore a step further in the evolutionary ladder, is defeated by the return of a Pagan New, echoing a Weberian prophecy, an iconodule state which comes to its maturity, graced by its Elysian opportunities. Some may say that the sublime is being sold too cheaply, for it can be bestowed upon just about anything that moves, or anything which is popular. It becomes a household artefact, a quality whose visibility is enhanced because of its adaptation to the mundane. But I am not sure this is a case for lamentation, for in its prior aristocratic role, only a chosen few were graced by it, which is no longer the case once applied to more secular forms of devotion.

It is here that we recognise that if art was once religious, by the end of the millennium it is religion that becomes a work of art. This means that every para-phenomenon which acquires the parameters of the religious could be considered to be an artistic act and it is on this assumption that the exhibition HEAVEN is built.

The moment it is allowable for the sublime to be manifested through chosen signifiers, be they from popular culture, media or traditional icons, a wealth of transformations take place. For example, it could be argued that gods and their mothers, apostles and angels, devils and saints who were confined within Pandora's box as long as the iconoclastic attitude held sway, are now free to find their apotheosis in celebrities and pop idols, aliens and heroes. It is true that they are called idols and not gods, which places them semantically in a pagan space, thus marking them as throwbacks in the evolutionary plan, but besides this act of equating the pagan with the secular in an apologetic gesture towards hegemonic monotheistic attitudes, the parameters of their worship parallel, in all practical aspects, that of the ancient celestial beings.

And so, the worship of such idols includes acts of adoration, mass hysteria and the collection of devotional items. Altars are built for them in houses and graveyards, and masses are held before their residencies or in rituals in stadia, halls and arenas. If they are song masters their songs become prayers accompanied by a procession of candles. They become the subject of pilgrimages and collections, bought, re-bought and commemorated through sales and market strategies, and after their death, since they are human, they are reconstituted as saviours, brought into the hall of fame of the eternally sacred. Hendrix, Morrison, Elvis, Joplin, Monroe, Diana, are more alive now, that is financially and emotionally, than they were in this world. Of course this ritual of the dead gods living happily ever after in the arcadia of the malls is not very different from the consummated fate of more traditional saints within the legacy of pilgrim places and devotional commerce.

But it is not only in cult idols, or in the rituals surrounding them, that the sublime and the religious find their expression. The whole ritual of beauty, including diet methods, plastic surgery and the cosmetic industry, is based upon the religious formula that equates beauty with virtue, obesity with sin, mutilation of the body with an act of martyrdom and faith. Indeed we are speaking about an industry with an annual turnover of billions of dollars that would not exist without an ethos that promotes its results. The sublime is then to be found in the gym, in making the body closer to the ethereal ideal, in de-naturalisation of the flesh so that it will be ready to enter the heavenly state of the spirit.

We are surrounded with new temples. If stadia are places of worship, tourist resorts paradise, shopping centres ecstatic experiences, and museums the bethels of good taste, then the cathedral by the same reasoning could be admired solely as a work of art, and it takes only a small step to regard that which it houses, namely religion, as an artistic project.

There is a great feeling of discontent when the religious (or religious feeling or the presence of the sublime) is manifested through lower forms of culture. I stress "low" not because I believe them to be such, but for the sake of argument it is convenient to separate them from all which is considered high, and I do so with the knowledge of the transitory character of both good and bad taste. In so far as the qualities of the authentic and the essential are attributed to Newman or Klein, Rothko or Mondrian and to St. Augustine or Rudolf Otto or Mother Teresa or the Pope himself, one might ask whether the cult surrounding Elvis Presley or Lady Diana, Marilyn Monroe or Madonna is basically any different, and whether, on the basis of qualities such as authenticity or truth, they could be dismissed as temporary phenomena that lack the inner core of that which constitutes the religious.

Taking authenticity as the canon that marks the difference between traditional religious passion and its transformation is of course one means to assuage the sense of discontent. But exactly what is authentic in our lives that are surrounded by the mirrors of virtual images emanating through all media, in advertising and soap operas, news and talk shows that form our opinions, guiding us in a tight and ritualised way, advocating good from bad and putting order in our lives? Our intelligence would not then be measured by our illusion of the existence of our own authenticity but rather by recognising its absence. In such a situation, when old parameters are recognised to be transitory, we tend to hang on to our own prejudices because they are the only good taste we will ever have, as Anatole Broyard wisely said. But knowing good taste to be a prejudice is already a step in accepting that the new religious forms are as inauthentic as everything else there is.

If we agree that the media has taken over the role of religious guide (it turns order into chaos, tells us what the "Good Life" is, localises us in the world and interlinks the individual with the communal space) then we should also accept that the figures this religious order offers us as icons will live forever as an image. It follows that we can understand every soap-opera as the battlefield between the sons of light and the sons of darkness, can realise that news bulletins are synoptic gospels and can find the numinous in advertisements. And all the more because from the beginning the icons of this matrix are not flesh and blood but virtual and as such given to exist in religious experience as mediators. It is not without reason that one of the titles of the mother of God is Mediatrix. If authentic religious feeling is then to survive, it will do so as a citation, which is now the only possible access to any form of the authentic, by being sipped through the sieve of the artistic, through artificialising it twice by means of quotation, so that the new religious construction, be it a feeling, ritual, or attitude, now acting as a work of art, becomes true exactly because it is false.

There are then two ways of building Jerusalem, either by being committed to the abstract or by pledging the fantastic, and in a world which lives by the truth of its simulation, that is by abstracting reality and virtualising it until the map stands for the territory, there seems to be no reason to re-abstract the abstracted, for it would be an act without logic. It is here that artists, by being compelled to point out the opposites arrive at new ways of showing the sublime.

Because art has become a religious phenomenon, artists do not even have to pursue such questions as to whether belief is a structure or a content, nor do they have to substitute in the name of a Grand Narrative, religious epiphanies with humanistic issues, or recognise religion as a paradigmatic error. Art as religion is the programme of the dispossessed. Both give room for desire to be manifested through an admire-admired relationship. Both create territories where the dispossessed can enact their desires, making the appearance of the sublime become compensatory. In doing this they differ from contemporary philosophers, like Jacques Derrida, Jean Baudrillard or Jean-François Lyotard whose aesthetics of the sublime are given almost always through an apocalyptic prism, whereupon the Now of the sublime as claimed by Barnett Newman is interchangeable with the Now of a forever apocalyptic state. Artists, unlike philosophers, substitute irony for eternal despair.

In HEAVEN, religious feeling is revealed through different strata and I would like briefly to explain why these specific artists were chosen. While artists like Jeff Koons, Olga Tobreluts, Karen Kilimnik, Ralph Burns, Haim Steinbach or Sylvie Blocher use icons of today to narrate the story of the transformation without wishing the work itself to emanate a religious aura, others like Jeffrey Vallance, the Art Studio Demetz, and Michael Schirner, use recognisable attributes such as the shroud of Turin or the motif of the Virgin or the actual form of a prayer to create a semblance. Jessica Diamond equates monetary value and faith in a single stroke. Eddo Stern locates the altar in the Internet domain, where avatars take on the role of messengers, virtual as the heralds of any religion.

Ed Ruscha, Gary Simmons, Jake and Dinos Chapman, Mariko Mori and Sylvie Fleury make the works themselves a locus of the sublime. For them religiosity is inherent in the media they use. Yinka Shonibare, Gil Shachar, Wang Fu, and Ron Mueck take the theme of the child and the alien, both a gestalt of redemptive possibilities through heavenly creatures or heavenly futures. Children, in a state of assumed innocence, are regarded as mediators, either angels or devils, no longer are they the small mature persons they used to be in the past.

Dresses suited to immortal gods and goddesses are made by Qin Yufen, Justen Ladda, Thierry Mugler and Viktor and Rolf. Glamour is transformed to religious bliss, as in the works of Inez van Lamsweerde, while elements of androgynity are highlighted to denote a primordial state of perfection as in the photos of Anneke in t'Veld. Fashion and religion are two opposites, or so we would like to think: one claims to win the present, the other, eternity. Yet, consider the fact that the first principle of fashion made visual is a bodily condition that signifies infertility, a condition that desires the body's evaporation. Saints and martyrs are never fertile. Their bodies are not made to bear children but to suffer for them. This means that the text underlying fashion, in spite of its transient character, is similar to the subtext of the religious model, for both claim the sacrifice of offspring as a primary condition for entering the heavenly kingdom.

Another way of turning one's own religion into a work of art is exercised by Shirin Neshat and Majida Khattari. As women within Islamic tradition, they are not fighting in the name of gender-wars or for the rights or wrongs of their tradition but are manipulating its given elements into an artistic statement, making danger an aesthetic credo. Orlan, who comes from a Western tradition which equates suffering with virtue, rebels against this notion by turning her own body into the arena of her art. The plastic operations which she endures are not so much a critique against the cult of beauty as an analytic approach to the nature of sacrifice in a secular world. A similar parallel is to be found in the work of Gilbert & George whose repetitive dance echoes the steps of the mediaeval Saint Vitus' dance in which the body, encapsulated in a trance, cannot stop its zealous movement.

When religion becomes art and art is a religion it follows that artists could become priests or else resume the role a society with a tendency towards cynical reason could assign them. Not wishing to be shamans and not wanting to lead the way, either as heralds of mysterious doctrine or as society's outsiders, what is left for them is the evocation of the sacred in places least suspected of housing its presence. This is what HEAVEN is all about.

THE ARTISTS

born 1964 in New York, lives in New York

Solo Exhibitions (selection)

1998 Metro Pictures, New York
1997 *Gary Simmons: Gazebo*, Museum of Contemporary Art, San Diego
1996 *Boom, Bang!*, Philippe Rizzo Gallery, Paris
1995 *Gary Simmons: Erasure Drawings*, Lannan Foundation, Los Angeles
1994 *Directions: Gary Simmons*, Hirshhorn Museum and Sculpture Garden, Smithsonian Institution, Washington, D.C.
1992 *The Garden of Hate*, Whitney Museum of American Art at Philip Morris Branch, New York

Group Exhibitions (selection)

1998 *The Campaign against Living Miserably*, Royal College of Arts, London
1997 *Heart, Mind, Body, Soul: American Art in the 1990s*, Whitney Museum of American Art, New York
 Trade Routes: History and Geography, 2nd Johannesburg Biennale
 Gothic, ICA, Boston
 No Place (Like Home), Walker Art Center, Minneapolis
 New York: Drawings Today, San Francisco Museum of Modern Art
1996 *Under Capricorn: Art in the Age of Globalization*, Stedelijk Museum Eindhoven
1994 *Black Male: Representations of Masculinity in Contemporary American Art*, Whitney Museum of American Art, New York/Armond Hammer Gallery/UCLA, Los Angeles
1993 *Whitney Biennial*, Whitney Museum of American Art, New York
1991 *Interrogating Identity: The Question of Black Art*, Museum of Fine Arts, Boston/Walker Arts Center, Minneapolis et al.

Ashes to Ashes, 1999, chalk on board, Courtesy Gary Simmons (ill. pp. 16–19)

To a certain extent Gary Simmons's work is about traces and the way in which they form and effect collective and individual memory. Simmons draws directly on a black wall, using chalk to create his images which he then erases in such a manner that they are not completely obliterated, but are on the verge of disappearance. The drawings assume a fuzzy and blurred quality. They seem like something seen out of the corner of one's eye, something one knows should be remembered, which, however, is evasive and cannot be defined. Simmons thus maintains the primary form of the image, but negates it at in the same time, creating an ambivalent interrelationship between the image and the viewer, where the knowledge of the afterimage is intuitively grasped by the viewer as the location of meaning, while the physical representation becomes a grid sustaining this intuitive perception.

This implies that Simmons's places emphasis in his works on something which usually only emerges after observing an object, the contemplation which follows the act of seeing. The act of contemplation becomes the actual space and time of the work. One is tempted to say that the drawing contemplates itself. The work always takes place in the past. It is never present but remembered in retrospect; for what we perceive is a vanished image, its transformation, its denial.

Blurring the image is a method used by artists when they wish to represent something that cannot be depicted in a definite manner. When the surrealists painted their dream landscapes, they did so under the stark rays of an enlightened attitude so that no secret could escape the projections of reason. This clearly outlined way of representing dreams evoked the illusion of being able to define the undefinable. Memory, on the other hand, functions in a more elusive manner. If dreams are initially riddles which are subsequently exposed as coherent structures, then memory begins as a fact and ends as a subjective or collective myth. If dreams are executed in sharp contours in order to maintain their immanence, then memory may be represented through erasure which serves as a metaphor of its virtuality. Gerhard Richter, a painter much admired by Simmons, uses blurring techniques to balance the banality of the primary and framed image. As in Simmons's works, this brings about a temporal dislocation in regard to the perception of the work.

What then is the nature of the memories depicted in Simmons's art? They are racist and collective in the sense that they reflect a stereotypical view of black people as seen by white people and, insofar as they focus on the manner in which prejudices are expressed consciously and unconsciously in popular culture, such as in cartoons. But racism intertwined with collective memory is only part of a larger theme. It is the time of childhood, when archetypes are fixed and categories are formed, which Simmons takes as the perspective from which he represents his motifs. The black wall functions like a school blackboard, and upon it fears, ideas, prejudices and knowledge are inscribed. The wall offers a parallel history by means of the power of erasure. It is a laboratory, where concepts are examined, tested and remembered. Simmons's blackboards remind us through the rise and fall of the signs inscribed on them that we are not what we remember, but rather what we choose to remember, all else vanishing like the Cheshire Cat in *Alice in Wonderland*, until only its smile remains, suspended in air. DLH

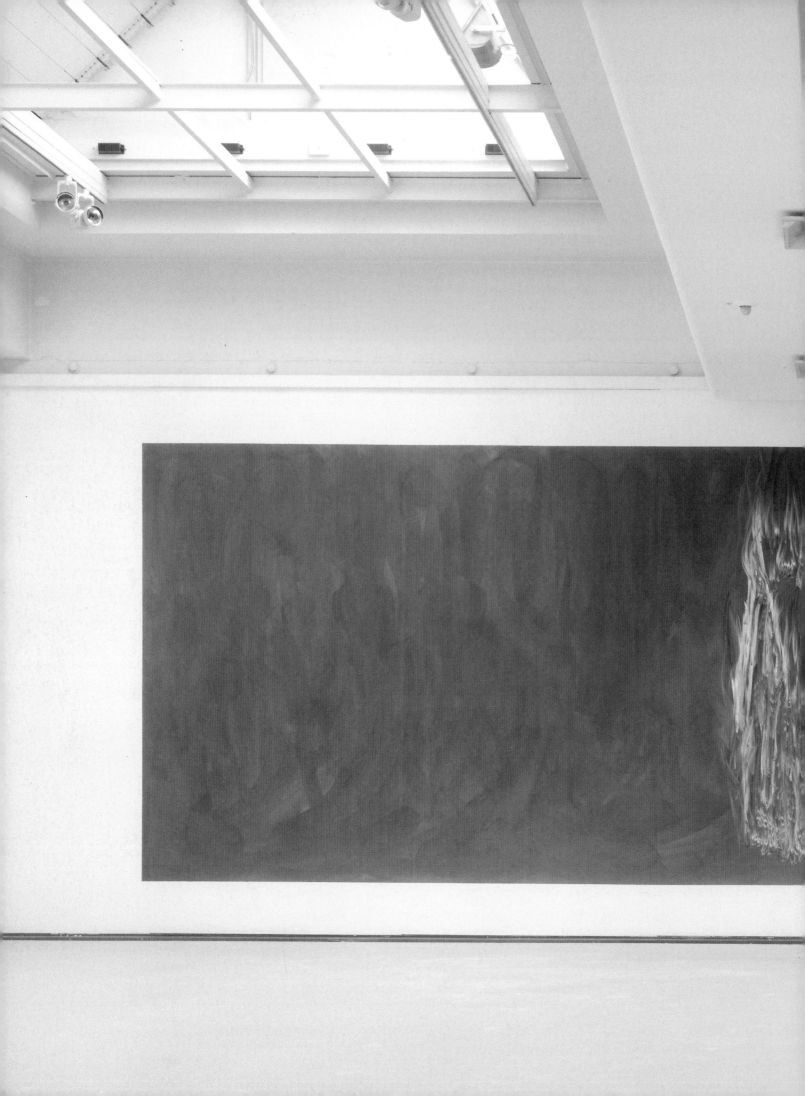

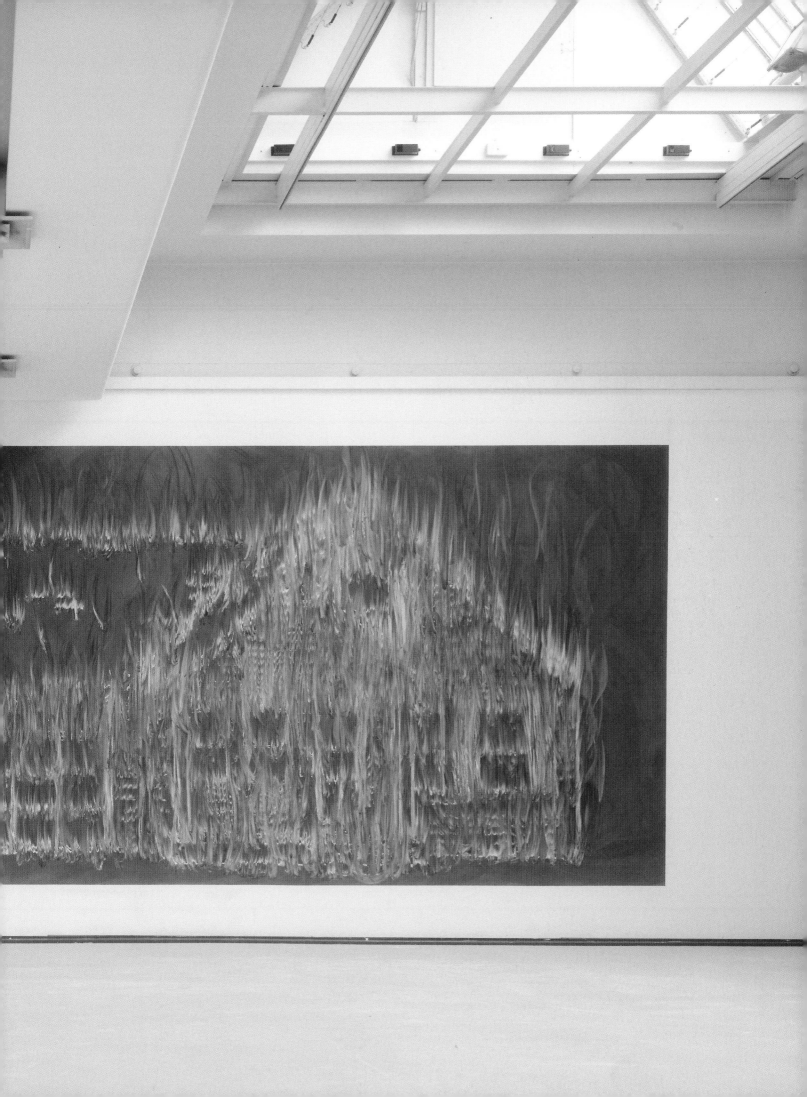

Jake Chapman, born 1966 in Cheltenham, Dinos Chapman, born 1962 in London; live in London

Solo Exhibitions (selection)

1997	*Jake & Dinos Chapman*, Grazer Kunstverein, Graz
	Gagosian Gallery, New York
1996	*Chapmanworld*, ICA, London
	P-House, Tokyo
1995	*Five Easy Pissers*, Andrehn-Schiptjenko Gallery, Stockholm
1993	*The Disasters of War*, Victoria Miro Gallery, London
1992	*We Are Artists*, Hales Gallery, London

Group Exhibitions (selection)

1997/98	*Sensation. Young British Artists from the Saatchi Collection*, Royal Academy, London/Hamburger Bahnhof, Berlin
1997	*Gothic*, ICA, Boston
	Campo 6, Bonnefanten Museum, Maastricht
1996/97	*Full House*, Kunstmuseum Wolfsburg
1996	*Biennale di Firenze*, Florence
1996	*Live/Life*, ARC, Paris
1995	*General Release: Young British Artists*, *Biennale di Venezia*, Venice
	The Institute of Cultural Anxiety: Works from the Collection, ICA, London
	Brilliant, Walker Art Center, Minneapolis
1994	*Five British Artists*, Andrehn-Schiptjenko Gallery, Stockholm
	Great Deeds Against The Dead, Andrea Rosen Gallery, New York
	Watt, Witte de With/Kerdamunsthal Rotterdam

Disasters of War, 1993, mixed media, Tate Gallery, London, © Tate Gallery, London (ill. pp. 22/23)
Disasters of War, 1999, 83 etchings, 24.5 x 34.5 cm, Courtesy Collection Max Wigram, London, © Stephen White (ill. pp. 24–29)
Model of Hell, 1999, mixed media, Courtesy Jake & Dinos Chapman

In the works of Jake & Dinos Chapman the body most always appears as an obscene monstrosity, as it completely negates the sacred image it is traditionally supposed to embody and because it is mutated, tortured and transformed into an object. It is represented in the form of a doll or a mannequin, i.e., it is twice removed from the original model, on the one hand, in its being shaped into its grotesque counterpart and on the other, through the sense of uncanniness associated with such devices per se. Here the body is depicted in its hour of doom, when nothing is conceivable beyond it, caught up in an obsession with its own surface.

The body becomes a site of horror in these works, because they question the classic dichotomy of body and soul which, ceasing to exist, makes all promises regarding present and future obsolete. In his book *The Tears of Eros* Georges Bataille points out to what extent art history has been linked with horror. Human flesh becomes the meat for a cannibalistic feast devoured by the voyeuristic gaze of the viewer.

Goya's work cycle *Disasters of War*, upon which 83 models and 83 etchings by the Chapman brothers are based, are a supreme example in the history of art of a committed approach that manifests itself in fighting inhumanity by artistic means. Goya's achievement was to create a work whose artistic quality did not conceal or gloss over the horror of the subject matter. Moreover, since the event depicted by Goya actually took place at the time when he produced his work, the fact that the horrors are ultimately incorporated into the fine arts does not diminish the viewer's ability to grasp its message. Goya, as did many other artists as well, chose the etching as a medium to express truths ineffable in painting.

Jake and Dinos Chapman were inspired by this practice in creating 83 etchings relating to the Goya's *Disasters of War*, as well as 83 tiny three-dimensional models representing these disasters, so that the mode of representation based on the notion that art depicts a given event in a descriptive manner is abandoned, leaving the work suspended between the categories of good and bad taste and increasing the viewer's aversion towards both the content and the formal execution of the works. The horrors of the disasters are no longer located within the subject matter of the work; they permeate the work itself. It is no longer a work of art on the topic of horror, but rather a metamorphosis of art into an actual site of horror, a place suited to hybrids and monsters. Seen from this perspective, the etchings function as a kind of therapeutic measure, an attempt to heal the wounds of both art and its subject matter, restoring, ironically at least and to a certain extent, the traditional dignity attached to the fine arts. DLH

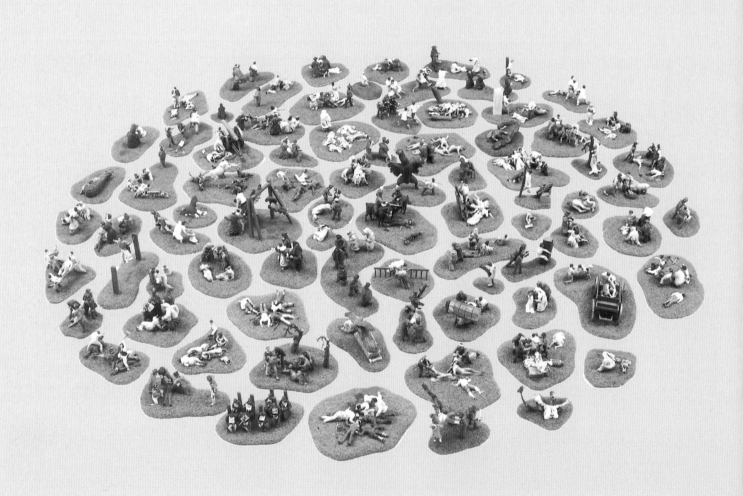

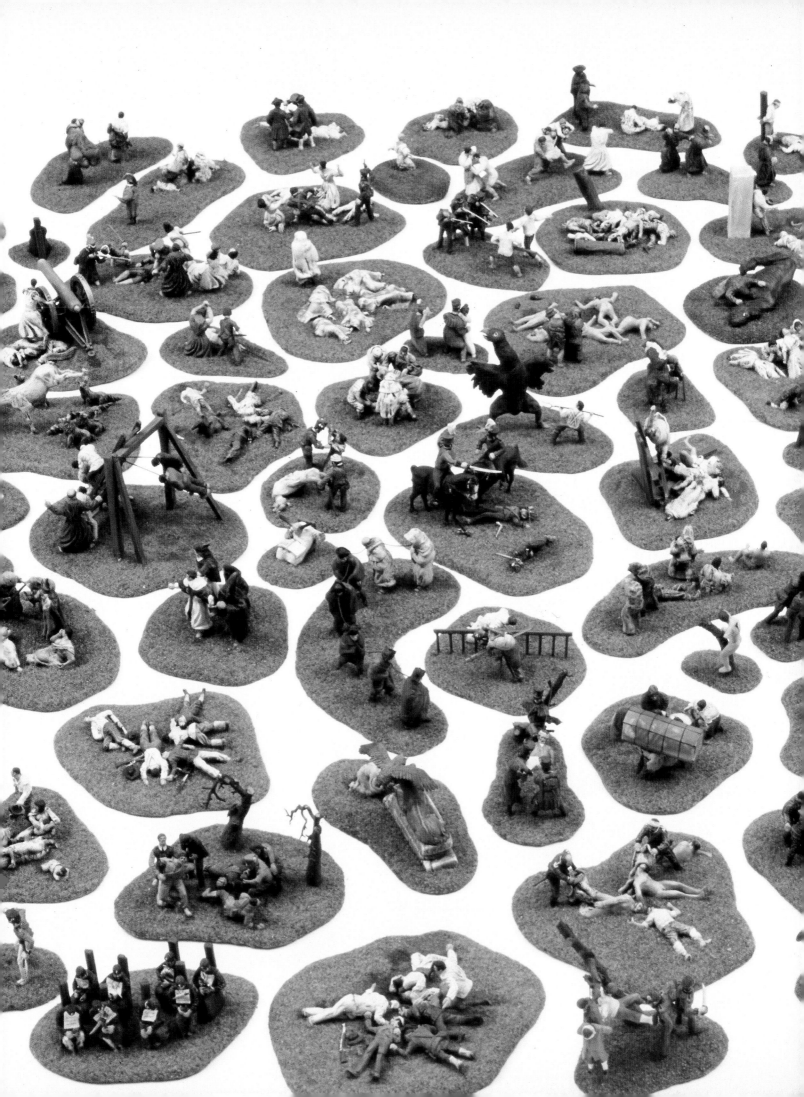

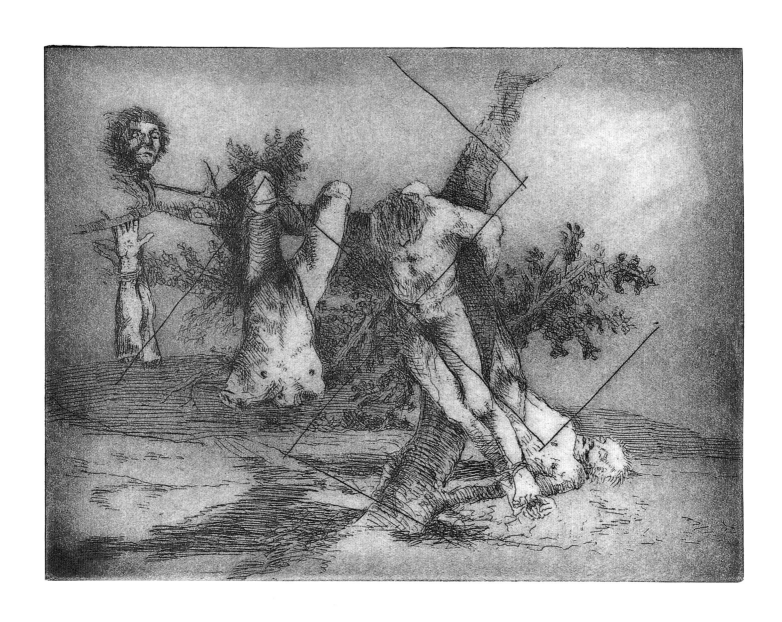

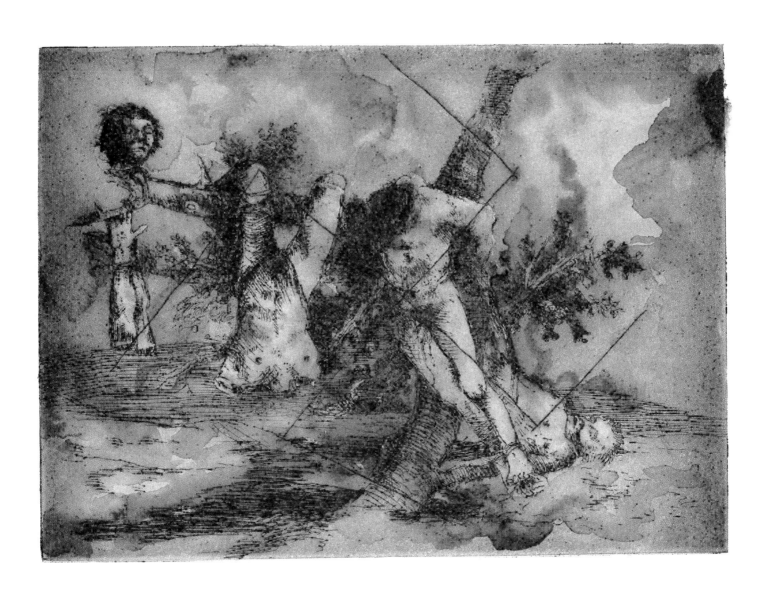

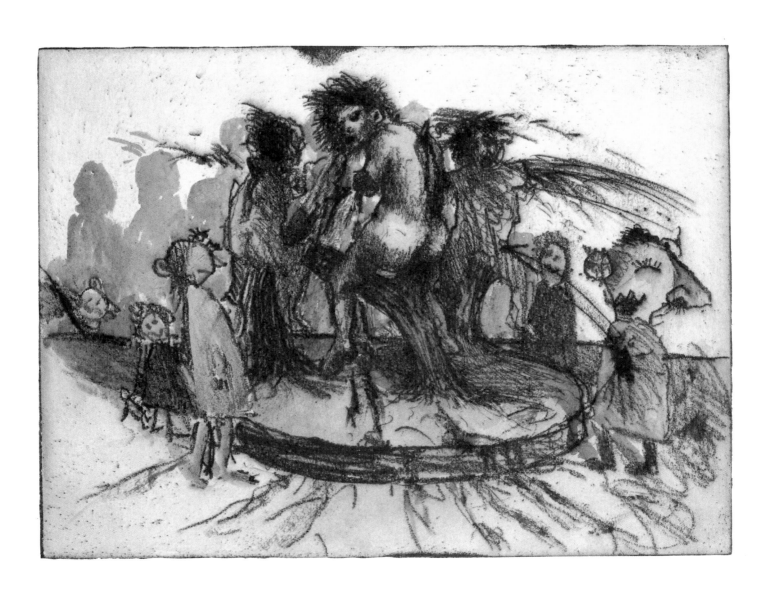

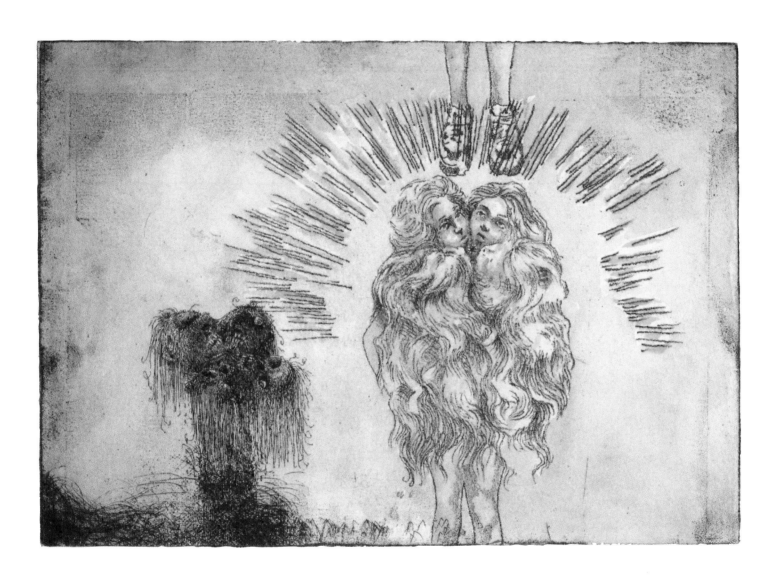

29

ED RUSCHA

Solo Exhibitions (selection)

1998	Ed Ruscha's Light, The J. Paul Getty Museum, Los Angeles
	Ed Ruscha, Anthony d'Offay Gallery, London
1997	Spaghetti Westerns, Milwaukee Art Museum
1995	The End, Denver Art Museum
1990	Los Angeles Appartment, Whitney Museum of American Art, New York
	Ed Ruscha, Serpentine Gallery, London
	Ed Ruscha/Paintings, The Museum of Contemporary Art, Los Angeles
1989	Edward Ruscha, Musée National d'Art Moderne Centre Georges Pompidou

Group Exhibitions (selection)

1998	Speed, Whitechapel Art Gallery, London
1998/97	*Sunshine and Noir*, Louisiana Museum, Copenhagen/Kunstmuseum Wolfsburg/Castello di Rivoli, Turin/Armand Hammer Gallery/UCLA, Los Angeles
1997	*Whitney Biennial*, Whitney Museum of American Art, New York
	Biennale di Venezia, Venice
1996	*L'informe: Mode d'Emploi*, Musée National d'Art Moderne Centre Georges Pompidou
1995	*Hall of Mirrors*: Art and Film since 1945, Museum of Contemporary Art, Los Angeles
1993	*Artists: Books I*, Museum Haus Lange, Museum Haus Esters, Krefeld
1991	*Collage of the Twentieth Century*, Musée d'Art Moderne et d'Art Contemporain, Nice
1989	*Whitney Biennial*, Whitney Museum of American Art, New York

Eternal Amnesia, 1982, oil on canvas, 50.8 x 404 x 3.8 cm, Courtesy San Diego Museum of Art, Gift of the Frederick R. Weisman Art Foundation (ill. pp. 32/33)
Is, 1998, acrylic on shaped canvas, 193 x 182.8 cm, Private Collection (ill. p. 34)
The Mountain, 1998, acryl on shaped canvas, 193 x 182.8 cm, Private Collection (ill. p. 35)

Already in 1959 Ed Ruscha began incorporating words into his pictures. Sometimes the words are placed against an abstract background and sometimes they are superimposed on images, either repeating the image or erasing it through the puns they generate.

In Rusha's works the words are strangely interrelated with the image. In his famous picture *Hollywood* the letters of the word comprise the subject matter. They manifest the phenomenon and the associations it evokes, acting both as signifier and signification. Rendering the world through words is like stating the obvious. It is an ironic and heroic gesture, because the attempt to represent something that is immanent in the representation is futile. The desire to substantiate a phenomenon by expressing it in signs is like spelling out an emotion whose vague character is mirrored in the diffuse background, reminiscent of intermediate phases in the course of a day such as twilight, dusk or sunset Ruscha chooses to employ in his works.

However, when depicting objects, using both photography and painting methods, Ruscha does so with crystal-clear vision. The twenty-six gas stations lining Route 66 or the documentation of all of the buildings on Sunset Boulevard are true landscape epics which conceal their meaning in a peculiar way. Since Ruscha renders them purely as they present themselves, without employing additional elements or mannerisms which might point to other levels of significance, the possibility that in their banality they might imply something totally different appears disturbing. The sublime mystery inherent in the everyday anticipates its revelation in transcending the manifestation of the obvious. This opens up a rhetorical field which by its very nature is deeply rooted in the ordinary, casting a spell which magically charges the "America" Ruscha shows at face value with more significance than directly meets the eye.

Words are therefore a tool for the artist to come within closer proximity to the dimensions missing in the immediate environment he depicts. He lives and works in Los Angeles, i.e., in the home of America's dream factory which tells people which fantasies to imagine and what their icons should look like. Ruscha himself favourably conceives of fantasy as a rebirth of history. Peter Schjeldahl has referred to him as a "Raymond Chandler" of art, which is reminiscent of the fact that Dave Hickey named another Californian artist, Jeffrey Vallance, a "Phillip Marlowe", leaving us with the question as to what makes people compare these artists with this particular author and his detective-character. I believe that in the case of Ruscha the answer to this question may be found in the romantic approach which characterises his work in the same manner as it adheres to the protagonists of the American detective genre. It is a Romantic notion which borrows from European Romantic movement its sensitivity in regard to the dualism between nature and culture. While in the European tradition nature wins over civilisation, in the American variation civilisation gains the upper hand, even though being in a sad and pitiful state.

Another feature that is derived from the Romantic tradition is the melancholy quality which pervades Ruscha's work as a whole. He casts a gloomy and frozen eye, a realistic glance perhaps, on an urban environment which initially promised glamour and a dream-like existence. It is a philosophical attitude which, while taking things as they really are, seeks in the depth of their existence a revelation, a promise of things to come; and it is this hope that imbues the work of Ruscha with a religious aura.

Finding the sacred sphere in spaces occupied by a Californian mentality whose lack of a historical underpinning can easily lead to a synthetic understanding of religious questions which views the abstract as an automatic response to the sublime is not an easy task. Ruscha avoids the pitfalls of such an attitude because he masters his objectives and regulates them through the incorporation of words into his works. In the manner of an adept following the cabbalistic tradition he superimposes letters and sentences, puns and riddles on surfaces as the sole means of achieving a sense of depth. The word is the ultimate image. It conveys all of the possible images of a given object—its limit is the sky. *Eternal Amnesia* is a picture with a width of four metres displaying an abstract panoramic view, yet the element of the sublime it seeks is located in the tiny inscription superimposed on it, like a treasure found in the midst of chaos. With its assertive authority the inscription, like the address on the wall, liberates and provides the depth the image as such is devoid of. The manner in which words are employed in Ed Ruscha's works of art is nothing less than an act of grace. DLH

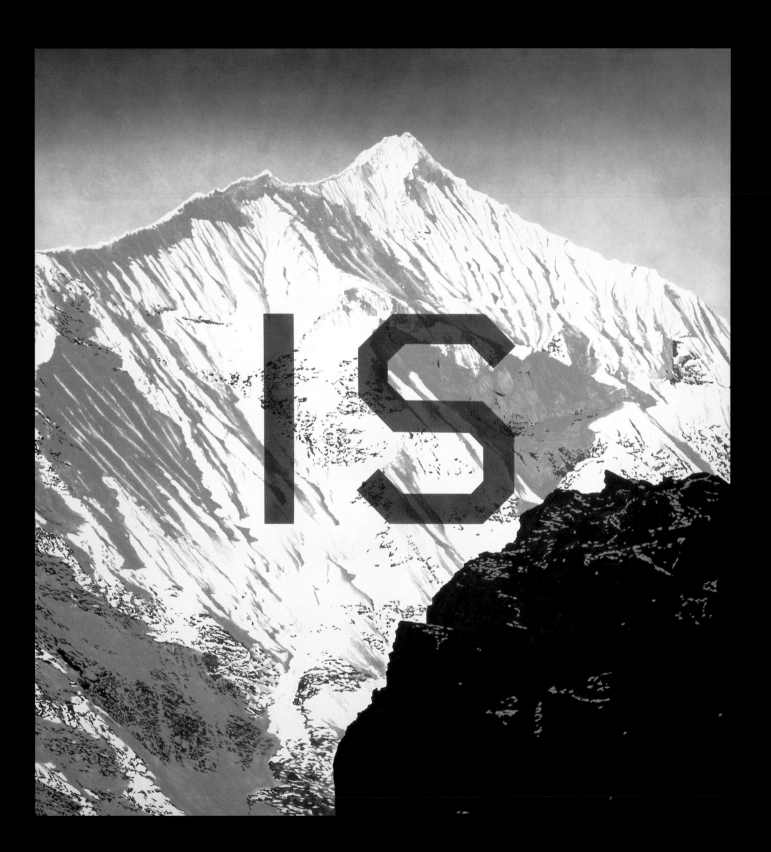

MARIKO MORI

born 1967 in Tokyo, lives in New York

Solo Exhibitions (selection)

1998/99 *Mariko Mori*, Kunstmuseum Wolfsburg/The Museum of Contemporary Art
 Chicago
1998 *Mariko Mori*, The Serpentine Gallery, London
1997 *Play with me*, Dallas Museum of Art
1996 *Made in Japan*, Deitch Projects, New York
 Centre National d'Art Contemproarain de Grenoble

Group Exhibitions (selection)

1998/99 *I love New York*, Museum Ludwig, Cologne
1998 *View: One*, Mary Boone Gallery, New York
1997 *Biennale de Lyon d'Art Contemporain*
 2nd Johannesburg Biennale
 Biennale di Venezia, Venice
1996 *By Night*, Fondation Cartier pour l'Art Contemporain, Paris
 New Histories, The Museum of Contemporary Art, Boston
 The Scream, Arken Museum of Modern Art, Ishoji/Finland
1995 *Self Made*, Grazer Kunstverein

Empty Dream, 1995, cibachrome print, aluminium, 274.3 x 731.5 x 7.5 cm, Courtesy Mariko Mori and Deitch Projects, New York (ill. pp. 38/39)
Enlightenment Capsule, 1996–98, synthetic material, himawari, fibre glass, 210.8 x 274.3 cm, Courtesy Fondazione Prada, Milan

In the video and photographic works of the Japanese artist Mariko Mori ancient traditions and utopian visions of the 21st century are conflated and given a unique shape. The artist's dream and fairytale worlds evoke a sense of extremely mundane topicality fused with an awareness of the timeless presence of divine powers. With the aid of digital image-editing processes Mariko Mori creates visual worlds which appear strange and novel to the viewer, but at the same time create the impression of being, in an uncanny way, familiar. Their technical perfection is reminiscent of the contemporary genre of action cinema in which the ability to distinguish between authentically acted scenes and digitally generated sequences in their appearance on the interface of perception—the monitor or film screen—is no longer possible. The overwhelming force of the visual revelation lets it appear even more authentic than the material reality surrounding the viewer. The transformation of authentic phenomena—of the palpable into the visual, of the body and material matter into surfaces, i.e. visual phenomena—is carried out to the point of perfection. Mariko Mori makes use of this development by adopting it as a subject matter in her works, thus drawing attention to the ideal, philosophical significance of this transformation.

In her performances of the early nineties, Mori appeared as a creature from another galaxy or as an envoy of a higher power. In the mega-picture-installations *Empty Dream* and *Kumano* she extends this approach to scenarios in which she appears in various guises. Through illumination from behind and the autonomous radiation they emit, these works establish a distance from the surrounding space, thus gaining a cosmological significance. While in *Kumano* the digitalisation and alienation is carried so far that the question as to whether an actual model exists in reality becomes obsolete. In *Empty Dream* an authentic, artificial beach in Japan serves as the setting for Mori's—fourfold— appearance as a mermaid who inconspicuously and nearly unnoticed mingles with the bathers. Already the images of her live performances as a cyber-girl in *Tea Ceremony III* or in *Subway* document the general disregard of the surrounding people for her in such a striking manner that the impression is suggested that the images have been digitally edited. Here the transformation that has taken place in the awareness in regard to the naturalness of self-generating image media becomes apparent. However, in *Empty Dream* the artificiality and irrelevance of the act is enhanced by the fact that the scenario is staged in a setting that is quite obviously simulating naturalness. The hermetic artificiality of the depicted environment is experienced as a unique quality, obtaining a metaphysical significance in the true sense of the word through the artistic comment inherent in staging the digitalised image. The brilliance, the supernatural light that radiates from the perfect appearance of the picture-installations, is perceived as a divine promise and taken as perfectly natural. Thus, Mariko Mori's works may be viewed as a contemporary quest for meaning under positive circumstances. When the technoide shaman girl in *Miko no Inori* looks at the future in a crystal ball, this gaze recognises authenticity in virtuality. This does not imply a loss of meaning, but rather is experienced as an enrichment. The light shining from the *Enlightenment Capsule* alludes to a divine light both to illumination in the material sense as well as to enlightenment in a metaphysical sense. The dream and fairytale world which lights up in her videos and picture-installations as a synthesis of references to tradition and future visions generates a hyperreality whose perfection fulfils itself in the eternal value of a hypersensitisation.

Mariko Mori has thus managed to create a visual experience, "which with its emotional and philosophical content penetrates directly into the subconscious" (Stanley Kubrick). MM

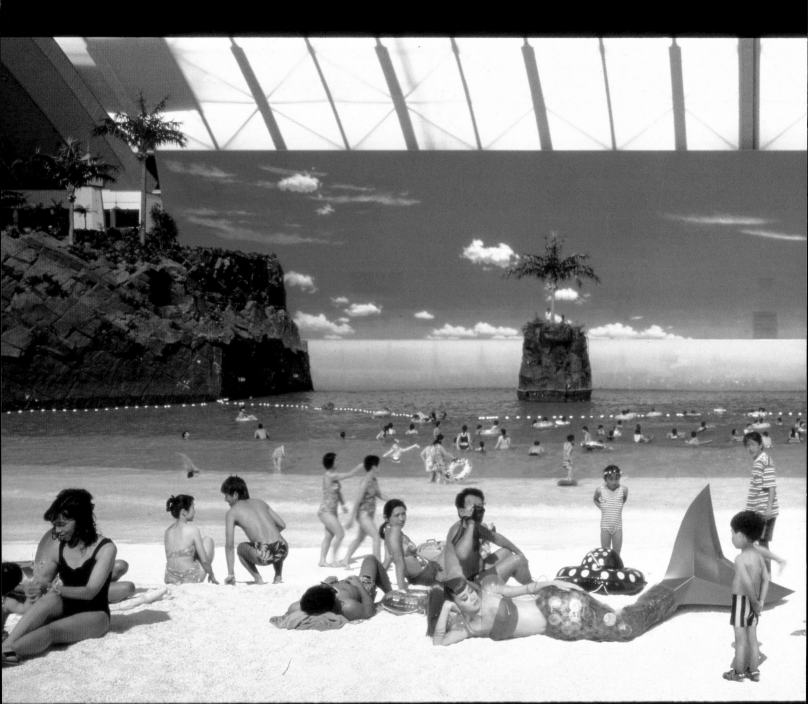

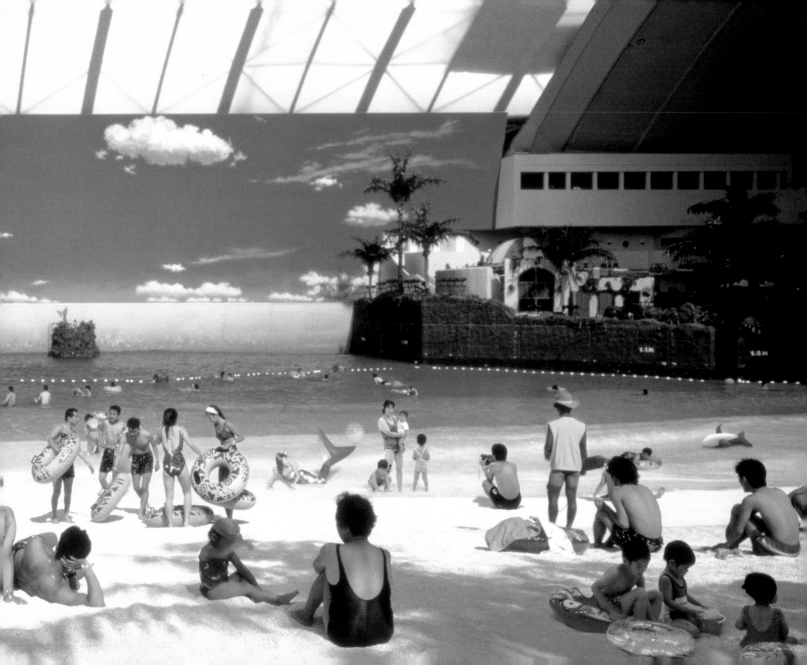

born 1958 in Melbourne, lives in London

Solo Exhibitions (selection)

1998 Anthony d'Offay Gallery, London

Group Exhibitions (selection)

1997/98 *Sensation. Young British Artists from the Saatchi Collection*, Royal Academy,
 London/Hamburger Bahnhof, Berlin
1996 *Spellbound*, Hayward Gallery, London

Big Baby 2, 1996–97, polyester resin, mixed media, 85 x 71 x 70 cm, The Saatchi Gallery, London,
© Stephen White (ill. p. 42)
Big Baby 3, 1996–97, polyester resin, mixed media, 86 x 81 x 70 cm, The Saatchi Gallery, London,
© Stephen White (ill. p. 43)

The central theme in the sculptural works of Ron Mueck are the dimensions, the format, the proportions. In depictions of the works, the naturalistic babies, the corpse of the father or just a head appear as if they were life-sized; however, confronted with the actual sculptures one realises that as far as their size is concerned they do not correspond to a model in real life. It is assumed that authentic models for the works exist; however, the hyper-real figures are either magnified to gigantic proportions or have become minute. But the irritating fascination of the works is due particularly to the disparity between appearance and projection, between the obsessively detailed manner in which they are carried out and their obvious artificiality. In a similar way in which moods and nuances of flavour may take on the character of colours, in the sculptures of Ron Mueck coherence and paradox correlate with one another. Unlike Duane Hanson's work, Ron Mueck does not employ the effects of irritation and surprise in order to unmask consumer society, but rather his manner of undermining particular categories of perception is aimed at the deconstructive analysis of the means employed for identifying and distinguishing—the assumed identity of perceiving and denoting, i.e., signifier, significance and object. What correlates much more with the actual dimensions of his sculptures than the size of the corresponding models is the high degree to which notional connotations may be associated with the works in the process of viewing them. In their innocent presence and their nearly omnipresent self-assurance the "babies" actually appear larger than life, the impression of animosity, of impending doom that the *Mask* radiates seems to be of overwhelming proportions, and the state of frustration in which the *Angel* appears is synonymous with his reduction in size. Thus, Mueck achieves in his sculptures an expression of particular emotional states not by attempting a representation that is as true to life as possible, but rather by means of an inherent commentary which lies in the choice of proportions. As the hyper-real representation immediately excludes an objective perception of Mueck's works, irritation must be aroused through their dimensions. Only this enables the viewer to perceive the sculpture as such and to question its meaning.

Accordingly, the artistic fascination of *Big Baby*, *Mask* or *Dead Dad* lies particularly in unmasking the viewer's wish to experience a feeling of uncertainty in regard to the actual content of the work. Here content and form coincide because the intricately perfect forming of the figures is fascinating indeed, when, for example, as is the case in *Angel* Mueck even pays attention to the hairs on the big toe of the figure. As far as the content of his works is concerned these are bizarre figures—for what is the actual meaning of a life-size man with angel's wings and a frustrated gaze, who is pensively sitting on a stool in real size, i.e., corresponding to the size of the viewer? In larger-than-life dimensions *Mask* recalls a caricature in a newspaper rather than the avenging countenance of God the father. The references to various meanings are treated here with irony in an impressive manner. Mueck manages to perturb the recipient with grotesque humour, as beneath the perfect and hyper-real surface horror might possibly be lurking. The programmatic exaggeration of the typified infantile image transforms the oversized *Big Babies* into feeble-minded monsters suffering "cold turkey". The exposure of the father's corpse testifies to a true sympathy with the deceased person; the extreme reduction in size creates the shock. Thus, the sculptures of Ron Mueck are far more than bizarre figures or strange beings; they represent a subtle commentary on the misuse of conceptual terms and on the manipulation of sign systems. MM

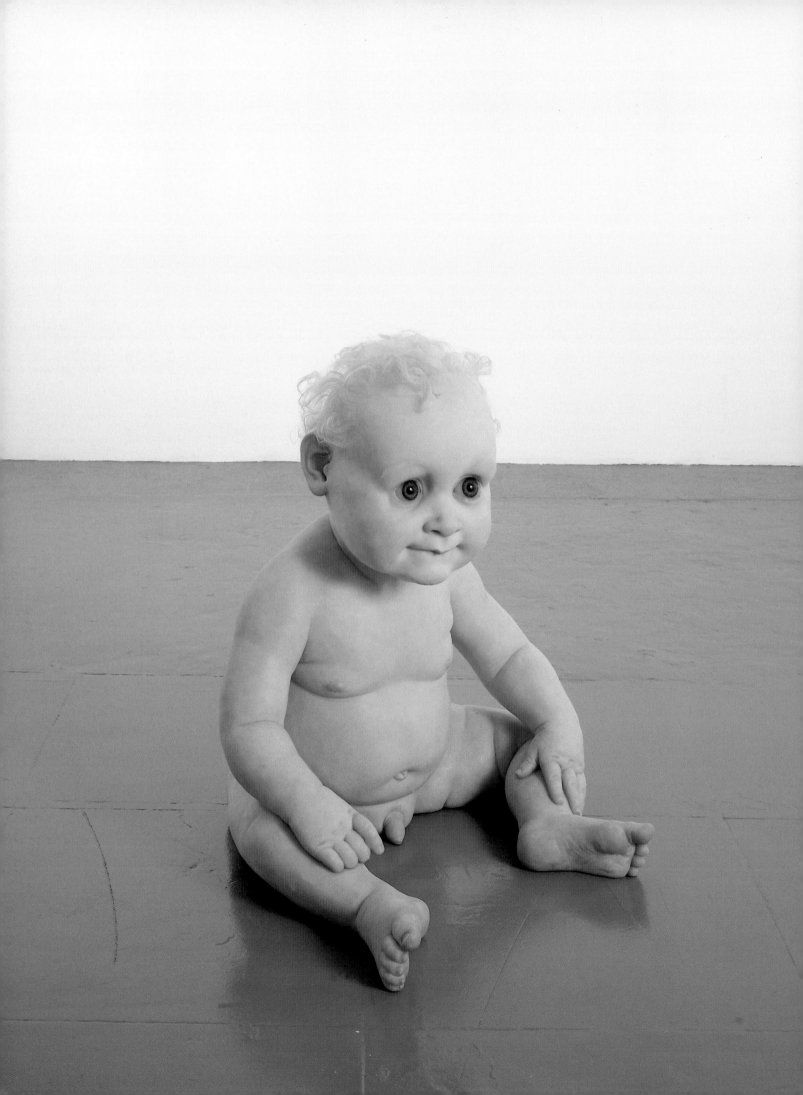

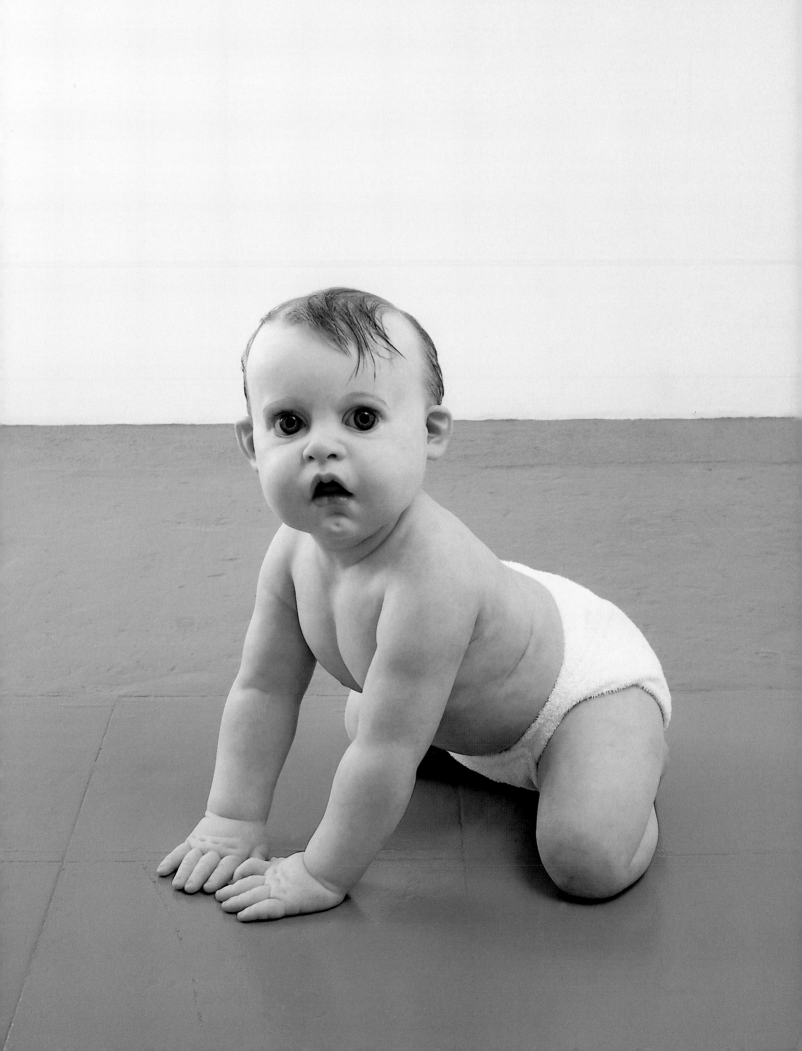

The image is always sacred, if we must use a term that can so easily lead to confusion. In fact, it is constantly confused with the religious. But religion is the observance of a rite which forms and which maintains a link (with others or with itself, with nature or something supernatural). It is not the same thing as the sacred. (Nor is it the same as faith, which is something else again). The sacred signifies that which is separate, set apart, removed from its background. In a certain sense, then, the religious and the sacred are opposites. In another sense, though, the sacred is only what it is because of its separation, and there are no links with it. It is essentially something that stands apart, at a distance, with which no link can be made. In order to avoid such confusion, I shall call it the distinct.

THE IMAGE - THE DISTINCT

Jean-Luc Nancy

The thing that seeks to create a link with the sacred is sacrifice, which is in fact part of religion, under one form or another. Religion ceases at the point where sacrifice ceases. But it is there, by contrast, that distinctness begins, and maintains of its distance. It is here, perhaps, that art has always begun—not in religion (whether or not associated with it), but at a remove.

The distinct is distant, it is the opposite of near. That which is not near can be distant in two ways: distant from contact or distant from identity. The distinct is distinct in both these ways. It does not touch and it is dissimilar. The same is true of the image: it must be detached, placed outside and before the eyes of the spectator (thus it is inseparable from a hidden surface, that cannot detach itself) and it has to be different from the thing. An image is a thing that is not the thing itself: essentially it distinguishes itself from it. But what is essentially distinguishing itself from the thing is, equally, strength, energy, drive, intensity. The "sacred" was always a force, or even a violence. It is important to grasp how force and the image both belong in the same distinction.

The distinct stands apart from the world of things in so far as it is the world of the available. In this world, things are available both for use and according to their manifestation. That which withdraws from this world is of no use, or rather has quite a different use, and does not manifest itself (a force is not exactly a form; it is necessary to understand the way in which the image is not a form and is not formal). It is that which does not show itself but which gathers itself together within itself, its force lying coiled beneath or beyond form, but not as another shadowy form: but as the "other" of the form. It is intimacy and the passion of intimacy, distinct from all representation.

The distinct is characterised, then, by its distance: its tension lies in maintaining this distance at the same time as overcoming it. In the religious language of the sacred, this overcoming constituted sacrifice or transgression (sacrifice is legitimised transgression). The essence of such a step lies in the fact that it does not establish a continuity: it does not seek to remove differentness. It maintains it, at the same time as making contact with it: collision, confrontation, meeting or embrace. It is not so much a relationship as a transport. The distinct throws itself against the indistinct, but it does not attach itself. It is in this way that an intimacy exposes itself to us: exposed, but for what it is, with its force coiled up inside, not relaxed.

Continuity only takes place within the indistinct and homogenous space of things and of the operations that link them to one another. The distinct is, by contrast, heterogeneous, or in other words unbound—that which cannot be bound.[1] This is the essence with which we are presented, which proximity does not appease and which therefore remains at a distance: just far enough away to allow us to brush its surface. It draws near across a distance, but what it brings up close is distance. This is well illustrated by all portraits, that are like nerves of the image in general. A portrait has an effect, or else it is nothing more than a photograph on an identity card, a description, not an image. What affects us is some part of an intimacy that is carried up to the surface. But a portrait is only an example. Any image comes into the category of "portrait", not in that it reproduces the appearance of a person, but insofar as it *draws out*, or *extracts* something, an intimacy, a force. And in order to extract it, it takes it away from homogeneity, makes it distinct, detaches it and projects it.

The image confronts us with an intimacy that reaches deep within us—through the senses of sight, hearing or by the meaning of the words themselves. Because the image is not only visual: it can equally well be musical, poetic, or experienced through touch, smell, taste or movement. This differential lexis is insufficient, and I do not have the time here to analyse it. The visual image certainly plays a role as model, and for precise reasons that will become clear in due course. For the moment, I will cite the example of a literary image, where the visual aspect is evident, but which is nevertheless one created by a piece of writing:

A girl came out of Lawyer Royall's house, at the end of the one street of North Dormer, and stood on the doorstep. It was the beginning of a June afternoon. The spring-like transparent sky shed a rain of silver on the roofs of the village and on the pastures and larchwoods surrounding it. A little wind moved among the round white clouds on the shoulders of the hills, driving their shadows across the fields... [2]

Thus glimpsed, framed in an open doorway giving onto the intimacy of a home, a girl of whom we perceive nothing but her youth, is already revealing the imminence—a captured "instant"—of a story, of we know not what meeting, what happy or tragic event: she reveals it in the light emanating from the sky, and this sky provides the broad and "transparent" background, unbounded, against which the successive lines of a street, a house and a door detach themselves. It is less a question of the image, that we cannot fail to imagine, but more a matter of the function of the image, light and correct balance of shadow, framework and detachment, the emergence and touch of an intensity.

The image always comes from the sky (*ciel*)—not from the heavens (*cieux*), which are religious, but from the skies (*ciels*) in the sense used by the artist, in the sense of the Latin *firmamentum*, the fixed vault to which the stars are attached and whence they shed their light.

The painter's sky retains within itself the sacredness of the heavens insofar as it is the essence of the distinct and the separate: going back to the ancient cosmologies, the sky is the separated, where a god or some force older than the gods separates it from the earth:

When the Sky was separated from the Earth
—that formerly had been solidly joined—
And when the mother goddesses appeared. [3]

Before the sky and the earth, when all was one, there is nothing distinct. The sky is the distinguished par excellence, and in its essence distinguishes itself from the earth on which it sheds light. It is also itself distinction and distance: endless brightness, simultaneously near and far, the source of light that nothing illuminates in its turn (*lux*) but by which everything is illuminated, and everything takes on distinctness, which is in its turn the distinction between shadow and light (*lumen*), by which a thing can shine and take its radiance (*splendor*), which is to say its truth.

The image comes from the sky: it does not descend from it, but proceeds from it, it is celestial in essence and contains the sky within it. All images have their sky, whether it is represented as standing outside the image or is not represented at all: it gives it its light, yet the light of an image comes from the image itself. Thus the image is the sky detached for itself, coming with all its force to fill the horizon, but also to remove it, raise it up or to pierce it, carrying it to infinite power. The image that contains it overflows and expands into it, like the resonances of a chord, like the halo of a painting. There is no reason for any consecrated [*consacré*—in both its senses of 'holy', or 'dedicated'] place or use, nor for any magic *aura* conferred onto the image.

This celestial force is that of the passion that is conveyed by the image. The intimacy is *expressed* in it: but this expression should be understood quite literally (*ex premere*). It is not a translation of a state of mind: it is the mind itself that presses against the image, resting on it, or rather the image is this pressure, this animation and this emotion. It does not provide its meaning: in this respect it has no object (or "subject", as in the subject of a painting), nor has it any intention. So it is therefore not a representation: it is an imprint of intimacy and of its passion (of its motion, agitation, tension, passivity). It is not an imprint in the sense of a type or of a laid-down, fixed scheme. [4] It is rather the movement of the imprint, the pressure that marks the surface, the raised and indented parts of this surface, its substance (canvas, paper, copper, plaster, clay, pigment, film, leather), its impregnation

or its infusion, the burying or the discharging of it in the pressing. The imprint is at one and the same time the receptivity of a formless support and the activity of a form: its force is the mixture of the two.

The image is separated in two simultaneous ways. It is detached from one background and it is picked out against another background. It is detached and deflected. Its removal detaches it and brings it forward: a "front" is created, a surface, when the background had no face and no surface. As the image is picked out, edges are created, framing the image: this is the *templum* traced on the heavens by the Roman auguries. It is the space of the sacred, or rather the sacred as a separation that distinguishes.[5]

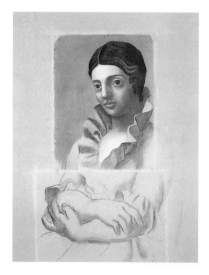

Pablo Picasso, *Portrait of Olga,* 1921,
Musée Picasso, Paris

In this double operation, the background disappears. It disappears into its essence as background, which is to not be visible. Disappearing as a background, it becomes an integral part of the image. Yet it does not appear, and the image is not its manifestation, nor its phenomenon. It is the force of the image, its sky and its shadow.

The image brings together this force and this sky with the thing itself. Yet it is neither the thing nor an imitation of the thing (and it is all the less so since, as we have already said, it is not necessarily plastic or visual). It resembles the thing, which is not the same thing. In its resemblance, the thing is detached from itself. It is not the "thing itself" (or the thing "in itself"), but a "sameness" of the thing present as such. It is distinct from its being, from its simple presence in the homogeneity of the world and in the relationships of the operations of nature or of technique. Its distinction is a dis-similarity that lies within its resemblance, that works on it and disturbs it with an impulse of separa-tion and passion. It is the being-image that is distinct from the being: it is not here, but there, at a distance, at a remove whose "absence" (by which the image is often characterised) is nothing more than a convenient name. The absence of the portrayed subject is nothing more than an intense presence, turned back on itself, gathered together in its intensity. Resemblance comes together within force: from this comes the pleasure we take in it. *Mimesis* embraces *methexis*, a participation or a contagion by which the image touches us.

It is this harmony (*convenance*) with itself created by the resemblance that touches us: it resembles itself and thus it assembles itself. It is a totality that harmonises with itself. By coming to the fore, it goes within. Its "inside" is nothing other than its "front": its ontological import is surface, exposi-tion, expression. Here the surface does not stand in relation to the observer: it is the place of concentration in harmony. (This is why it has no model, its model being within it, its "idea" or its energy). If the spectator remains standing in front of the surface, he will see only a disjunction between the resemblance and the dissimilarity. If he enters into harmony with it, then he enters into the image and is no longer merely observing it.

The harmony of the image in itself excludes precisely its conformity with a perceived object, a coded feeling or a defined function. On the contrary, the image ceaselessly draws in around itself. This is why it is motionless, becalmed in its presence, harmony of an event or an eternity. Musical, choreographic, cinematographic or kinetic images in general are no less immobile in this sense of the word: they are distensions of an intense present. Here too succession is also simultaneity. (The exemplarity of what is visual when it concerns the image, depends on the fact that it is first and foremost in the field of immobility as such: the exemplarity of what is aural, on the other hand, is that of distension as such.)

There is a French expression *"sage comme une image"* (literally, "as good/wise as a picture/image", the usual English equivalent being "as good as gold"), but the goodness/wisdom of the picture/image, if indeed it is a restriction, is also the tension of an impulse. It is first of all offered and given to be taken. The seduction of images, their eroticism is nothing more than their availability, to be taken, caressed with the eyes, hands, belly or the mind, and penetrated. If flesh has played an exemplary role in painting, it is because it is the spirit of painting, something much more than the mere depiction of nude figures. But to penetrate the image, as with the penetration of a lover's body, means being penetrated by it. The eye is flooded with colour, the ear with sound. There is nothing in the mind that is not also in the senses; nothing in the idea which is not in the image. I become the blue in the portrait of Olga, the dissonance of a chord, the step in a dance movement. "I": it is no longer a question of "I".

Cogito becomes *imago*.

Each thing, in the distance to which its harmony withdraws, departs from its status as a thing and becomes intimacy. It can no longer be moulded. It is neither body, nor tool, nor god. It is outside the world, being in itself the intensity of a concentration of the world. It is similarly outside language, being in itself an assemblage of a sense without meaning.

Neither world nor language, we can say that the image is "real presence", as in the Christian sense of this expression[6]: the "real presence" is precisely not the presence of the reality in question. It is a sacred intimacy conveyed by a fragment of matter. It is real presence because it is a contagious, participating and participated presence, communicant and communicated in the distinction of its intimacy.

To take another example, the same can be said of what we call the "poetic image". This is not the decoration that can be derived from a game of analogy, comparison, allegory, metaphor or symbol. Or rather, in each of these possibilities it is something other than the mere enjoyment of a series of verbal substitutions.

When Rilke writes: *Au fond de tout mon coeur phanérogame*[7]

the metaphor of the exposed open heart—simultaneously botanical and sexual—produces a shock of meaning and sound between the noun and the adjective that is provocative and even amusing; this shock conveys the density of the word *"phanérogame"*, with its substance foreign both to the French language and to the language of feelings, a double alienation that at the same time depicts the heart as a plant or a flower. But it also communicates, and it is through the visibility that make both the sense and the sound of the word, which gives it the appearance of a sort of infringement of the poetic form at the same time as it discreetly introduces the words *"coeur phanérogame"* into the decasyllabic rhythm of which it is the hemistich, in a subtle but clear reference to French prosody which is what concerns the German poet. The image is all this—at the very least: it is in the arrangement of the line of verse and the choice of language, it is in the balance of rhythm and attention, it is in the word *"fond"*, the "f" of which is repeated in the "ph", a dull consonance, echo and variation of another line (another decasyllable) of the same poem:

les mots massifs, les mots profonds en or,

where the material of the image is poetry itself.

For the image is always material: it is the material of the distinct, its mass and its density, its weight, its edges and its brightness, its sound and its shadow, its footstep.

Clear and distinct, the image is incontestable evidence. It is proof of the distinct, its distinguishing mark even. The *image* only exists where there is this evidence: if not, there is only decoration, or

illustration, in other words support for a meaning. The image must involve the invisible presence of the distinct, the distinction of its presence.

The distinct is invisible (the sacred was always so) because it does not belong to the domain of objects, their perception and usage, but to that of forces, their affections and their transmission. The image is the evidence of the invisible. It does not make it visible like an object: it reaches into its knowledge. Knowledge of the evidence is not a science, it is the knowledge of a whole insofar as it is a whole. In a single instant, the image delivers up a totality of meaning, or a truth (as some prefer to say). Each image is one variation out of the totality of the distinct sense: of that sense that does not arrange meaning in any one order. This sense is infinite, and each variation is itself infinite. The overabundance of images in the multiplicity and in the historicity of the arts is an indication of the inexhaustible nature of the distinct. But each time, at the same time, there is the pleasure of the sense, the shock and the savour of its tension: a portion of sense in its pure state, open or infinitely lost (as some say).

Nietzsche said that "*Wir haben die Kunst, damit wir nicht an der Wahrheit zugrunde gehn*".[8] But it should be made clear that this cannot happen unless art involves truth. The image does not stand before its background like a net or a screen. We are not dragged down, but instead the background rises up to us in the image. The double separation of the image, detached and cut-out, forms both a protection against the background and an opening to it. In reality, the background is not distinct as a background except in the image: without it there would be nothing more than an indistinct adhesion. To be more precise: in the image the background makes itself apparent by itself dividing. It is both the depth of a potential shipwreck and the surface of the luminous sky. Such is intimacy, at one and the same time threatening and captivating us from afar where it has withdrawn.

The image contains this ambivalence by which sense (or truth) endlessly distinguishes itself from the tight network of meaning. It is in this that art becomes necessary, and not merely an amusement. But it is also in this that it is itself troubling and can be threatening: both because it conceals its being from meaning or from definition and because it can threaten itself and destroy within itself the images of itself that have ended up by arranging themselves into a significant code or an assured beauty. This is why there is a history of art, and why within it there are so many upheavals: because art cannot be a religious observance (neither of itself, nor of any other thing), and is instead always found in the distinction of that which remains distant and irreconcilable, in its tireless exposure of an ever-detached intimacy. This detachment, this endless unchained freedom is what the precision of the image weaves and unravels each time.

Let us conclude with one last image,[9] which speaks of the image's gift of love and of death:

NOTES

1 This is the focus of Bataille's remark.
2 Edith Wharton, *Summer,* Macmillan, London, 1917, p.1.
3 Sumerian and Akkadian version of the Creation, in Jean Bottéro and Samuel Noah Kramer, *Lorsque les dieux faisaient l'homme,* Paris, Gallimard, 1989, republished 1993, p. 503.
4 It is thus a question of arousing the "instability" that the "onto-typology" analysed by Lacoue-Labarthe "had been assigned the task of fixing" (cf. "Typograhie" in *Mimesis desarticulations,* various authors, Paris, Flammarion, 1975, p. 269). Art—if the image of which I am speaking is indeed art—has always been this awakening, and the recollection of an awareness that existed long before any "onto-typology".
5 An example of this double operation can be seen in Picasso's *Portrait of Olga* (1921), where only the area around the head is painted, a detached field, stuck on or detached from the background of the first field where the drawing of the body has been executed and which is overlaid by other detached sketches.
6 At least all except Protestantism.
7 Fragment of a French poem from 1906, included in *Chant eloigné,* ed. Jean-Yves Masson, Lagrasse, Verdier, 1990.
8 Posthumous fragment, Werke, Munich, Carl Hanser, 1956, vol III, p. 832.
9 Verdi, *La Traviata,* act III, "Prendi, quest'è l'immagine…": just before she dies, Violetta holds out her portrait to Alfredo. The music is already funereal, marking her approaching to death and is prolonged by the tensely ascending strings, the parlando and then the last sung notes.

JUSTEN LADDA

born 1953 in Grevenbroich, lives in New York

Solo Exhibitions (selection)

1998 *Rear Views*, Feature, New York
1988 *Simulation Meltdown*, Galerie Lelong, New York
1987 *1+1=2*, Israel Museum, Jerusalem
1986 *Art, Fashion & Religion*, The Museum of Modern Art, New York

Group Exhibitions (selection)

1998 Pusan Museum of Contemporary Art, Pusan/Korea
 Here, The Aldrich Museum of Contemporary Art, Ridgefield
1996 Tempozan Temporary Museum, Osaka
1994–97 *Elvis + Marilyn: 2x Immortal*, ICA, Boston/Contemporary Arts Museum,
 Houston/The Cleveland Museum of Art e.a.
1993 *Quotations*, The Aldrich Museum of Contemporary Art, Ridgefield
1989 *The Presence of Absence: New Installations*, University of New Mexico, Albuquerque
1984 *Ein anderes Klima*, Kunsthalle Düsseldorf

Dress I, 1998, steel, oil paint, acrylic, 152.4 x 38.1 x 25 cm, Courtesy Justen Ladda,
© Justen Ladda
Dress II, 1999, steel, oil paint, acrylic, 170 x 137 x 45.7 cm, Courtesy Justen Ladda,
© Justen Ladda (ill. pp. 54/55)
Dress III, 1999, steel, oil paint, acrylic, 116.8 x 71.1 x 83.8 cm, Courtesy Justen Ladda,
© Justen Ladda (ill. pp. 52/53)
Dress IV, 1999, steel, oil paint, acrylic, 127 x 27.9 x 20.3 cm, Courtesy Justen Ladda,
© Justen Ladda

In 1986 Justen Ladda produced an installation with the title *Art, Fashion and Religion*, which consists of an allusion to Michelangelo's *Pietà*, fashion mannequins and geometrical shapes. The "Pietà" was constructed from packages of household goods, similar to the *Tide* packages from which he reconstructed the famous hands of Dürer in 1985. In retrospect it almost appears as if Ladda had anticipated the exhibition HEAVEN with his work *Art, Fashion and Religion*, for it displays interchangeable belief systems, whose intertwining strands reach far beyond the three systems explicitly represented, touching upon the very material from which icons of art and culture are made.

Ladda made use of several levels of meaning in employing everyday refuse as a material for producing high art, and in reconstructing particularly aural works from garbage, he introduced a new way of perceiving them. In combining the banal with the sublime, trash with highly esteemed art treasures, ready-mades with the icons of genius, he dislodged the culturally fixed image. This image was transferred from a past realm of absolute certainty to the risky present, leading also to the incorporation of critical aspects regarding consumption and other contemporary maladies into a system innocent of such notions. Above all, it lead the icons of the past to express themselves in a new manner, for the components they were comprised of belonged to a totally different set of values.

Imposing contrasting systems onto one another, each saturated with its own characteristics, is a tactic repeatedly employed by Justen Ladda. The constructive elements, whether these are *Tide* packages or the glass beads the three dresses in the exhibition consist of, are subversive, hiding their true features behind the disguise of the image. As if employing the strategy of a chameleon in order to survive in the Olympian environment of the museum, once the image is accepted as a coherent whole by the viewer, they reveal themselves in the manner of a Trojan horse, before—at second glance—murderously destroying it. In many of his works Ladda offers one perspective from which the representation makes sense, while when viewing it from other angles, it ceases to be comprehensible. The fact that his work is seemingly graspable from only one point of view is a metaphor for the manner in which icons are rooted in a world view that permits no change. If the image is fixed, the whole must be revolutionised by its constituent parts.

Ladda works in the manner of a *bricoleur*. He assembles his objects from parts devised to serve other ends, imbuing the objects with a mythological quality. Myths are constructed from bits and pieces belonging to different levels of meaning, and in them hybrids are created from parts borrowed from other entities. The mythological method at the same time negates and sustains the objects Ladda offers for consideration. These new mythologies re-legitimise the work to occupy the space of the museum.

The same procedure takes place in the case of the three dresses made of glass beads. The glass dress cannot be worn. It would break or injure its owner. The meaning of the dress does not correlate with its initial function. In its new syntax the dress becomes a metaphor for its own significance. It is now the quintessence of glamour. Each bead is a metonymy which stands for the whole object, for in each individual part the notion of glamour is represented. The dresses have the shape of a woman, whose curves—although the woman herself is not present—fill and form the dresses outlines. The actual woman is no longer required, as the symbol standing for the "ideal woman" has already taken control and disposed of her. Here one is confronted with the notion of the metaphor replacing the phenomenon it was supposed to stand for. DLH

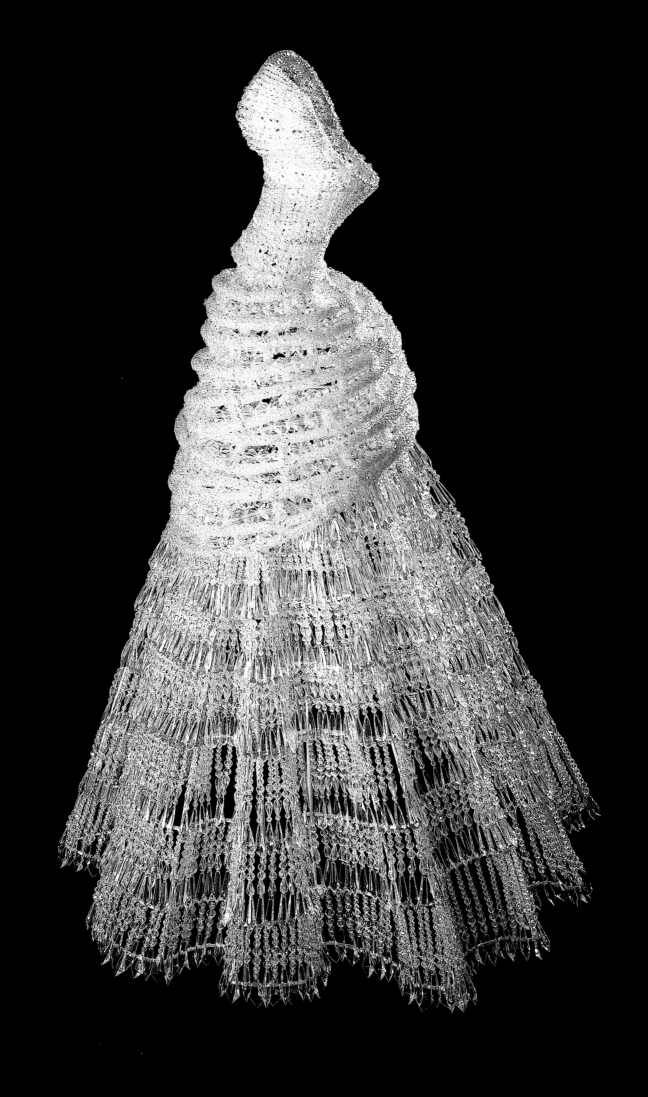

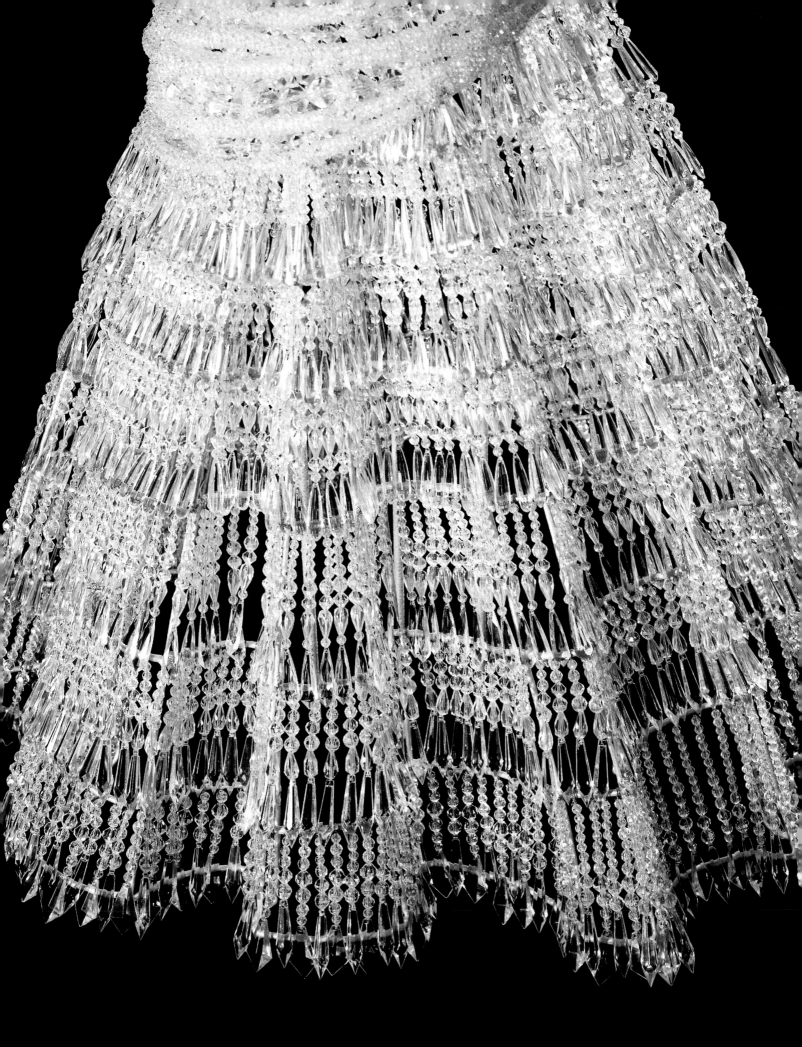

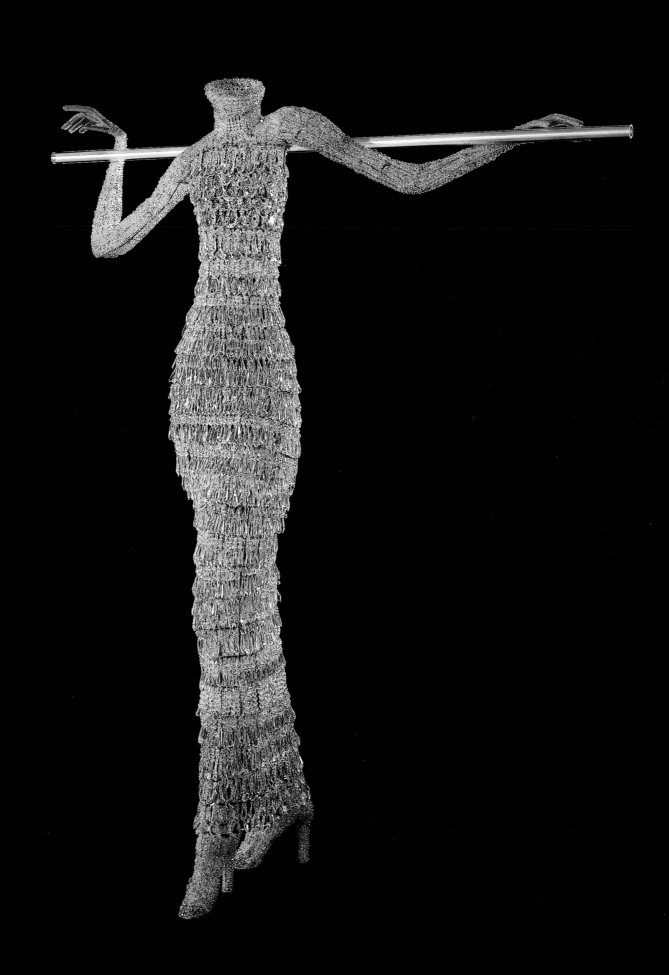

KATJA KLOFT

born 1973, lives in Düsseldorf

Group Exhibitions (selection)

1998 *Artomat,* Kunstverein Düsseldorf
1998 *Eingemacht,* Frauenmuseum, Bonn

Col. 228, 1999, satin acetate, cotton, Courtesy Katja Kloft (ill. pp. 58–61)

The first work carried out by Katja Kloft in large dimensions allows for numerous associations. If her previous works were easier to specify through their respective context, format or title, the first large-format work transposes the thematic and formal approach that Katja Kloft pursues in her fabric sculptures onto the ideal level of proportions. The softness of the material and the palpable character of the work correspond to the softness of the colours. The dimensions and extensiveness of the installation evoke a feeling of claustrophobia. Viewers are almost unable to adequately guage their relationship with this dominant form. Might this be a gigantic mouth in which one loses oneself during a French kiss, being sucked into it, or might this be a mega-vagina where a similar trauma is experienced during the sexual act? Are the tentacles countless fingers reaching for the viewer or are they huge phalli? Could this be a monster appearing in a rosy, shimmering guise while stretching out, expanding and smothering everything?

What might be viewed as hell by some may be perceived as paradise by others. Katja Kloft does not offer any guidelines and leaves the assessment of the situation up to the individual. The associations the installation evokes depends just as much on the work's appearance as on the mood, attitude and psychological disposition of the recipient. If the wigs made of patterned material, the tentacles, fabric plants, flowers and animals are first and foremost cute creatures and funny comments on the efficiency and consumer culture of contemporary everyday life, then the large-format works penetrate the space and design an utopia that links up with the social models of the early seventies. What distinguishes them, however, from these is the wittiness and self-irony with which they appear on the stage of the "real" world. In so doing, they appear to lay claim to the social values of the late 20th century based on notions such as efficiency and a cost-effectiveness ratio exposing these as being just as virtual and constructed as the values that they seemingly draw upon. The fact that nothing makes sense, but that it nevertheless is fun to establish some kind of significance, belongs to the fundamental realisations of the generation of the nineties, trained by video clips, the computer and Internet, which has dismissed dogmatic ideologies in favour of a pragmatic realism.

MM

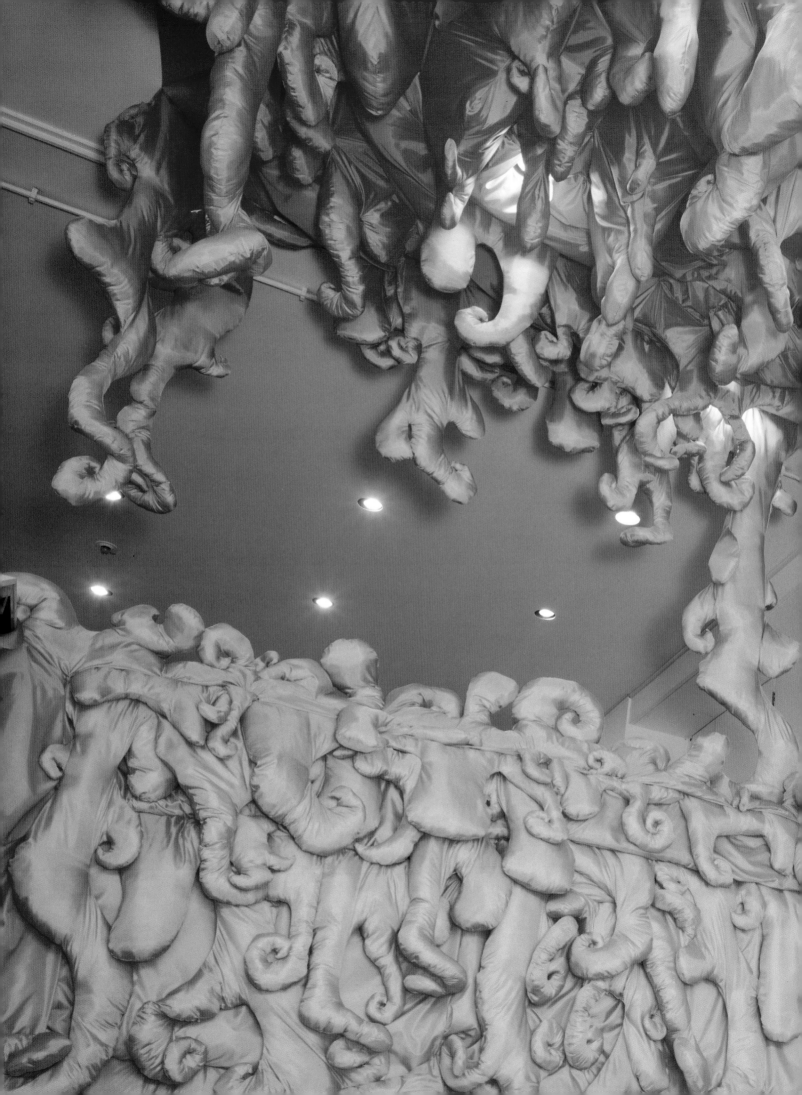

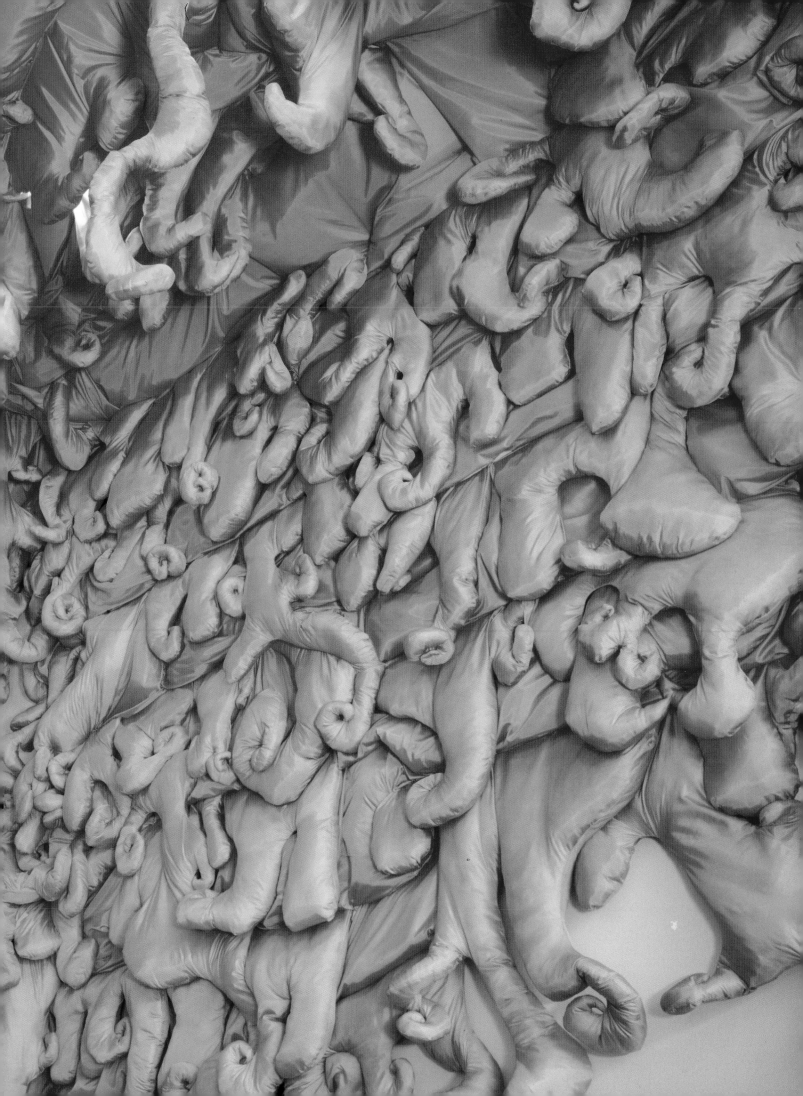

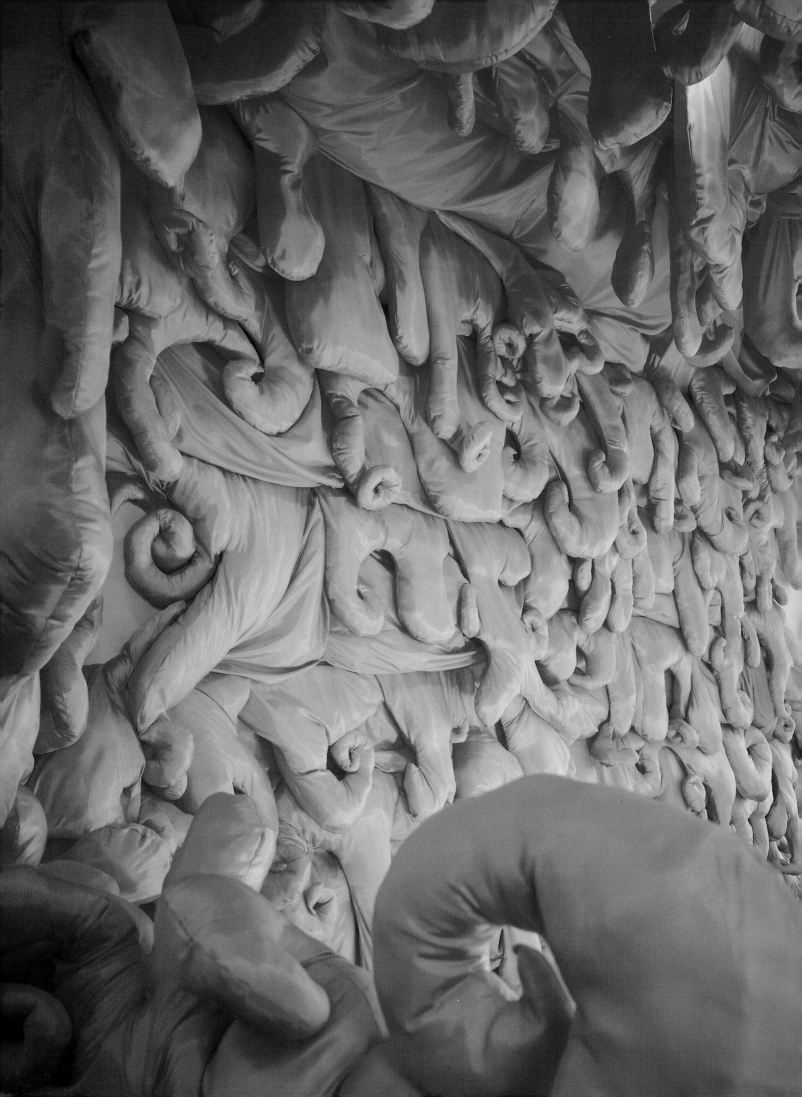

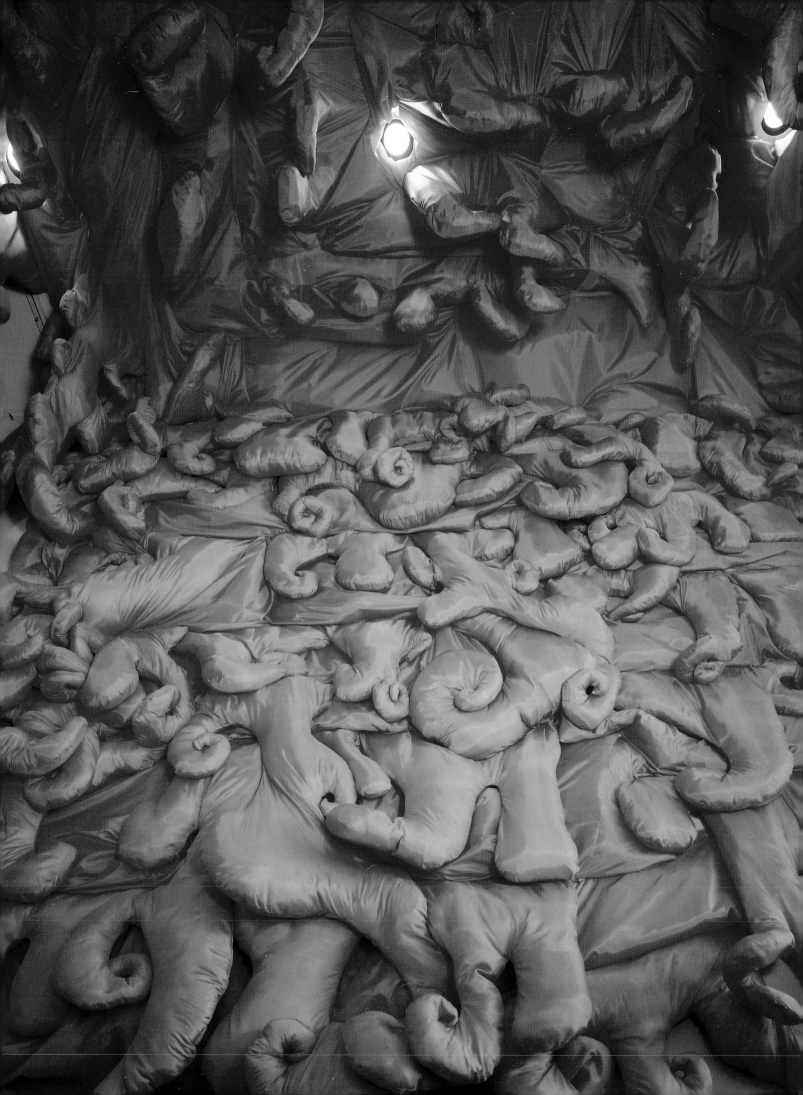

WANG FU

born in Shijazhong/China, lives in Göppingen

Solo Exhibitions (selection)

1999 *Wang Fu,* Kunstverein Hartingen
1997 *Das exotische Tier,* Galerie Bochynek, Düsseldorf
1996 *Kontrabaß,* Staatliche Akademie der Bildenden Künste, Stuttgart
1995 *Was ist denn das,* Städtische Galerie, Mainz
1991 Städtische Galerie Glasperlenspiel, Asperg

Group Exhibitions (selection)

1998 Biennale Maastricht
1996 Kunststiftung Baden-Württemberg, Stuttgart
1995 Stipendiaten der Kunststiftung Baden-Württemberg, Städtische Galerie, Reutlingen

Unter den Sternen, 1999, polyester resin, fibre glass, oil paint, 27 x 71 x 131 cm,
Courtesy Wang Fu (ill. pp. 64–67)

In Wang Fu's work *Under the Stars* the innocence of children is God-given. In the hermetic and at the same time fragile form in which they are presented they are simultaneously prisoners and the content of their dreams. The identification is acute and perfect. The magical figures, fairies, dragons and mythical creatures which inhabit their cosmos are as authentic as totally mundane phenomena: balloons, clouds, animals and toys. In their meaning they are one with their essence. The division between sign and signification does not yet exist, the distinction between idea and object is still unknown. Only later will it be constructed through education, experience and society in which the subjective self also constitutes itself through separation from an objective "other". The Confucian and Buddhist model of an essence which is shared by all living beings and objects is visualised in the works of Wang Fu in a surprising and subtle manner. On the one hand, there is the joy in combining colours and forms which then in the various results always appear very natural and hardly conceivable otherwise. On the other hand, the coherence and stringency of the representation guarantees a consistency which grants the development of thematic formal elements a high degree of freedom. The absolutely precise and detailed realisation of the work makes clear the thematic significance of the motifs and the formal stringency of the inherent statement.

The life which seems to already have been breathed into the children, their floating in space, is both proof of the existence of God and prayer; the innocence which the children in their beds personify elevates them to the status of angels who, like figures from fairytales, know and see all, have divine power and belong to a higher system. The identity of the fable which, independent from particular media, is contained in many East Asian works of art is transposed in the works of Wang Fu to the level of collective validity. The symbiosis between Asian tradition and contemporary Western imagery presents a mode of perception that lets the sublime take on an everyday countenance, as an omnipresent phenomenon that can emerge at any time. MM

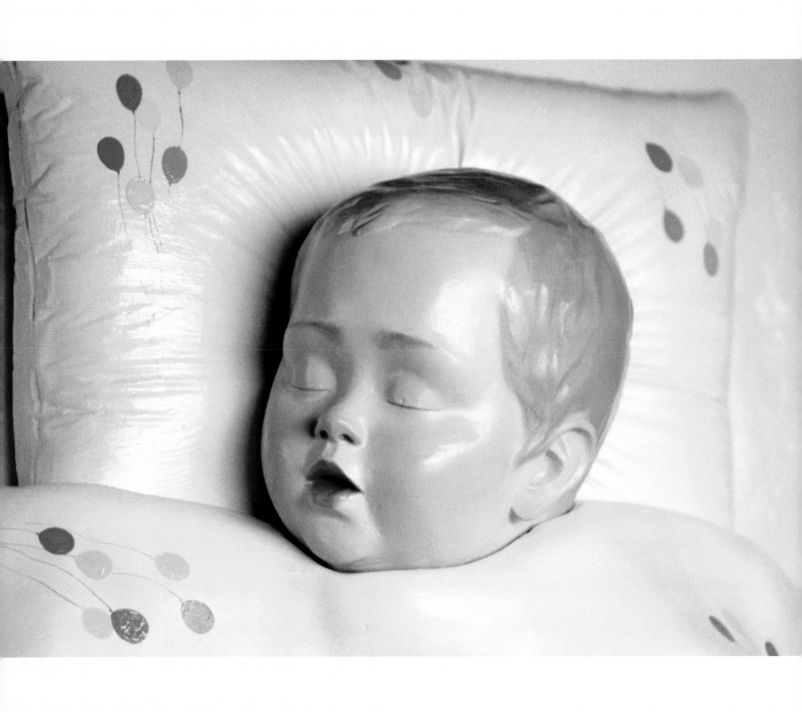

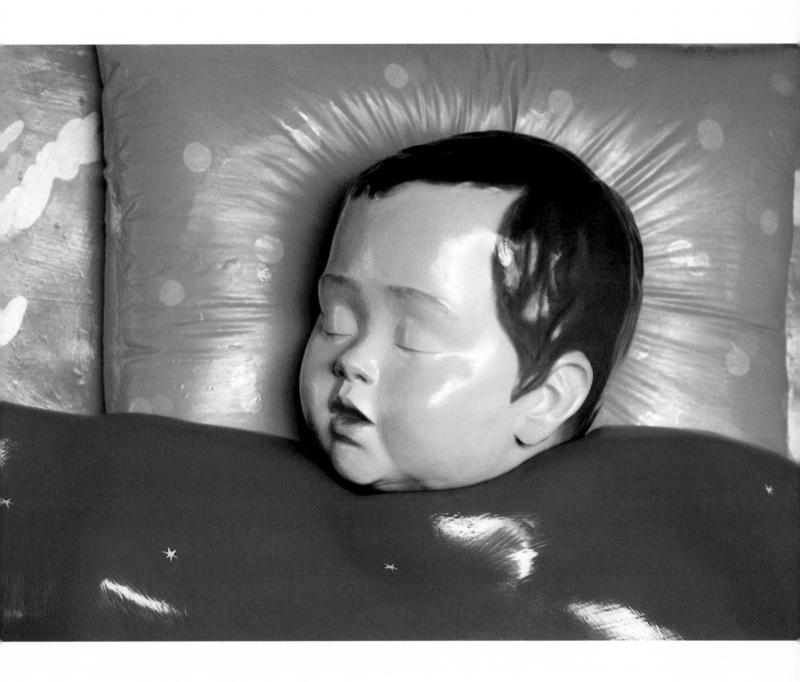

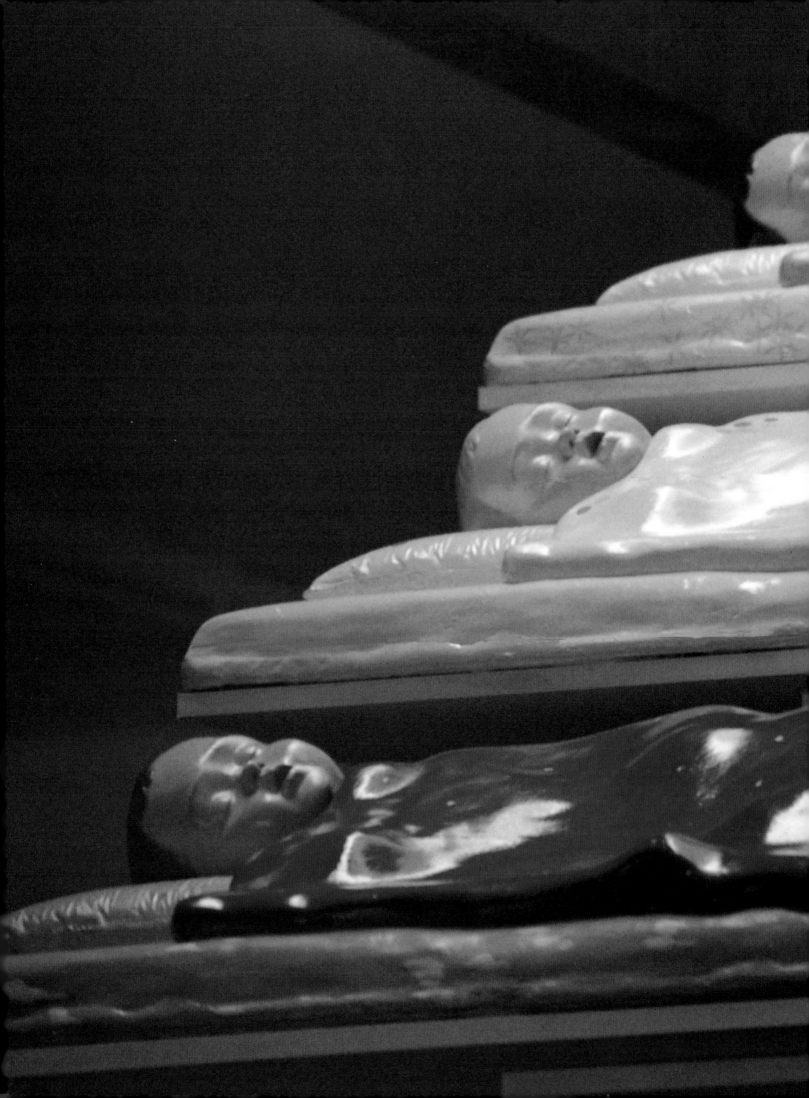

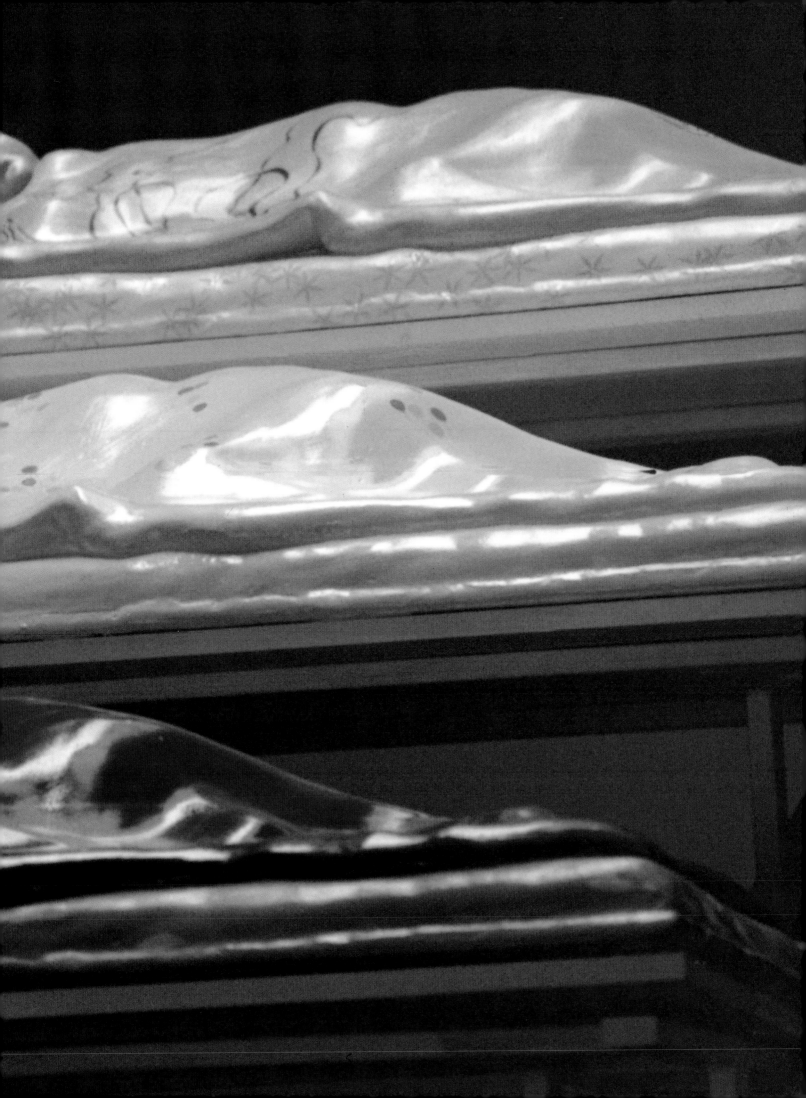

KIRSTEN GEISLER

born in Berlin, lives in Haarlem/The Netherlands

Solo Exhibitions (selection)

1998	Galerie Franck+Schulte, Berlin
1993	Galerie Kaai, Ijmuiden
1993	W139, Zentrum für Moderne Kunst, Amsterdam

Group Exhibitions

1999	Frans Hals Museum, Vleeshal Haarlem
1998	Espace de L'Art Moderne, Chateau de Mouans-Sartoux
1997	Museum für Mediale Künste, ZKM Karlsruhe
1996	*World Wide Video Festival,* Gemeentemuseum Den Haag
1995	*Change*, Vishal Haarlem/Stedelijk Museum, Amsterdam

Dream of Beauty 2.0, 1999, computer animation, in collaboration with Sabine Hirtes, Institut für Bildmedien ZKM, Thomas Zeitlberger HFG, and Philips Speech Processing, TeleCats bv, Courtesy Kirsten Geisler (ill. pp. 70–73)

The dream of ideal beauty has not yet been fulfilled. Nobody is in the position to actually state what this "ideal" might be, however, Kirsten Geisler shows the manner in which it manifests itself today in her computer-animated, interactive projections.

At the precise moment when the distinction between a virtual, projected ideal image and the physical and psychological self-perception is increasingly descending into the subconscious, Kirsten Geisler brings into play her works based upon an artificially generated beauty, taking up the struggle of the individual to correspond in appearance and nature to a heteronomous and ideal model. Today the identification of the individual with his or her numerous virtual representatives has reached the point where physical presence is not required for interaction and psychological presence is in danger of becoming totally obsolete.

The head of "beauty" is oversized and conveys the notion of a proportional rather than a fashionable model, since—shaven to the bare skin– it propagates an aseptic, sterile ideal that easily corresponds with the ideal of a perfect, computer-generated "New World". In regard to its larger-than-life proportions and its absolute symmetry, Kirsten Geisler draws upon the eternal image of the infallible God, whose model man is to emulate by striving for the symbiosis between God and himself. The divine example and the commandment to fulfil this example lies at the basis of this eternal striving to achieve an ideal state whose perfection is the impetus and not the aim of the endeavour. In the course of the 20th century this quest has shifted more and more to a secular level and today fulfils itself, among other things, in the cult of beauty and the obsession with slenderness. The supposed alienation of inner values, however, should not be understood so much as a loss, but should rather be seen as resulting from the transformation of the communicative systems within the media. The increasing dominance of visual and symbolic signs in contrast to written linguistic signs, causally linked to the developments of new image media and the computer, enables Kirsten Geisler to investigate the discrepancy between "natural" and "artificial" worlds, to question how far they are at all distinguishable.

Apart from gestural and mimical reactions, such as the smile, the kiss, the opening and closing of the eyes, the turning of the head, "beauty" now also increasingly proceeds with phonetic articulations. Its counterpart has the possibility of posing questions or making a linguistic statement upon which "beauty" reacts. At the moment the limits of the system are reached, the inadequacies and the imperfections of the being on the screen become apparent. This makes "beauty" appear very human despite its radiant brilliance, but does not, however, reduce its effect; rather it multiplies it many times over. For the meaning of these works does not lie in the acknowledgement of the ideal state of this virtual being, but rather in experiencing the proximity and identity of the animated image and the ideal concept, the illusory difference and distance to this system, while at the same time participating in it in a subconscious yet constitutive manner. MM

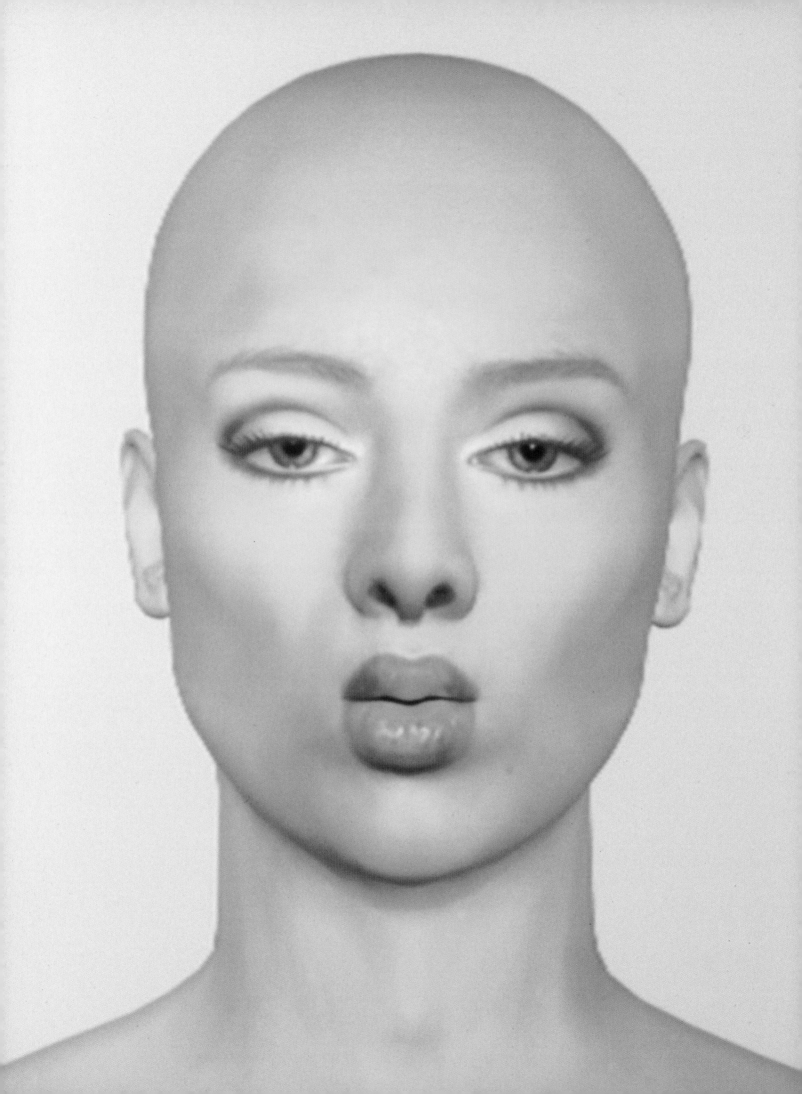

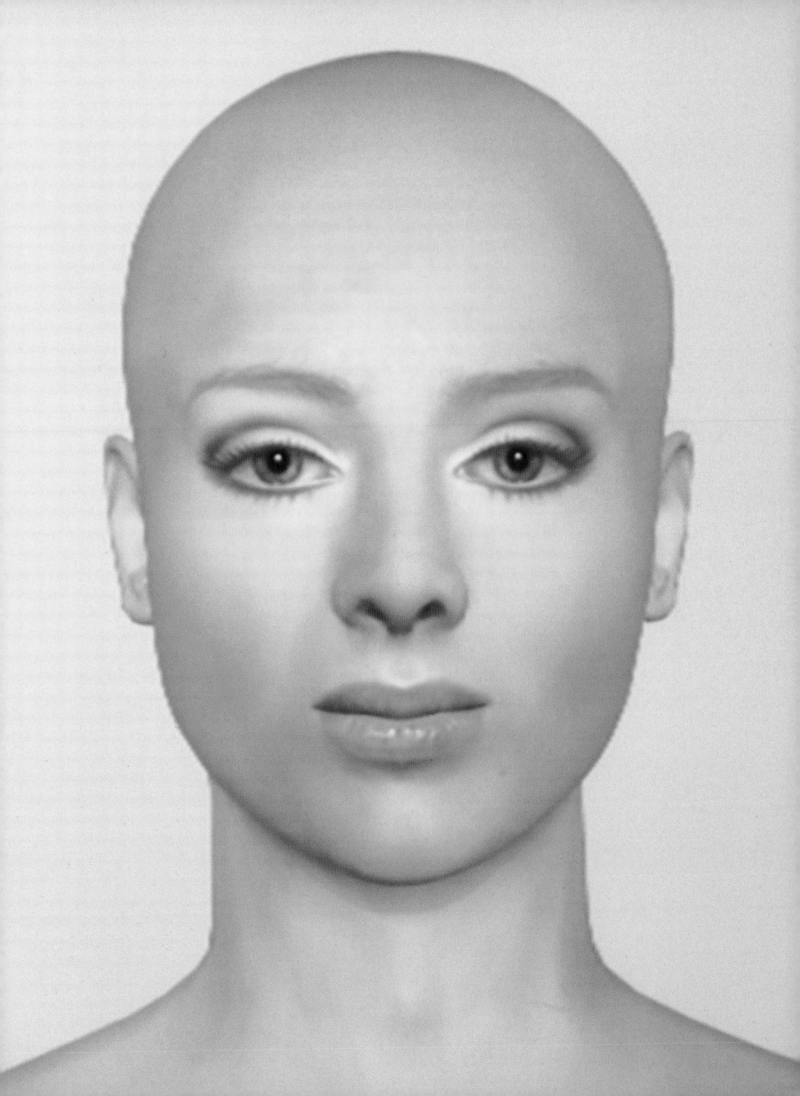

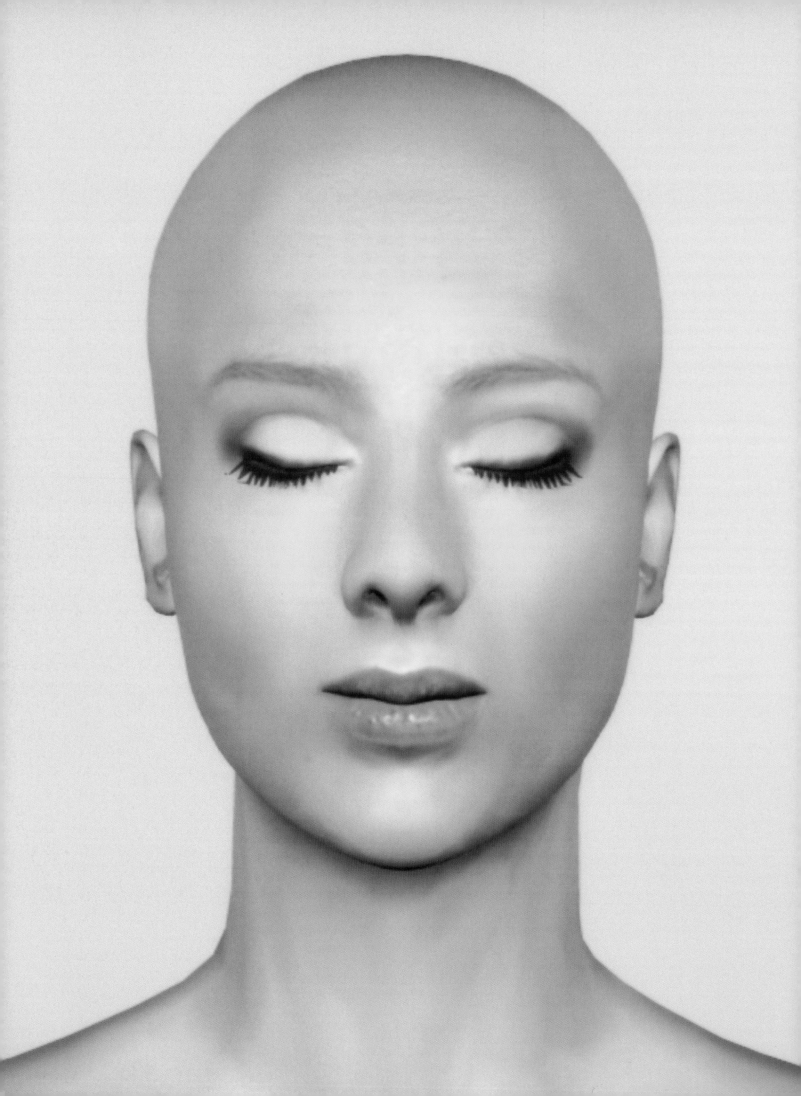

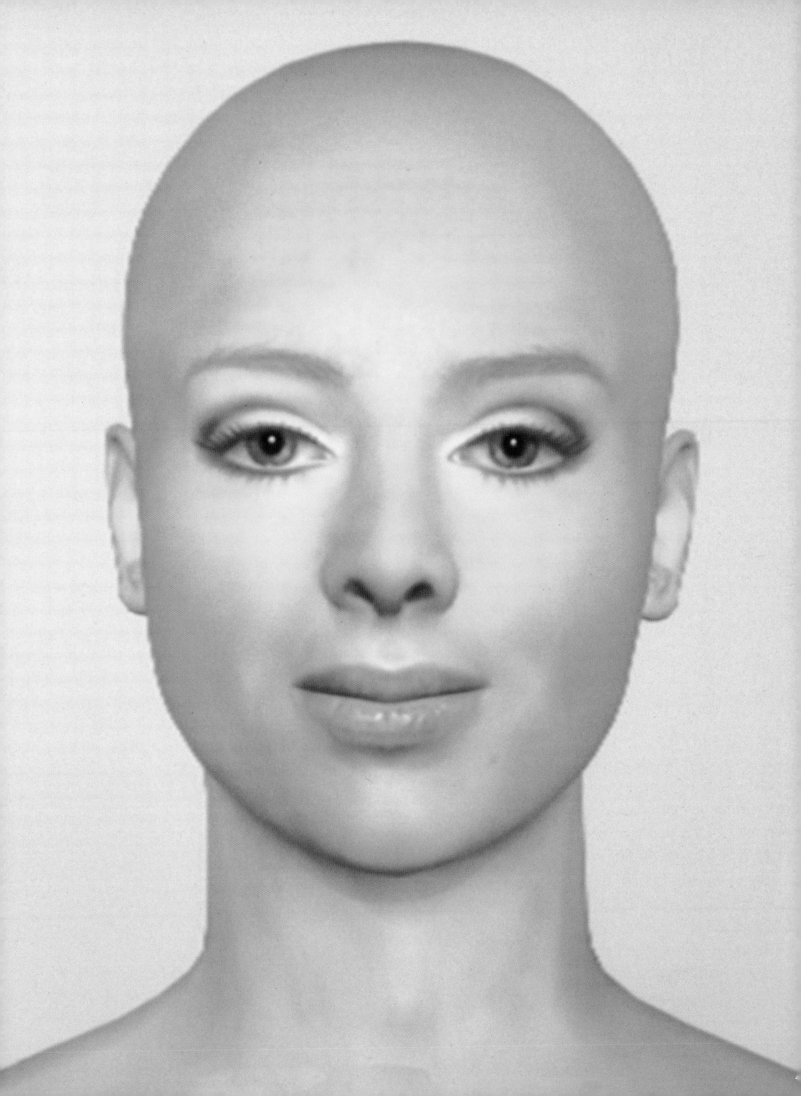

And now abideth faith, hope, love, these three;
but the greatest of these is love.
St. Paul, *Letter to the Corinthians,* I,13,13

If I've properly understood the theme of the exhibition HEAVEN, it has to do with showing to what extent the forms of cultural production in our contemporary lay societies are permeated, infiltrated and fashioned by religiousness. Doreet LeVitte Harten offers a few examples. The icon of film stars deifies them, sanctifies princesses who are victims of tragic accidents, and turns top models into madonnas. Ecstatic crowds at raves and rock concerts behave like hordes of fanatical believers fired by mass hysteria. Aerobics, plastic surgery, and strict diets are all secular equivalents of the self-

Thierry de Duve

COME ON, HUMANS, ONE MORE STAB AT BECOMING POST-CHRISTIANS!

mutilation rituals that a religion which regards the body with contempt forces upon its faithful flock. Not only are museums temples and concert halls churches, but the very same thing applies to sports stadia and shopping malls. Fashion offers angelic creatures with androgynous sexuality as models to be imitated—the same models, incidentally, that a seductive Satan hijacks to his own advantage. In a word, entertainment has replaced religion, and the "cathodic church" has replaced the "Catholic Church," but *religiousness* is still there. If this is, indeed, the thesis of the exhibition, it is not particularly original. What is original and risqué—is having the exhibition's thesis *shouldered* by works of art rather than merely *illustrated,* as might well have been done by sampling the trivial iconography mass-produced by the new religiousness taking hold of the social arena. At the time of this writing, the Vatican has just launched a CD titled *Abbà Pater,* which is a compilation of papal homilies and prayers interspersed with New Age tracks. For its release, the Vatican has seen fit to produce a clip worthy of Benetton, where we see a mother breastfeeding her baby and a naked couple, without so much as a fig leaf—a contemporary version of Cranach's *Adam and Eve*! It shows how much even established religion is beginning to realise that it must keep up with the new religious fashion for cultural consumption, if it is to keep its head above water. But there is every chance that the pope's CD will join the hagiographies of Lady Di and the cute little melodies of her minstrel angel, Elton John, in the contemporary kitsch heaven. It *illustrates* the social phenomenon that HEAVEN is keen for the artworks chosen for the show to *shoulder.*

A certain judgmental laziness reigns over contemporary art circles, which takes it for granted that once something is shown as art, it must have a critical dimension. Ever since artists have had to resign themselves to abandoning the utopia that would have art change the world, art circles have drawn comfort from the thought that all an artist needs to do is show the world as it is in order to criticise it. The fewer illusions the artist entertains about the state of the world, the more critical his/her art will be. HEAVEN goes against the grain of this judgmental laziness. It has come to my notice that the exhibition is to include one or two borderline cases between art and the neo-religious kitsch of pop culture memorabilia. The purpose of these exhibits, it seems to me, is to give the entire exhibition an ambiguous responsibility which, in my view, constitutes the whole interest and riskiness of HEAVEN. It is up to each one of us to judge whether such and such a work illustrates the remanence of religiousness, or whether it shoulders it. And in the latter instance, whether it approves of it or opposes it. Lastly, whether approval or opposition is the right attitude. Anyway, we shall all have to judge whether the works in the exhibition—and which particular works—have a critical dimension—and which particular critical dimension. Let me say right away that I am personally expecting the show to prompt me to make this choice, and that the works with some chance of enlisting my support will be those which take it upon themselves to shoulder the contemporary phenomenon of religiousness, while at the same time opposing it. I can thus declare my

criteria, as honestly as is possible. They are ideological. I am pinning my long-term hopes on a humankind that will manage to do without religion. In the short term, this means that I am like (almost) everyone else in favour of a lay society, otherwise put, a society for which religious belief is a strictly private matter, but also that I don't entertain hopes of any such society being feasible. This particular hope was peculiar to the Enlightenment and to the positivist versions of that age, and the theme and thesis of HEAVEN are precisely to dash any such hope. The examples given earlier by Doreet LeVitte Harten display, as clearly as you can get, the congruence of present-day religiousness and what the Situationists called the society of the spectacle. On the one hand, it just so happens, the society of the spectacle nowadays encompasses the public sphere (with all due respect to the heirs of the Enlightenment, such as Habermas), so it is illusory to pigeonhole religiousness in the private sphere. We are living more than ever in a state of confusion between the political and the religious. On the other hand, religiousness is extremely hard to avoid once you wish to *testify to death* from within the society of the spectacle. The day when people stop testifying to death, we shall perhaps be through with religiousness, but we shall also be through with what makes us human. As I don't glimpse any foreseeable end to the society of the spectacle, my criteria involve opening my arms to art which manages to *shoulder* religiousness while *opposing* it. This ideological criterion does not entail any aesthetic criterion. Without seeing them, I have no way of saying which works on view in HEAVEN have the critical dimension I expect of them. So I am not in any position to comment on the content of the show.

I should prefer to try my hand at a modest exercise in translation, and attempt to show what might be meant, on the philosophical level, by "shouldering religiousness while at the same time opposing it." This exercise precisely involves the Enlightenment, and, more specifically, that groundbreaking moment in modern secularism, the French Revolution. Its motto—*Liberty, Equality, Fraternity*—seems to me to translate the three Christian maxims represented by those theological virtues, *Faith, Hope and Love,* into the political register. The two threesomes are congruent, and I don't think it will be that hard to show as much. But why show as much? At first glance, to demystify the modern claim to secularism and state its failure, to flush out the religiousness lurking therein, to provide a (hasty and partial) explanation for the stubborn remanence of religiousness in the public sphere. This is the *illustrative* part of the little exercise in translation I shall undertake. Actually, I expect more than this from it. I expect it to be shown, first and foremost, that the motto of the French Revolution *shoulders* the three Christian maxims, and that it is only by shouldering them that it opposes religiosity. Next, I expect it to be shown that the Revolution still only shoulders them insufficiently and that, at the risk of approving religiousness rather than opposing it, there is a much longer way to go with the maxims, Faith, Hope and Love, before making out how their translation by Liberty, Equality, Fraternity really does point to a possible exit from religion—at the same time, incidentally, as an incipient response to the dead-end of political thinking bequeathed by the Enlightenment. The exercise and what I expect from it entail a somewhat paradoxical conception of religiousness, which I am borrowing from a liberating book—and one of the few such books, it seems to me, which offer new intellectual tools for disentangling the present-day confusion in the political and religious arena. This book is Marcel Gauchet's *Le désenchantement du monde.*[1]

With Gauchet, then, let's start from the "firm persuasion that there is very possibly somewhere beyond the religious age".[2] Gauchet clashes with the thesis most current among historians of religions, which has it that the religious idea became more developed, complex and systematic as more and more refined religious practices and doctrines have come into being—all this stemming from a primitive religious feeling that might have been the first existential response to the inescapable horizon of death, and the earliest attempt to explain—in order to make it tolerable—the extreme destitution of people cast into the thick of nature, whose hostility is the great mystery. This view of things, Gauchet suggests, is one-sided and overlooks the element of voluntary choice in the gesture of the earliest humans, when they laid the foundations of religiousness. This gesture, in which Gauchet sees the essence of religion, is a kind of pact drawn up with nature, by whose terms people consent to a cosmic order invested through and through by supernatural forces, which they give up lording it over, in exchange for a stable place in this cosmos, guaranteed by respect for ancestral

law and the unchanging renewal of the social order willed by the ancestors. It is evident that, for a very long time, we have no longer been living in compliance with this pact, but rather in compliance with another contrasting pact, by whose terms nature is offered to us, subject to the domination we exercise over it by science and technology, at the expense of the expulsion of the supernatural from the world and our dash into the irreversibility of history. According to Gauchet, the human species thus made two successive and contrasting choices regarding what underpins and structures its being-together, two choices, the first of which alone yields religiousness. Gauchet doesn't explain why they succeeded one another in this order, but it is understandable: for our barely hominized forebears, the animism of nature and social immobilism must definitely have had a selective advantage. Once this choice was made, the possibility of the opposite choice could only emerge extremely slowly. From this angle, "the most systematic and most complex religion occurs at the start," and, far from representing a development of the primitive religious gesture and advances in the conception of the divine, the stages through which the world's great religions have been formed "actually represent as many stages in the process of challenging religiousness".[3] The three principal stages are: the emergence of the State, the advent of monotheism, and the inner movement of Christianity, which Gauchet unhesitatingly proclaims to be the "religion of the exit from religion".

At this juncture I shall not dwell any further on Gauchet's thesis, but I should like to emphasise the extent to which it refreshes and renews the issue of religiousness and relieves it of the weight of historical fatality. By making the relationship to social foundations religiousness's centre of gravity, Gauchet turns inside out the common view that made the relationship to religiousness the centre of gravity of social foundations and, by the same token, made it so hard to disentangle the political from the religious. There is nevertheless no question of denying that religion is what links (*religare*) the members of a society together, nor is there any question of refuting that, in the monotheistic religions, the horizontal link welding the community depended upon the vertical link with the Transcendental Principle which, in return, organised the community, either by retreating from it, as in Judaism, or by incarnating it, as in Christianity. It is simply a matter of seeing that if the religion of incarnation seems to have taken the entanglement of the political and the religious to its limit, it is this religion, too, that permits and prepares its disentanglement. "Come on, humans, one more stab at becoming post-Christians!"—such might be the optimistic message of Gauchet's book. Which leads me fairly naturally (by this allusion to Sade and his period) to the little exercise in translation I just announced.

To start with, it is a striking fact that the three theological virtues should have been conceived and practised in this order: first faith, then hope, and, last of all, charity or, better said, love. Striking, too, that, in tandem, liberty, equality and fraternity should likewise be listed in that order. It is enough to suggest a term-by-term match. That love and fraternity should be one and the same thing is readily understandable, provided we are not fooled by the gendering of the word "fraternity" (which, needless to say, we must address in due course). That faith and liberty should be inextricably linked is a little harder to understand, but only a little. Liberty only assumes its meaning if we understand thereby the freedom of the other. Laying claim to freedom for oneself without granting it to the other obviously runs counter to liberty. It follows that an act of faith lies at the root of liberty—faith in the fact that the other will make good use of his or her freedom. The most enigmatic pairing is the link between equality and hope. And yet, equality in the face of death is the only equality that is certain. And hope is the obverse certitude or fortitude, the endurance of life, an alerted and disinterested receptiveness to the event. We hope that something will happen, and something that is not just this event which we know to be inevitable—death. Hope postulates equality in the face of life, the only maxim that acts as a barrier to death.

This, then, is a very brief introduction to the issue at hand. We must now try to get a tighter grip on it, which I shall attempt to do with a series of turns of the screw, the emphasis being on signs pointing to the exit door from religion, already contained in the Christian maxims, and sometimes even more so than in their lay translation. Animist religions are belief systems which are not upheld by any autonomous, subjective adhesion, but simply by an absolute compliance with the authority of

tradition. There is no distinction between the physical and metaphysical worlds: nature is the seat of magical forces which the individual does not have it in his or her power either to challenge or to cast doubt on. There is no place for faith in any such system, nor is there in ordinary superstitions. Further, faith has only a very limited place in all phenomena of religious fundamentalism, including contemporary variants. Belief is an abdication of thought, whereas faith is an explicit acknowledgement of the limits of thought. Belief is a state, faith is an act. One might think that it is essentially a religious act. If we go along with Gauchet, it appears, on the contrary, like the supreme anti-religious act, proclaiming the break with belief and the solitary destitution of the individual before the unknowable. Any act of faith declares on its own behalf the disconnection of the subject in relation to the common rule and the atavistic authority. Agreed, when faith in God is at issue, its declaration is an act of allegiance, but shouldered and therefore free allegiance, which stands for the social bond only in so much as it presupposes the same adhesion, independently, on the part of others. The act of faith is an ethical act, that remained shielded behind the mask of religiousness as long as there was not sufficient progress in the awareness of the disenchantment of the world—to quote Max Weber's expression which gave Gauchet's book its title.[4] With the advent of the Enlightenment, history thought it was ready for the religious maxim of faith to be translated into the political maxim of liberty. As it happens, the translation stopped underway, for lack of having sufficiently separated the act of faith from its wrapper of belief, and of having muddled the bases of ethics with theoretical anti-obscurantism. Positivism would be the belated outcome of the fact that the Enlightenment (with the exception of Kant) did not take the anti-religious virtualities of Christianity far enough.

Without faith, there is no hope. Without liberty, likewise, there is no equality. Christianity was the first religion to proclaim the equality before God of all his creatures and, among them, the equality of all human beings before the chance of salvation. This presupposed that human beings are beings of liberty and that the equality of all is based on shared faith. Whence the militant proselytism of the first universal religion. But because the faith of Christians radically distinguishes itself from belief, its main object is no longer the existence of God but rather the resurrection of his Son. Clearly the twofold human and divine nature of Christ upholds the postulated existence of the Father, but based on a new link, unknown to the Old Testament. This is the link of filiation that sustains the Father's fatherhood and which the believer reasserts by imitating Jesus. The gesture, already triggered by Judaism, which posits the origin of the world beyond the world no longer involves renouncing—as in primitive animism—an understanding of the here below. Moreover, it is released from submission to the transcendence of the Law. It has to do with the merely symbolic assertion of the separation between the creator and his creatures, under the novel form of paternity. God the creator is much less the progenitor of the world than the symbolic father of men forming a community of sons, through the mediation of Christ's sacrifice. Men are equal in Jesus Christ because they are equal before the hope of salvation. Otherwise put, before the hope of resurrection. Faith in Christ's resurrection converts equality before death—the only certain equality—into equality before life. It is not hope in the eternal life of souls after death that is the correlative of faith, rather it is hope in the resurrection of bodies on the day of the last judgement. When modern secularism arrived, history thought it was time to relegate the fable of the resurrection to those private closets where people keep their personal convictions and superstitions, and failed to realise that the place left vacant by the fable would sooner or later be forcefully filled in by death-dealing myths—the most fearsome of all being the myth that dared to proclaim inequality before death.

From being sons of one and the same Father, all men are brothers. When the French Revolution translated the Christian maxim of love by "fraternity", it merely took cognisance of a virtuality contained from the very start in the doctrine of Christ. As a corollary of equality in the hope for salvation, fraternal love extends to all. The only love that saves is universal love: this is the point that articulates the political and the religious, and it applies identically to St. Paul and to Marat. Because this point is one of articulation, and not one of confusion, it is, at the same time, the point from which the political and the religious can be disentangled. Not that they have been—at least not enough—but we shall return to this in the second turn of the screw. What matters, for the time

being, is seeing that just as faith is the condition of hope and hope is the condition of love, so liberty is the condition of equality and equality is the condition of fraternity. It is also important to see that, in both instances, it is the third term that retroactively feeds the first. Fraternity yields liberty, love gives faith. Or, if we cross the wires a little, love of another is what establishes the other in his or her liberty, which is thus never a liberation that is conquered, but a gift that is received. And fraternity is what fuels the act of faith whereby I accept the liberty of my brothers. It goes without saying that faith is never acquired once and for all, for it has to fight belief at all times; that acquiescence to the liberty of the other forever threatens to spill over into submission; that equality may remain formal and act as an alibi for injustice; that it is all too easy to muddle expectation with hope of retribution; that at any given moment, fraternity runs the risk of closing in on the cohesion of the most immediate group and taking up arms against the outsider; and that love is suspect as long as it can swathe itself in self-sacrifice or self-hatred. On many occasions, historical Christianity has yielded to these temptations, with which theoretical Christianity nevertheless contrasts this salutary antidote, which is its sole law: "Love thy neighbour as thyself". Such a maxim is political, what else? It is political because it is universal: my neighbour might be living far away, and my fellow humans are of a kind. Why was the Revolution less radical than theoretical Christianity in its ideal of fraternity? The obvious and easy answer is because politics is the art of power, and it would be quite naïve and sentimental to have politics based on the commandment to love. But this is not the nub: there will always be unequally distributed power. The real question—which we should try to consider outside any legal framework—is the issue of the legitimacy of power. If the Revolution had shouldered its fraternal maxim in a Christian way, it would have placed the legitimacy of political power within the reference of the brothers, in other words of the sons, to the shared symbolic father. It neither could nor would do as much, and, even if it hesitated, it was in the end of the day the illegitimacy of power which it placed in the paternal principle. Regicide was not unavoidable, but it took place, with, as its immediate consequence, the fantasy of a society of fatherless brothers. It is obvious that the Revolution was bent on beheading not a man but a symbol. When a symbol is beheaded, however, the head grows back again, and sooner or later a tyrant arises to pick up the stake of revolutions betrayed. Robespierre shows that this happened sooner rather than later.

Something awkward emerges from this first turn of the screw. Not only was the French Revolution pretty unaware (except perhaps for Marat) of the fact that by inventing the three maxims Liberty, Equality and Fraternity, it was translating the three Christian theological virtues, Faith, Hope and Love, into the political register; it was also very unfaithful in its translation, and on a point that is not at all theoretical, since it involves the outbreak of violence. More precisely put, parricide. There is nothing very Christian about this, and the question now is knowing—or deciding—whether the head of the king (by divine right) rolling in sawdust represents an advance in the direction of the exit from religion, or not. The least that can be said is that the execution of Louis XVI was a capital sin against the maxim of love. But neither morality nor sentiment are involved here. It is simply a matter of testing the hypothesis whereby the French Revolution did not sufficiently shoulder the three Christian maxims, and according to which it is for this reason (I'll stick with Gauchet's paradox) that it failed to push the anti-religious virtualities of Christianity any further. Because love retroactively gives and grounds faith, it is from love and from its translation by liberty that we must embark on the second turn of the screw.

Whereas belief stems from closely held conviction and can cling to it, faith is declared. An act of faith stands for a declaration of faith, and this is certainly one of the reasons why lay civil society illudes itself by expecting to pigeonhole religious convictions in the private domain. Over and above the gesture which releases me from common belief and abandons me to my liberty, what is at issue in the act of faith? We have already seen what is at issue: the freedom of the other. I pledge an act of faith whenever I surrender, in complete confidence, to the wager that you will make good use of your freedom. "You", not "he" or "she". The act of faith is addressed, which is why it cannot be separated from a declaration. It presupposes another in the second person facing me. Were my own freedom to be won to the detriment of the freedom of others, it does not have any ethical dimension. The freedom of the other, in the third person, has only a diminished ethical dimension.

What does *their* freedom cost me (freedom of slaves, the oppressed, the wretched of the earth, or those shut out of society) as long as I have not been confronted by them, in a face to face situation where their silent rebuke forces me to address them? *Your* freedom alone is altogether ethical: the freedom of the other in the second person. As soon as the dimension of the other as addressee is opened up, this other is recognised at once in his or her uniqueness and in his or her humanity, in other words, in the universality of his or her belonging to the human species. It may appear that the *de jure* equality of all others stems from this twofold recognition, as is asserted by the Universal Declaration of Human Rights. In the rush to conclude this much, there was in fact something like a missed historical opportunity, the consequences of which—all too obvious today—can be seen in the confusion surrounding human rights and humanitarianism. Since the French Revolution, the dis-entanglement of the political and the religious has been a task set in the judicial domain, and the judicial domain establishes a subject of law conceived in the first person, an "I" and not a "you". In its translation of the Christian maxim of faith into the maxim of liberty, the French Revolution finessed the address to the other, and I am on the verge of thinking that this finesse lies at the root of the tragic misunderstanding of the political hope which has turned the two centuries separating us from the French Revolution into the repeated history of revolutions betrayed.

The address to the other is an initiative, a beginning, an opening of time counted irreversibly from zero time. Such, too, is one of the meanings of the word "revolution". Its other meaning is "circu-larity," the hand of time rotating on itself, and closure of the initial openness onto the expected result. In this sense, any revolution is, from the outset, a revolution betrayed, and any hope is a promise put by me into the other's mouth, from which I now inevitably deduce that it has not been fulfilled, or at least not yet. The initiative, in this instance, derives its meaning from the expectation; the address to the other is formed in the awaitening of his or her response, and even (this is usually what happens with hopes having to do with ordinary life), in the anticipation of the desired response. An address would have to be devised that is absolutely not a request, so that revolutions might not be betrayed and hope could be freed from the wrapper of ordinary expectations. There is something inhuman here, which verges on saintliness, but who would deny that this is what Chris-tianity has aspired to? It goes without saying that Christian hope veers towards the future—Christ's second coming and the resurrection of bodies—yet it is a future that does not derive its meaning from the anticipation of the event to come but, on the contrary, from the conviction that the deci-sive event has taken place. Compared with the various forms of political Messianism that took off in the wake of the French Revolution, Christian Messianism turns out to be strangely more "realistic" and disenchanted: the Messiah came and the world's injustices are just the same as before. Hence-forth, the act of faith in Christ's resurrection has to be renewed on a daily basis, and herein lies the root of hope, which thus turns out to be nothing other than the endurance of faith and absolutely not something akin to the daydream of revolution. Being equal in hope is not the same as being equal *de jure* and hoping one day to be equal *de facto*. The revolutionary maxim of equality has caused this confusion. It has put the law rather than the event at the ground-breaking moment: the right to liberty rather than the initial address ushering in freedom; the right to equality in a future earthly life rather than victory over death, a one-time event but a decisive one by having occurred; the right to fraternity, as if love were something due to men, rather than the ordeal of love which is proven in the triumph of Eros over Thanatos.

It is one of the ironies of history that as soon as the possible disentanglement of the political and the religious was pinpointed, its re-entanglement won the day. It is no coincidence if the French Revolution was signed with a parricide and the invention of Christianity with the Son's sacrifice con-sented to by the Father. Christianity has been distinctly more anti-Oedipal than the Revolution, for which the social bond is still and notwithstanding *Totem and Taboo*. The Revolution assigned the fraternity of the sons to the authority not of the Father but of the Mother—goddess of Reason in the religious order, female figure of the Republic in the political order. By dint of this dual reference, the Revolution ran the risk of seeing all thinking about love forever being tugged between the utopia of its absolute rationality and its re-territorialisation in the ties of blood. As if the only alter-native were either the old Platonic identification of love with the love of wisdom (philosophy), or

the assimilation of love to the tribalism, pure and simple, of the only filiation that can be attested to—filiation by the mother. With the myth of fusional love on both sides: the hermaphrodite of the *Symposium,* the communion of the pure in the impure blood that waters our furrows (as the Marseillaise puts it). Fortunately, because the French Revolution was universalist, it did not give in to the temptations of ethnic tribalism. But it paid a very high price for its universalism, specifically, in the form of a considerable repression of the feminine. It is not just that the maxim of fraternity crushes sorority—even though there is a whole brand of feminism which, since Olympe de Gouges,[5] legitimately attempts to grant sorority its rights. It is above all the fact that the feminine and maternal representation of the Republic—and this ranges from Daumier's extraordinary picture to the effigies of Marianne in France's townhalls, modelled on the features of Brigitte Bardot—, inevitably presents it as a phallic mother (as psychoanalysis would put it), because she has been put in the symbolic place of a Father, replacing the father or the king beheaded by the Revolution, as if it were possible to behead a symbol.

At the end of this second turn of the screw, something emerges which backs up the conclusions drawn at the end of the first and adds something to them. On the one hand, what the translation of the maxims Faith, Hope, Love by Liberty, Equality, Fraternity fails to think through revolves around the definition of paternity. Still without lapsing into either morality or sentiment, it can be said that parricide involves a definition of paternity in so much as the Revolution was keen to slit the throat of a symbol and not just of a man. On the other hand, the repression of the feminine—indeed resulting from the fact that the denied paternal function surges up on the mother's side—indicates that the other thing that the Revolution failed to think through revolves around sexual difference. The reduction of universal love to fraternity is the most obvious symptom of this. Whence the hypothesis that, in order to advance towards the exit from religiousness, it is perhaps necessary, at this present time, to "gender" the anti-religious virtualities of Christianity left untended by the Revolution. This is a loaded issue which, it goes without saying, I can only scratch the surface of. For, on the one hand, more than any other religion before it, theoretical Christianity makes explicit room for sexual difference in its very foundation; and, on the other hand, it has no equal as far as the historical responsibility for the repression of the feminine is concerned. On this level, Christianity must be incriminated as much as, if not more than, the Revolution. We shall not become post-Christian simply by taking the virtualities of Christianity to the limit. A break must be made. But where? The essential question seems to me to be deciding whether we will have to break with the doctrine of incarnation, which is the great invention of Christianity, or whether we will have to break from within this doctrine. Will there be a way of rewriting it so that women have a different place in it, and that the repression of the feminine is no longer the consequence of it?

Whether to break with the doctrine of incarnation or not is a terribly delicate question (and I think that one of Doreet LeVitte Harten's intentions with HEAVEN is to broach it), because, in due course, it entails taking up positions with regard to the place occupied by Judaism in relation to Christianity in the matter of the exit from religiousness. Given the monstrous denial of place earmarked for Judaism in our century by the Shoah, caution is called for. Gauchet can be reproached for entertaining a teleological view of history which attributes Christianity with having carried off an irreversible surpassing of Judaism on the way to the exit from religion. This is undeniable, and I myself admit following in his footsteps when I base my optimism on his interpretation of the "religion of the exit from religion". But I see no reason to exclude other exits from religion from being possible and desirable today, including one which takes as its point of departure Judaism and its ethics. There is cause here for reflective endeavours whose premises are divergent, and for which it would be premature to decide now that they will not one day converge. All I need as proof are the reflections of Hans Jonas about the concept of God after Auschwitz, or alternatively, the whole philosophical work of Emmanuel Lévinas.[6]

As I embark on a third turn of the screw, which once again takes up the question of the address to the other as articulating faith and freedom, this mention of Lévinas is not haphazard. Lévinas would say that otherness is the dimension of infinity attached to the other's visage. But it is one thing to *envisage* the other from within a religion of transcendence, such as Judaism, and it is quite another

thing to do so from within a religion of incarnation, such as Christianity. For Lévinas, the other is definitely never the other in the third person, the other about whom one speaks, but rather the other who is presented to me face to face. He is nevertheless not in the second person, as in the Christian act of faith. The Lévinassian other is not primarily the other to whom I address my words but, first and foremost, the other who addresses me. The "me" starts by being a "you". This is why it is the subjection to the other which defines the subject as ethical: "the 'me' always has one *more* responsibility than all the others."[7] Responsibility is asymmetrical and irreversible, nonreciprocal and non-egalitarian. It is the most fearsome aspect of ethics, according to Lévinas. Whereas, for a Christian, the face of the other is the incarnation of his fellow man, for the Jewish philosopher it is the epiphany of Infinity and the presentification of the Law.[8] Whereas, for a Christian, the act of faith is an addressed declaration which abandons the other to his freedom, for a Jew it is the reception of the address which declares to him that he belongs to the chosen people. May my Jewish readers please forgive me, but, insofar as I am following in Gauchet's footsteps, I can only see in the invention of Christianity an advance on the path to the exit from religion, articulated, needless to say, with the religion from which it issues. It is noteworthy that this invention should be signed with an act of faith that is altogether similar to the Jewish one—an act of faith that accommodates an election: it is Mary's acquiescence to Gabriel's "Blessed art thou among women". But it is no less noteworthy that this signature instantly entails a brand new casting of roles based on sexual difference. God the Son was born from the womb of a woman fertilised by the divine word—herein lies the foundation of the religion of incarnation. But at what price, because from that day on, women have been condemned to being the medium and the vehicle of incarnation, only receiving their own incarnation from the feedback from this Word made flesh through their agency. So they are virgins and mothers, bereft of their own flesh, unless they are fallen women. I surmise that the place of woman in the economy of incarnation will be a sensitive point in the exhibition HEAVEN because it is on that place that the status of images—and hence of art—has depended in Christianity, at least since the "economic" resolution of the 9th century quarrel about iconoclasm.[9] I shall not dwell on this matter here except to say that I am calling for an image incarnate not born from the breath of a God and the womb of a Virgin, and that I know some artists—women artists, would you believe?—who are working on delivering it.

At the starting point of incarnation, we thus find an address to a woman and a "Jewish" act of faith—or a feminine one, since we can put it down to receptivity and acquiescence. It is immediately followed by a second act of faith, little stressed by the Scriptures, but which is really the first one where it can be seen that faith is the retroactive gift of love. It is St. Joseph's acquiescence to Mary's pregnancy and the assumption of his role as "foster father". I have now and then quipped, as if it all resulted from a syllogism: Joseph knows he didn't sleep with Mary. But Mary is pregnant. So God exists. The effect is comical, with Joseph being propelled into the role of a cuckold with his head in the sand. The joke actually reveals more than hides the profound beauty of the thing and its no less profound truth about the paternal function. In the Gospels, of course, Joseph is alerted by an angel appearing to him in a dream, telling him that Mary is pregnant as a result of God's works. This is a concession to belief in the vein that recurs so often in the Gospels—somewhat obvious to the eye of the modern reader. Like all dreams, according to Freud, Joseph's fulfilled a wish—the wish, it so happens, of finding an unalarming answer to the uncertainty of paternity. But this concession to belief can be bypassed, in order to release the most subversive virtualities of Christianity in relation to religiousness. Christianity was probably closer to any other mythology to recognizing what I think is the essential source of both the oppression of women by men and the repression of the feminine by the social order. This source lies in the uncertainty of paternity, in the anxiety and denial of men when it comes to admitting it, and in the crazy inventiveness that they have invested in the making of systems of kinship and apparatuses of power designed at once to conceal this truth from themselves and deny women their freedom. Joseph does more than merely put his finger on what Lacan has called the paternal metaphor. He removes from paternity in general the fantasy of any father's certainty of his biological fatherhood. Accordingly, belief in God the creator— the progenitor—of the world takes a step backward. It is only essential to the dogma of incarnation

insofar as the twofold nature of Christ makes the link with the God of Abraham. But, once incarnated in his Son, God the creator can withdraw from the world created much more radically than the God of Abraham. He is pure Word, the simple name of the uncertainty in which humans are immersed when it comes to the origin of the world. By becoming Father, God admits to his purely symbolic existence. It is the same God, of course—the New Alliance could only emerge from the virtualities of the Old one—, this God who created the world in seven days and produced out of the transgression of a woman the awareness of sin in men's hearts. Whence the equation which turns Mary into the new Eve redeeming the old one. Isn't it time we changed this point of view? For twenty centuries, Christianity has been obsessed by Mary's virginity-maternity, in order not to have to deal with the consequences of Joseph's much more liberating virginity-paternity. It is not for nothing that the Marian cult has been relaunched, and the theology of the Virgin developed in greater detail every time the patriarchal order has had to cope with an upsurge of women's power on the historical stage, as occurred in the 13th and 19th centuries. From Joseph's viewpoint, God the Father is the name of his recognition of the uncertainty of paternity. And his act of faith in Mary's faithfulness—faith in faith, given by love—thereby becomes the non-religious launch of the doctrine of incarnation.

The rest of the doctrine follows on. Incarnation-birth yields incarnation-death. Once cast among mortals, the Son had no option but to be mortal himself, too. The Story has him dying an ignominious death, and I would not want to minimize either the dramaturgical effect and its effectiveness in Christian propaganda, or the revolutionary (Pasolinian) political novelty that makes the Son of God the weakest among the weak. But I would emphasise that if the Calvary led Christ to his death, it was for two unconnected reasons: because death is the logical consequence of incarnation, and because the humiliation of Christ, which is more essential than his physical suffering, is the sign of the Father's loss of power. The God of Abraham intervened in order to interrupt the sacrifice of Isaac, thus demonstrating his omnipotence and his goodness, alike. The God of the Christians does not intervene. This powerlessness is more than the patriarchate can bear, and it is quite understandable that, over the 2,000 years of its existence, within a society in which the least that can be said is that the patriarchate has done pretty well for itself, Christianity has done its utmost either to deny it or to convert it into supreme glory. But the worm of the father's powerlessness was in the fruit of the patriarchate, at the outset. Once the father has been reduced to nothing more than a metaphor, power is no longer his inevitable attribute. If, for Lacan (who I cannot help thinking has achieved the Christian translation of Freudian Judaism), the name-of-the-father is synonymous with the law, it is a law that governs the father, not a law that he decrees. The father is merely the agent of the law of the signifier when he hands down his name, when he transmits the phallus.

I sometimes catch myself dreaming of a post-Lacanian utopia which makes the phallus not the signifier of castration, but rather, the signifier of the uncertainty of paternity. It amounts to the same thing, needless to add, but why does Lacan leave it only half said? Granted that the truth can only be half-said, why could this particular one be acknowledged only with the greatest reservation? Didn't Lacan, who was something of a patriarch himself, stop halfway along the path of his Christian translation of Freud? I think he did, to the extent of imagining that the point where it is a matter of being post-Christian merges with the point where it is a matter of being post-Lacanian (I don't think I am alone in thinking as much. If I have understood correctly, Alain Badiou is on the same track. I shall come back to this.). The fact remains that if one wonders why the signifier of sexual difference (therefore applying to both genders) were to be on the masculine side, and why, in addition, on the side of paternity rather than the side of masculinity in general, the answer is quite obvious: because maternity doesn't need a signifier. The mother doesn't need her mother's status to be approved by a sign, acknowledged by a symbol. She knows in her flesh that she is mother. Man needs his paternity to be recorded by a symbolic act, because he doesn't enjoy any physical signal of paternity. This is why phallus and name-of-the-father are synonymous and phallus and penis are not. And why the phallus is a signifier and not a sign. It is not the father, like a name to the thing it names, that it substitutes, but the uncertainty of paternity. It is a sign without any signified (or rather, referent; perhaps Lacan is creating a confusion here that has much to teach us). If a utopia

were needed at any price to entertain hope, my post-Christian utopia would simply be this: when it has been understood that paternity consists in acquiescing to a basic uncertainty through an act of faith, and faith in the faith of the other—which is to say that the man who gives his name to a child relies blindly on the trust he puts in the faithfulness of his woman—, the power of the fathers evaporates. Obviously enough, this has been understood from the word go, but one simply doesn't wish to admit this because it calls for too much love. Foolish are those who think that a DNA test can be a substitute.

But let us be realistic and get back to the translation exercise under way. Hope and equality. Now that the issue of sexual difference is on the table, it is the equality between men and women that is involved as much as the equality between "undifferentiated" human beings. As I said earlier, hope is the endurance of faith, and Christian hope is buttressed by a quite specific faith—faith in the resurrection of the Son of God, in relation to which faith in his incarnation would seem to be merely its condition. In order to rise up from the dead, Christ had to die, and in order to die he had to have been born. Resurrection is the event, not incarnation. In a slim volume devoted to St. Paul—slim in size but big in terms of complex challenges—Alain Badiou, referred to a few lines earlier, minimises faith in incarnation and maximises faith in resurrection. "Paul's thought dissolves incarnation in resurrection," he says.[10] Badiou does not believe any more than I do in the fable of the resurrection, so he does not dwell on the fabulous character of this particular event. Any event can take its place provided it grounds the uniqueness of the subject declaring it: "Declaring an event is to become the son of that event."[11] For Badiou, the political meaning of the resurrection of Christ proceeds by way of humankind's becoming-the-son—humankind transfixed by an event, like Paul on the road to Damascus. Revolutions, including the French one, may be such events. This becoming-the-son proceeds in its turn by way of the deposition of the Father. Because, for Badiou, the event and its declaration alone "filialise," he is prompted to deny that Christian humankind has been "filialised" by the mediation of Christ's sacrifice. He thus acts as if Christ's death did not count in his resurrection, and as if the ignominy of his death did not call the Father into question. The deposition of the Father, for Badiou when he reads St. Paul, results from the spiriting away of the mediation. This is a forceful reading but it is not the only one possible, even if "with Paul, one notes a complete absence of the theme of mediation."[12]

Badiou clearly breaks with the doctrine of incarnation. His theme, let it be clearly said, is not the exit from religiousness—he reckons he's already free of that. Because my theme, which is more cautious, is to display the anti-religious virtualities of the said doctrine, it is from within this doctrine that I am trying to make the break. Like Badiou, however, I think that it is necessary to disregard the concept of mediation—it is here, fairly and squarely, that the break will be made; but what interests me is seeing whether incarnation itself can be conceived in non-mediatory terms. The emphasis put on Joseph's act of faith is a first step in this direction. As a non-religious launch of the doctrine of incarnation, it shifts the question of the advent of the Son of God in the carnal, mortal world from maternity to paternity. We shift from a line of thinking about the mediation of the maternal womb, when it is touched by the received word and responds by engendering, towards a line of thinking to do with the public declaration of the name-of-the-Son/name-of-the-Father, whereby the symbolic order records an addressed act of faith. But Christ's death issues from his birth, and I have the same reservations as Badiou when faced with the obligation to proceed by way of the mediation of the sacrifice, Calvary and humiliation of Christ to justify the resurrection. And this, for the same reasons as his: the event does not have to be mediatory. It is evident that by refusing to minimise incarnation, I am forcing myself to conceive of not only Christ's birth but his death as well in terms other than those of mediation. The fact is that sacrifice is a rather cumbersome and pathetic mediation in the dynamics of redemption. What purpose does it serve?

The real outrage is that God consented to the sacrifice of his Son. This was a profoundly ambiguous gesture. It's fine by me that Christ's ignominious death on the cross was just a structural consequence of the New Testament repetition of Isaac's sacrifice. This merely highlights all the more the difference between a God withdrawing into the purely symbolic function of paternity, and a God, creator of the Law, and thus omnipotent, who from time to time manifests his power by his inter-

vention in earthly matters. It also highlights the fact that in the Old Testament it is Abraham the father, and God the Law. In the Old Testament arrangement it took extraordinary measures to remind men that fathers are subject to the paternal law, the law of the signifier. The progress made by the New Testament is measured: God finds himself so to speak in the position of Abraham, and this is one hell of a blow for the patriarchate. You don't have to read the Scriptures (it's enough to go to the movies) to find out that when the patriarchate feels threatened, it never hesitates to sacrifice and humiliate its sons. It is even in this way that it is reproduced when the Oedipus complex no longer plays its normative role. The Oedipal conflict settled by the humiliation of the son is thus the perverse driving force behind the reproduction of a patriarchate that is all the more inured because it is the humiliation and not the normative resolution of the Oedipal conflict which is the channel through which the phallic torch is passed down; the latter, henceforth, can no longer be conceived other than as a power to humiliate in turn. But the reproduction of the patriarchate is not the meaning of the humiliation of Christ abandoned by his Father at Golgotha. I would advance as a sign, though not a proof of this, the total absence of Oedipal conflict. "Thy will be done," the Son says to the Father, and the clouds darken—another concession to belief and to the miraculous, but one which ill-disguises the new and outrageous powerlessness of the Father. Without this powerlessness, one could not understand why the resurrection is the event. It would just be a *coup de théâtre,* with the Father pulling the strings. But the Father is helpless and the Son arises off his own bat. It is only then that humankind is "filialised" in the equally shared hope of its own resurrection. Which prompts Badiou to say that the death of Christ is merely the *site* of his resurrection. Yet it seems difficult to me to separate, as Badiou does, the resurrection from the Passion and to claim—a somewhat mechanical consequence of this refusal of mediation—that it is possible for us to take the place of the Son. It is his very own utopia. For my part, I think that this utopia is insufficiently disenchanted because it is too militant; that instead of disentangling the threads of politics and religiousness, it ties them up in knots again, and runs the risk of once more finessing the issue of the feminine. For Gauchet, conversely, it is impossible for us to take the place of the Son because it is already taken.[13] Humankind is consequently "filialised" for no more than the time needed to be emancipated. Paradoxically, this will be a humankind freed from its subordination to the power of the father because it refers its fraternity—and its sorority—to the empty place of the symbolic father rather than the filled place of the son, with whom one identifies. Because Badiou abstracts the event from its "site," he sees God "renouncing his transcendent separation" precisely where I would tend to see him renouncing his patriarchal omnipotence; "inseparating himself through filiation," precisely where I would tend to see him keeping stalwartly in his separate, symbolic father's place; lastly, "sharing a constituent dimension of the divided human subject"—which is right, but in my view for quite different reasons.[14] By relinquishing his power of intervention in the midst of the incarnate beings that we are, everything comes to pass as if God the Father were acquiescing in his turn to Joseph's acquiescence; he too had refrained from intervening in the process of incarnation. Or it is as if God were acknowledging receipt of the foster father's act of faith in the faith of his woman. It was addressed, but to whom? Or it is as if He were replying to the launch of incarnation by approving all its consequences, including the death of his Son and the radical redefinition of his own paternity. I read God's consent to the sacrifice of his Son in a light, pathosless, almost disrespectful way, because I see in God's abstention in the course of earthly things the very opposite of a mediation. The abandonment of the Son by the Father is neither the negative moment in a dialectical process nor simply the "site" of the resurrection. It refers back to birth, and every birth is the particular resurrection of the life which is transmitted through it—there is absolutely no need to believe in the Christian fable to be in wonder about this. In due course, women and the feminine should take up, in this reading, a quite different place than in historical Christianity.

All I can do in this essay is to point to leads. Here is one, which brings us back to the question of the other as recipient, as addressee. The universal address of the Christian "Glad Tidings" overlooks sexual difference just as it overlooks ethnic and class differences. St. Paul: "There is neither Jew nor Greek, neither bond nor free, neither male nor female." (Letter to the Galatians, 3.28.) How should we read this levelling of differences in universality? It is fashionable to promote difference for

difference's sake, and those who give in to fashion will be feminists, multiculturalists and anti-universalists, all in the same breath. Politically speaking, this is neither very clever nor very relevant. Organically without truth, says Badiou.[15] For all this, should the field be left open for the "ungendered" interpretation of Paul's universalist message, as broadcast by the French Revolution when it translated it by "fraternity"? This would be like giving credit to the repression of the feminine when it uses the so-called neutrality of the masculine as a pretext. Or, as Badiou does, should we defend Paul by stressing the novelty of the "reversibility of the inegalitarian rule" introduced by him, in relation to the customs of the period?[16] I'm not sure that this is sufficient, because Badiou clings to the "necessity of traversing and attesting to the difference between the sexes *in order that* it become undifferentiated in universality."[17] The fact is that the difference between the sexes is not just any old difference. It is not contingent but constituent, and it is not sure whether it can or should be undifferentiated in universality. Especially when it is not simply the problem of the universal that is envisioned on the basis of a structure of address, but also the problem of incarnation, and even the one through the other. It seems to me peculiar and quite precious that in most languages—in any event in those spoken by Christianity—the pronoun of address (the second person, you) makes no distinction between the genders, whereas the pronoun of the referent (the third person, he, she) does. If "you" did this, there would simply be a distribution of addressees as men and women. Let us not conclude that the pronoun of address is ungendered. It is two-gendered because it does not let us know the sex of the person, male or female, being addressed. Perhaps this uncertainty about the gender of the addressee is essential to the structure of the address.

What, now, is the address structure of universal love? Love, Badiou reminds us, *is* the universal address which faith alone does not constitute.[18] I wholeheartedly underwrite this definition (even if, as we shall see, I shall push it to St. Joseph's side rather than St. Paul's), and I stress the copula. If the act of faith is addressed, love *is* its address and its address to all. This dry and thoroughly unsentimental definition of love contains the wherewithal to put back in its place the rightful loathing that may be inspired by Christianity, precisely because it presents itself as a religion of love. Who, even among practising Christians, has never been irked by the intolerable certainty of those who know that they are doing good; by the dignified contrition of sanctimonious persons and the ostentatious self-sacrifice of charitable folk; by the inanity of "everyone is good, everyone is kind" broadcast by a schmaltzy Christianity; by the masochistic pride of those who offer their left cheek when someone has struck their right one; by the superiority of those who offer unilateral forgiveness; in a word, by the whole Christian paraphernalia of fawning types of behaviour which reek of cassock and holy water? They are the outcome of the false belief in a reserve of infinite love spilling out, through pure goodness, over sinful humankind—and in this respect it matters little that the convinced Christian situates it in God and not in himself; the mere fact that he takes himself to be the dispenser is enough to make his claim a suspect one. This rightful loathing can be contrasted, by way of antidote, with the wholesomeness of the precept: "Love thy neighbour as thyself." It reminds us, in the words of the proverb, that "charity begins at home". This is the basis. But if love is the address to all of the act of faith, wherein lies the proof of this universal address? In being in each and every instance singular, as if marked on the envelope which earmarks for a universal or indeterminate other, the declaration of faith placed in the freedom of a singular other. Love is not watered down in the universal (it is even here that the difference between love and its mediocre translation by "charity" lies); it is felt for beings of flesh and blood taken one by one.

Joseph's acquiescence to Mary's pregnancy is an act of faith shouldered by love. He loves Mary, not humankind in general. And it is because he loves her that he trusts her. Faith in Mary comes first, faith in God second. This is what the syllogism introduced earlier expressed as a joke. In the second stage, which coincides with Joseph's assumption of his purely symbolic paternity, his love for Mary is the address of his faith in God, and God, because he is One, is "for all".[19] Joseph's singular love for Mary thus becomes the universal address of his faith in God. But I am jumping the gun. Everything started with the dispatch of archangel Gabriel, with God's address to Mary. It issues from a God who is not yet the God of Christians, and who has chosen Mary among all women. Mary acquiesces to this choosing with a humility which is not just that of her feminine condition, but also that of her

people. As I have already suggested, the Jewish act of faith consists in the reception of and acquiescence to the mystery of one's choosing. For both sexes, receptiveness and the assumption of an addressee's place and not an addressor's place in the structure of address are the substance of the Jewish act of faith, a substance which in this respect can be called feminine. (I wonder if it is not this cultural feature of Judaism which has caused intolerance of the other to have been so frequently focused in one fell swoop on hatred of the Jews and of the feminine). Badiou does not talk only about the God of Christians, he also talks about what the "mono" in "monotheism" means, and thus above all about the Jewish God, when he says that "The One is what inscribes no difference in the subjects whom it addresses." Not even sexual difference? The pronoun of the address is two-gendered and it becomes differentiated only on reception. Mary receives Gabriel's "I greet *thee*" as a woman. When Joseph acquiesces to Mary's acquiescence (and it doesn't matter whether it is to an angel appearing to him in a dream or to Mary directly), he also finds himself in a state of receptiveness vis-à-vis a message addressed to him, in relation to which the act of faith consists in welcoming it. We can say that he welcomes it with his "feminine" side; we can also say that in this act of faith in Mary, Joseph behaves "like a Jew". And it is the second stage of Joseph's act of faith, his act of faith in God whose address is his love for Mary, which transforms the Jewish God into the Christian God, transforms the God-Law into the God-Love. It took the sequence of these two successive acts of faith on Joseph's part to make love become the universal address of faith. It is not my intent to minimise Mary's part, quite to the contrary; I merely want to alleviate and shift her responsibility in the advent of the doctrine of incarnation. Even if they did not sleep together, she and Joseph must have got together as a couple to make it happen. They in fact brought God the Father into being first, and God the Son only as the result of a ricochet, if you'll excuse the term. I use it with a dash of humour: like any earthly father, God the Father awakens to his paternity nine months before his Son. The unprecedented novelty is that He awakens at the very same time to a new definition of paternity: God becomes "Josephied" by becoming Father (He was not called Father in the Old Testament).

Thirty-three years later, this God who is still the God of the Jews, but who is now simply an agent of the law of the signifier and not the author of the Law, lets his Son die on the cross. I said earlier that everything came to pass as if He acquiesced in his turn to Joseph's acquiescence or as if He acknowledged receipt of the foster father's act of faith in the faith of his woman. He who throughout the Old Testament was the Sole Enunciator, deaf—with a few memorable exceptions—to the prayers and entreaties of his people (this deafness is an essential factor of his transcendence), finds himself in the addressee's position in the structure of address. In a "Jewish" and "feminine" position. He does not reply; He acknowledges receipt, which is not the same thing. In so far as an acknowledgement of receipt is nonetheless a message sent back to the sender, God does as He has always done when men's prayers forced him to forego his deafness; He talks through signs: Christ dies and the clouds darken. What is Christ's death the sign of? Not only of the fact that the Father has lost his omnipotence, but also of his acquiescence therein (this is why He is not deposed: He has lost his power but not his authority). He has just committed an act of faith, definitely not the first such act in his existence—Adam was also left to his freedom—, but a far more decisive act of faith in the exit from religiousness. The attribution to Adam of original sin was still a way of admitting that men, who are sinners by nature, will not pull through all on their own, and that if they want salvation, they will have to wait for the Messiah who will deliver them. Basically, they did not deserve their freedom. For now, the issue of merit has vanished, and it is this above all that is meant by the dispatch of the Messiah, and his death. He came, nothing has changed, so it's up to you from here on out. The God who abandons his Son to his ignominious death is under no illusions. In other words, he is belief-less. He had to take things thus far for the death of his Son to be the sign of his act of faith. God himself had to exit from religiousness for his act of faith to be credible. The death of the Son attests to this. Through this act, God shows human beings that he leaves it up to them as far as the use they will make of their freedom is concerned. He henceforward relies on them to disentangle the political from the religious, while He withdraws.

God exits from religiousness just when Christ dies and men, at the same moment, enter the society

of the spectacle. Let us remember Isaac's sacrifice, of which that of Christ at Golgotha was, *mutatis mutandis,* the New Testament repetition. I said earlier on that the Old Testament had been prompted to take extraordinary measures to show men that fathers are subject to the law of the signifier, and do not decree it. Indeed, to force a father to sacrifice his son with the sole purpose of reminding him that he does not make the law, is a bit excessive. Abraham falls into line and God, in his goodness, dispatches an angel to him who restrains his arm. The intervention is quite spectacular, and more than one Baroque painter has made use of it. Except that Baroque painters are Christians and have received from the doctrine of incarnation the right to make images, and even, since the Council of Trent, the injunction to put the full might of images at the service of the Church's propaganda. What their painting erases is the fact that there were no onlookers at Isaac's sacrifice, for God insisted that it be carried out in a remote and barren place. The contrast comes across: there are people at Golgotha, plenty of people. The *mise en scène* is highly successful: a long preamble with fourteen stations, each one with its moment of emotion; the simultaneous arrival of actors and spectators at the top of a natural hillock (much better than a raised podium); sound and fury, an incredible hubbub, the din of hammers, Roman soldiers all over the place; a man who is still young and quite handsome, wearing no more than a loin cloth; two thieves crucified to lend symmetry to the scene; a crown of thorns, a sponge soaked in vinegar, a spear wound, what a spectacle! And that cross! As Oliviero Toscani (the Benetton photographer and art director), who knows about such things, says, a logo that holds up for twenty centuries has what it takes to make Madison Avenue jealous. Especially when the society of the spectacle has at its disposal today's technological means, when it has absorbed the lay civil society that issued from the French Revolution, when it has become the only stage where the political can be shared, when it takes on the anthropological and sociological function of religion—being the bond that binds—, the society of the spectacle is what most effectively shrouds that fact that we made good our exit from religiousness two thousand years back.

I finally understand the awkward position I was in when I embarked on this essay. The theme of the exhibition HEAVEN clearly established an equation between religiousness and the society of the spectacle, that is, between the following two orders of phenomena: on the one hand, the remanence or comeback of iconographic motifs, rites and themes which so *visibly* borrow from the Christian tradition that they impose themselves as proofs of religiousness; on the other hand, the very fact that the spectacularization of the public sphere is nowadays the sole relationship to the political which, *visibly,* binds us together. In a more or less muddled way, I sensed that there was something blinding in this excess of visibility. Keeping aloof from the images and works of art that the show may contain (and which I could not have seen, in any event), I thus entrenched myself in an exercise of conceptual translation—faith/liberty, hope/equality, love/fraternity—which does or does not have its share of historical truth, but which, in my mind, was firmly based on the lesson learnt from Marcel Gauchet, namely, that Christianity was the religion of the exit from religion. In no less muddled a way, I also sensed that I had to make a distinction between images and works which *shoulder* the contemporary phenomenon of religiousness—which, otherwise put, assume its visibility while perhaps undermining it—and those which are content merely to *illustrate* it—which, in other words, amplify its visibility while perhaps disguising it. This gave rise to ambiguity, even if my reliance on Gauchet ushered in a paradox. I now understand more clearly why I clung to that word, "shoulder". What the works to which I hope to give my backing in HEAVEN shoulder is not religiousness; it is, we might so put it, by paraphrasing Gauchet, the religiousness of the exit from religiousness. Shouldering this particular religiousness is to assume, take upon oneself, go along with and push that much further the anti-religious virtualities of Christianity as the religion of the exit from religion *and* as the religion of incarnation. As for the works I might disapprove of—if there are any—because they merely illustrate what I have called the stubborn remanence of religiousness, I now know a little more clearly why I disapprove of them. The society of the spectacle is the form taken by religion when you have exited from religiousness. It starts with Golgotha, and with what lustre! It gains new strength in the 9th century in Byzantium, passing closer than ever to the mystery of incarnation, but straightaway mapping it onto the economy, that is, onto mediation, a medi-

ation that women and the feminine will pay for. It becomes the official politics of the Church with the Council of Trent and the energetic iconographic programme of the Baroque period. Churches have since managed to follow churches and the "cathodic church" has almost managed to absorb the Catholic Church (as we can see, to the point of caricature, in the pope's recent CD); the society of the spectacle is in fine fettle. By saying that it is what most effectively shrouds the fact that we exited from religiousness two thousand years back, I do not mean to say that it is no more than a smokescreen that can be dispersed. I mean that religiousness is fighting and standing up for itself; that it does not intend to die; that even at the end of the very long tale told by Gauchet, during which humans have very slowly learnt to do without mediation with the invisible, the desire for this latter is being fiercely defended. And all the more fiercely, need it be said, because the exit from religiousness has been more or less accomplished. The blinding, dazzling excess of visibility of the spectacle is there to conceal that there are things that remain invisible and that between the visible and the invisible there is no mediation. This is why, as I said at the outset, religiousness is extremely difficult to avoid when you want to testify to death from within the society of the spectacle—or testify to birth as well, which is to say, to resurrection. There were no witnesses at Christ's resurrection—something that remains to be pondered.

NOTES

1 Marcel Gauchet, *Le désenchantement du monde, Une histoire politique de la religion,* Gallimard, Paris, 1985.

2 Ibid., p. V.

3 Ibid., p. 12.

4 Max Weber, *Protestant Ethic and the Spirit of Capitalism,* London, Routledge, 1992.

5 French woman of letters (1755–1793) of revolutionary persuasion, author of the *Déclaration des droits de la femme et de la citoyenne* (1792).

6 See Hans Jonas, *Der Gottesbegriff nach Auschwitz. Eine jüdische Stimme,* Frankfurt, Suhrkamp, 1984; Emmanuel Lévinas, Ethique et Infini, Paris, Livre de poche, 1984.

7 *Totalité et Infini,* Paris, Livre de poche, 1992.

8 "Infinity springs to mind in the significance of the face. The face signifies Infinity. This never appears as a theme, but in this ethical significance itself: in other words in the fact that the more just I am, the more responsible I am; one is never quits with regard to the other." Ethique et Infini, p. 101. And also: "The face is what one cannot kill or at least that whose meaning consists in saying: 'Thou shalt not kill'." Ibid., p. 81.

9 See Marie-José Mondzain, *Image, icône, économie, Les sources byzantines de l'imaginaire contemporain,* Paris, Le Seuil, 1996.

10 Alain Badiou, *Saint Paul, La fondation de l'universalisme,* Paris, PUF, 1997, p. 78.

11 Ibid., p. 63.

12 Ibid., p. 51. "There is a deep-seated general problem here: is it possible to conceive of the event as a function, or as a mediation? It may be said in passing that this question permeated the entire period of revolutionary politics. For many of its faithful followers, the Revolution is not what happens, but what must happen in order for there to be something else; it is the mediation of Communism, the moment of the negative. […] For Paul, on the contrary, as for those who think that a revolution is a self-sufficient sequence of political truth, Christ is a coming, he is what interrupts the previous régime of discourse. Christ is, both in himself and for himself, what happens to us. And what is it that thus happens to us? What happens is that we are released from the law. [...] For Paul, this is a decisive matter, because it is only by being released from the law that one really becomes a son. And an event is falsified if it does not bring about a universal becoming-the-son. Through the event, we enter into filial equality."

13 *Le désenchantement du monde,* pp. 195–197.

14 "Through the death of Christ, God renounces his transcendent separation, inseparates himself through filiation, and shares a constituent dimension of the divided human subject. In so doing, he creates not the event, but what I call his site." *Saint Paul,* p. 74.

15 Ibid., p. 11.

16 For example: "The wife hath not power of her own body, but the husband...and likewise, the husband hath not power of his own body, but the wife." Letter to the Corinthians I.7.4, quoted by Badiou, Ibid., p. 111.

17 Ibid., p. 112.

18 Ibid., p. 92.

19 "The fundamental question is knowing what exactly it means that there is just one God. What does the "mono" in "monotheism" mean? Renewing its terms, Paul tackles the formidable question of the One. His thoroughly revolutionary conviction is that the sign of the One is the "for all," or the "without exception". That there is just one God should be understood, not as a philosophical speculation about substance, or about the supreme being, but in relation to a structure of address. "The One is what incorporates no difference in the subjects whom it addresses." Ibid., p. 80.

JEFF KOONS

born 1955 in York, PA, lives in New York

Solo Exhibitions (selection)

1998	*Jeff Koons, Encased Works,* Anthony d'Offay Gallery, London
1993	*Jeff Koons, Retrospective*, Walker Art Center, Minneapolis
	Jeff Koons, Retrospective Staatsgalerie Stuttgart
1992	*Jeff Koons, Retrospective*, San Francisco Museum of Modern Art
	Jeff Koons, Retrospective, Stedelijk Museum, Amsterdam
1991	*Made in Heaven*, Max Hetzler Gallery, Cologne
1988	Museum of Contemporary Art, Chicago

Group Exhibitions (selection)

1998	*Urban*, Tate Gallery Liverpool
	René Magritte and the contemporary art, Museum voor Moderne Kunst, Oostende
1997	*Biennale di Venezia*, Venice
	Objects of Desire: The Modern Stilllife, The Museum of Modern Art, New York
	Multiple Identity, Amerikanische Kunst 1975–1995, Kunstmuseum Bonn/Castello di Rivoli, Museo d'Arte Contemporanea, Turin
1995	*Signs and Wonders*, Kunsthaus Zürich/Centro Galego de Arte Contemporanea
1994/95	*Black Male. Representations of Masculinity in Comtemporary American Art*, Whitney Museum of American Art, New York
1993	*American Art in the Twentieth Century*, Royal Academy of Art, London
1992	*Post-Human*, Musée d'Art Contemporain Pully, Lausanne/The Israel Museum, Jerusalem/Deichtorhallen, Hamburg
1991	*Metropolis*, Martin-Gropius-Bau, Berlin
1990	*Aperto, Biennale di Venezia*,Venice

Michael Jackson and Bubbles, 1988, ceramic, 106.6 x 179 x 82.5 cm, Courtesy The Broad Art Foundation, Santa Monica (ill. pp. 93–95)

The work *Michael Jackson and Bubbles* belongs to the series *Banality* produced in 1988 and consisting of ten works, among them *Bear and Policeman*, *Saint John the Baptist*, *Fait d'hiver* and *Pink Panther*. In most of the works of this series animals and people are represented together, relating to one another in ways which appear highly unnatural. It is not that acts of bestiality are displayed, but rather a latent characteristic is present, conveyed by the manner in which the figures look at or touch one another or by their gestures, in which abides an undertone of something obscene and perverse, an implication that lurks in the background and is never explicitly substantiated. This theme of something going astray culminates in *Michael Jackson and Bubbles* where the element of the grotesque is multiplied through the images of both the man and the ape and through the manner in which they have been given shape.

Koons's *Michael Jackson* is a hybrid. In the artist's representation the evidence that Jackson is of Afro-American descent is completely eliminated, his original skin colour hovering like a bad spirit in the viewer's mind. The joke is not on Jackson but on the political correctness inherent in contemporary thinking patterns. The viewer's knowledge about the pop star is twisted through the art work and the form of its representation which abolishes the presupposed categories. Being neither black nor white, an icon of androgynity, rumoured to have a weakness in regard to children and being an eternal child himself, he is frozen into a state of non-existence, reflected by the figure of the ape that mirrors the gap which eludes categorisation, for *Bubbles*, equipped with a human facial expression, is made to bear a striking resemblance to *Michael Jackson* and is transposed into a "white" sphere, a notion which is enhanced through golden hair. Like his master he has no clear gender and is not represented as an individual but rather as an artefact which achieves immortality as an image through sales and marketing strategies. What is inherent in *Michael Jackson* is not the notion of a soul, nor is it a spiritual commodity art might sell the viewer as a side benefit. It is rather a sense of horror inscribed in the lascivious surfaces of the sculpture itself. In the same manner as the nobility of the Rococo era was depicted as shepherds, shepherdesses and farm boys in an attempt to idealise reality by turning it into a virtual idea, Koons's sculpture adapts the non-existent reality of the pop icon Jackson, re-sampling it as a work of art. Koons employs kitsch as a mode in all of its seriousness, i.e., kitsch as the mundane path to perfection, which, viewed through the eyes of the devotee, is devoid of the mechanism of an ironic approach. On the other hand, in Koons's case, kitsch is no longer embedded in the naïve or imbued with the sincerity of a popular commodity. The element of kitsch is given sovereign power, inasmuch as it is used purely as a technical means devoid of any ethical implications in Koons's work. In employing this tactic, Koons makes it possible for the work to exist beyond the general canon of good and bad taste, thus legitimising it as a focal point of desire.

DLH

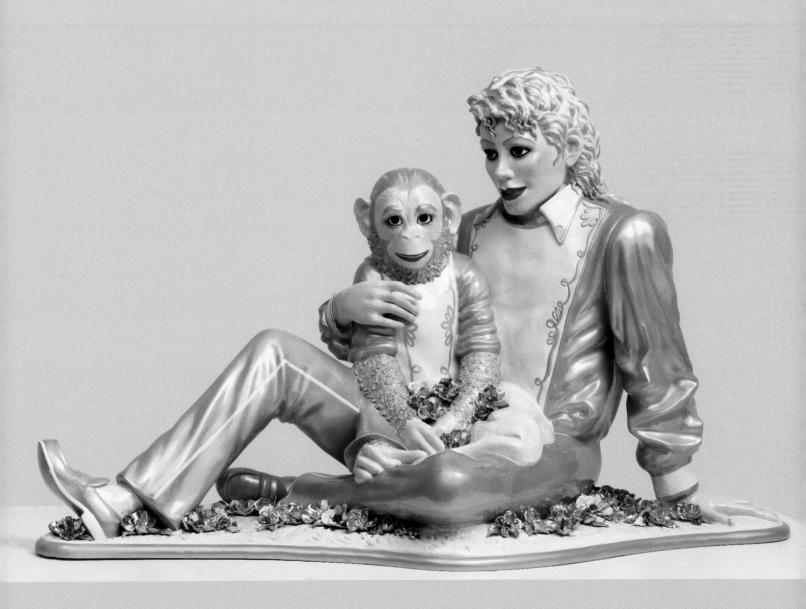

KAREN KILIMNIK

born 1962 in Philadelphia, PA, lives in Philadelphia, PA

Solo Exhibitions (selection)

1998 H & R Projects, Brussels
 Galerie Ghislaine Hussenot, Paris
1997 *Karen Kilimnik*, Kunsthalle, Zürich
1995 303 Gallery, New York
1995 Ynglingagatan 1, Stockholm
1994 White Cube, London

Group Exhibitions (selection)

1998 *Roommates*, Museum van Loon, Amsterdam
1998 *Hungry Ghosts,* The Douglas Hyde Gallery, Dublin
1997 *Belladonna*, ICA, London
1996 *Nirvana: Capitalism and the Consumed Image*, Center of Contemporary Art, Seattle
1995 *Saturday Night Fever*, Tom Solomon's Garage, Los Angeles
1994 *Reflex*, Wiener Secession, Vienna
1993 *The Art of Language*, Kunsthalle Vienna/Frankfurter Kunstverein, Frankfurt
 Whitney Biennial, Whitney Museum, New York
1992/93 *Spielhölle*, Grazer Kunstverein, Graz
1992 *Through the Viewfinder*, Stichting De Appel, Amsterdam
 LifeSize, Centro per l'Arte Contemporanea Luigi Pecci, Museo d'Arte Contemporanea, Prato
 Post-Human, FAE Musée d'Art Contemporain, Lausanne/Castello di Rivoli, Museo d'Arte Contemporanea, Turin/Deste Foundation for Contemporary Art, Athens/ Deichtorhallen, Hamburg

Prince Desirée on a Break from Sleeping Beauty out at Petrosian's for Dinner, 1998, oil on canvas, 45.7 x 35.5 cm, Courtesy Blake Byrne (ill. p. 101)
The Cloak of Twilight, 1998, oil on canvas, 50.8 x 40.64 cm, Courtesy Carol Green, Green Naftali
Prince Charming, 1998, oil on canvas, 50.8 x 60.9 cm, Courtesy Susan and Michael Hort
The Black Plague, 1995, oil on canvas, 50.8 x 40.6 cm, Courtesy Susan and Michael Hort
Prince Siegfried in Swan Lake Returning to His Castle Near the Baltic after Dinner with Friends at Trader Vic's, 1998, oil on canvas, 45.7 x 35.5 cm, Courtesy Georg Kargl, Wien
Twiggy at School at Cambridge, 1997, oil on canvas, 50.8 x 40.6 cm, Courtesy Michael Lynne
The Crush, 1995, oil on canvas, 71.1 x 55.8 cm, Courtesy Morton G. Neumann Family Collection (ill. p. 100)
Baby, 1995, oil on canvas, 50.8 x 40.6 cm, Courtesy Morton G. Neumann Family Collection (ill. p. 99)
Mercury as a Cut Purse, 1996, oil on linen, 50.8 x 40.6 cm, Courtesy Morton G. Neumann Family Collection (ill. p. 98)
Princess Di, That Dress, 1997, oil on canvas, 45.7 x 35.5 cm, Courtesy The Ann and Mel Schaffer Family Collection

The paintings of Karen Kilimnik establish a cosmos of romantic fantasies. Her subject matter comprising of film and fashion stars, celebrities and aristocrats, as well as the manner in which she converts it into paintings reminiscent of portraiture from past centuries, create an enchanting iconography. Might her work in the first place be based on young girls' dreams, a kind of Jane-Austen-romanticism that has been transposed into the 20th century, or does it rather centre on a subtle analysis of society, whose objective it is to investigate the significance of the public image for the constitution of a personal existence? The immaculate beauties portrayed in Kilimnik's paintings appear before the viewer's eyes in celestial and timeless serenity, far removed from the fortunes of the mundane world and free of the fears and aggressions of everyday life. These form a strong contrast to the pictures whose intensity has an extremely threatening impact on the viewer who is unable to exactly pinpoint the source of the disturbance. The mood that these pictures evoke reaches far beyond what is actually depicted in them. Atmospherically they recall the Gothic novel of the 19th century, séances and secret societies. The portrait of a young, immaculate and beautiful woman surrounded by burning candles radiates an attractiveness that one can hardly evade; however, at the same time it evokes the menace of secret, inexplicable forces. The subject in the work *Baby* is the epitome of innocence, but it appears in its unintentional naiveté also as an angel of death, in the same manner as the beautiful young lady in *Swiss Boarding School (Avalanche)* seems to emit a nameless danger, or in the way that fate appears to hover in the form of black reverberations over *Great Hampton Fire*. Figures like *Prince Desirée* or *Twiggy* who meet the viewer's gaze with such childlike innocence cannot possibly be evil. Or are these ideal figures possibly unaware of their actions? Their gaze is empty and their reactions seem as if they were remote-controlled. Might they even be the instruments of a higher power?

The dramatic atmosphere evoked by Karen Kilimnik's pictures and scenarios corresponds to the mood in classical fairytales, whose protagonists are also an embodiment of moral and ethical values. Kilimnik effortlessly manages to establish the connection to the pictorial language of the late 20th century in combining various forms of representation, such as the drawing, glazed and pastose painting, as well as the integration of writing, which in its characteristic flow creates the impression of an extreme authenticity and intimacy. In her concept of the picture she thus draws upon the comic strip and the animated cartoon. For the completion of the described picture effect, the titles are of decisive importance as they make the individual picture into part of a story. In the dichotomy between admiration and the wish for identification with the idol, on the one hand, and the envy resulting from the impossibility of realising this wish, on the other, the viewer suddenly assumes the role of competitor that the protagonists are permanently subject to in the tabloids and society columns. The artificiality of her world and the synthetic beauty of its image becomes evident in Karen Kilimnik's pictures. The tension between latent aggression, competition and jealousy, on the one hand, and superficial charm and friendly intimacy on the other, is a blatant commentary on the existing yearning for fulfilment and substance, for overcoming the alienation between the ego and the id. The fact that Karen Kilimnik herself and every viewer of her pictures must perceive themselves as part of this system may be due to the intensity of the concept of her work whose effect one can hardly evade. MM

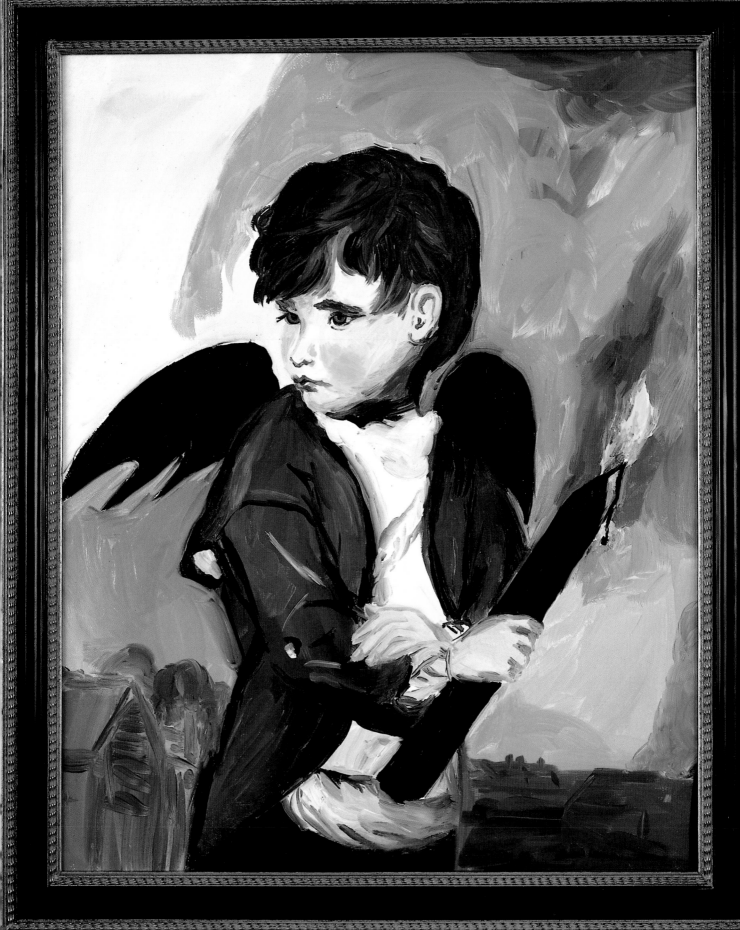

MAJIDA KHATTARI

born 1966 in Erfoud/Marocco, lives in Paris

Solo Exhibitions (selection)

1997 *Défilé/Performance,* Galerie Thaddaeus Ropac, Paris
1997 *Défilé-Performance,* Festival de L'imaginaire au Théâtre de la Maison des Cultures du
 Monde, Paris
1996 *Défilé/Performance,* Ecole Nationale Supérieure des Beaux Arts, Paris

Group Exhibitions (selection)

1999 *Passage,* Setagaya Museum, Tokyo
1998/99 *Premises,* Guggenheim Museum Soho, New York
1998 *Mediterranea,* Musée Botanique, Brussels
1998 Centre d'Art Contemporain, Kunsthalle Fribourg
1998 *XXIXième Rencontre internationale de la photographie d'Arles,* Arles
1996 *Novembre à Vitry,* Mairie de Vitry
1987 *Festival International d'Art d'Asilah,* Marocco

Le Mur, 1998/99, textile, silk embroidery, plastic, paint, Courtesy Majida Khattari (ill. pp. 104–107)

As a mysteriously veiled figure of unknown origin the entity enters into the light. The physical shape of a human being is not clearly defined and yet this does not appear to be an animal either. It creates the impression of an emissary from another world. While its motions, on the one hand, seem to reflect an attempt to escape, they appear, on the other hand, synchronous and coherent.

The performances of the Moroccan artist Majida Khattari incorporate the ambiguity and the same polarity which are found both in Islamic societies as well as in the manner in which the non-Islamic world looks upon Islam and its followers. Within the Islamic world itself no consensus prevails about the status of dress codes and the commandment of wearing the veil. While since the reign of Atatürk the strict separation between religion and secular state is stipulated in Turkey, in other Islamic countries the religious commandments are misused as mechanisms of prohibition and as instruments of power. In the course of doing so, traditions which have been handed down for centuries are partially suppressed, destroyed and distorted. The veil which women must wear according to Islam is, on the one hand, supposed to hide women's charms and to avoid provoking public attention. However, the traditional garb of the veil has always given women a special social status as well, guaranteeing them respect and self-assurance. The radical prohibition of the veil thus thrusts women into a public, unsheltered sphere which does not correspond to their traditional role within Islam. They are placed at the mercy of a situation many have not been prepared for through their upbringing and socialisation and in which they have to cope without having been granted the possibility of free choice. This may be experienced by many Moslem women as equally degrading and threatening as the oppression through Islamic law is experienced by others.

In this field of conflict many Moslem women—and as far as their reaction is concerned, also many Moslem men who are deprived of their orientation in a traditional social value system—must first find their way around. The struggle to find a social position corresponds to the attempt to come to terms with one's own body which in turn ultimately corresponds to the question of adequate clothing and motions within the public sphere.

This question is a central theme in Majida Khattari's animated fabric objects which she employs in performances and whose disturbing, fantastic appearance confuses performer and viewer alike. On the one hand, there are the highly seductive garments which emphasise the body but have dangerous edges as sharp as knives, or whose openings, allowing a fleeting view of the naked body underneath, are fortified with spikes. On the other hand, the figures wearing these objects are often imprisoned in them and every attempt to escape would inevitably lead to strangulation or castration. In ecstatic, convulsive motions the fabric and material encasements are animated and transformed into living beings whose human "core" becomes apparent only through the attempt at freeing itself, the struggle or the synthesis with the costume. The objects and performances of Majida Khattari thus become a forceful symbol of the entanglements that result from the interrelationships between society, politics and religion and their instrumentalisation. Again and again these conflicts surface both in the Islamic world as well as in the confrontation with the non-Islamic world; only through an open treatment of these conflicts and an open dialogue may these irritations be overcome. The fact that Majida Khattari is seeking this dialogue also by means of humour, irony and provocation is revealed not least in her most recent works, which refer to the numerous influences and interrelationships between the Islamic and Western worlds. If in Islamic script, *Coca Cola* is embroidered by hand on a magnificent *tshador*, then this is naturally a blasphemy for radical Islamic followers. However, it also appears as an affront from a Western point of view, because the coherence of the sign and its meaning, of symbol and object are undermined: only a few Western viewers will be able to identify the embroidered writing as denoting the words *Coca Cola*. As far as the colour is concerned, the allusion to a Western superpower in the case of another object also indicates the attraction of the given value system while at the same time revealing its hermetic character and its orthodoxy—the body within the costume is imprisoned and only openings in the surface of the costume allow a view of the person wearing it; whether or not that person can also gaze outside from within depends on his or her own flexibility. The fact that here the traditional Islamic abstinence regarding images, the extreme significance of writing and its signs, is united with a form of motion based on content and ritual, with ritual invocation and the Western form of free dance, with performance and body-related art, emphasises the conceptual approach that Majida Khattari pursues in her works. MM

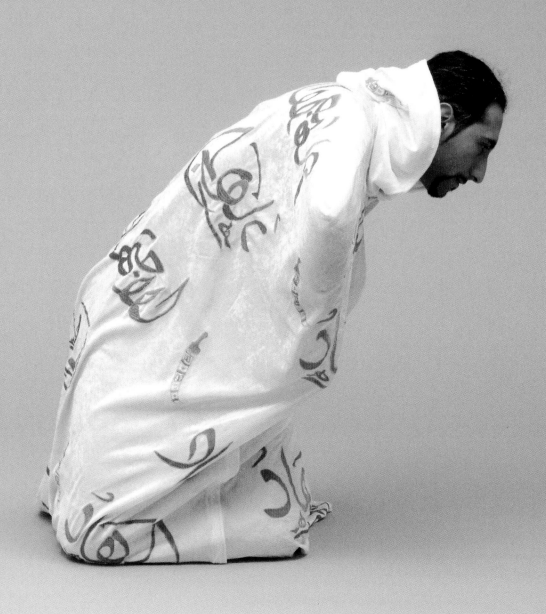

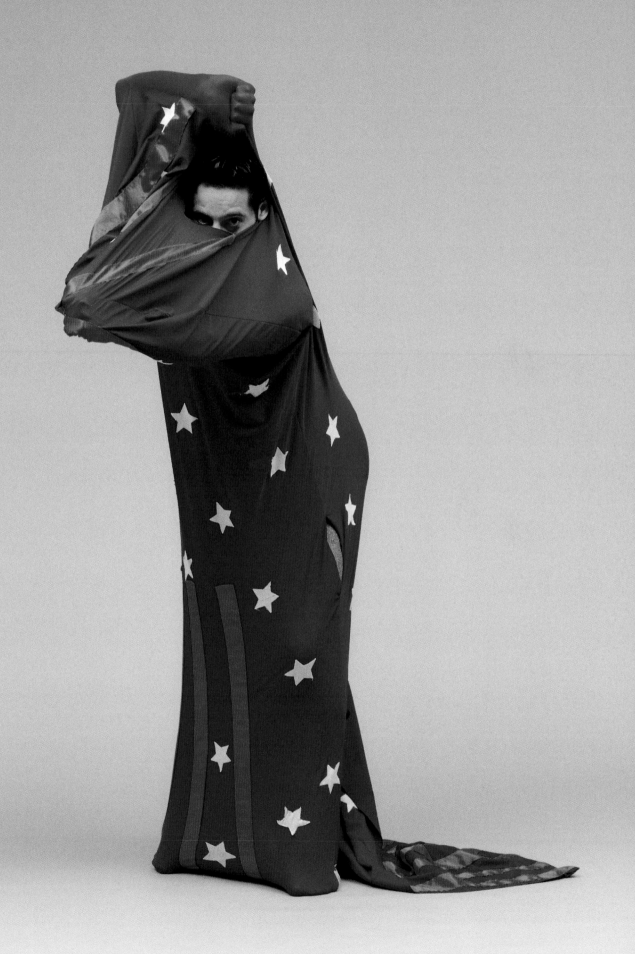

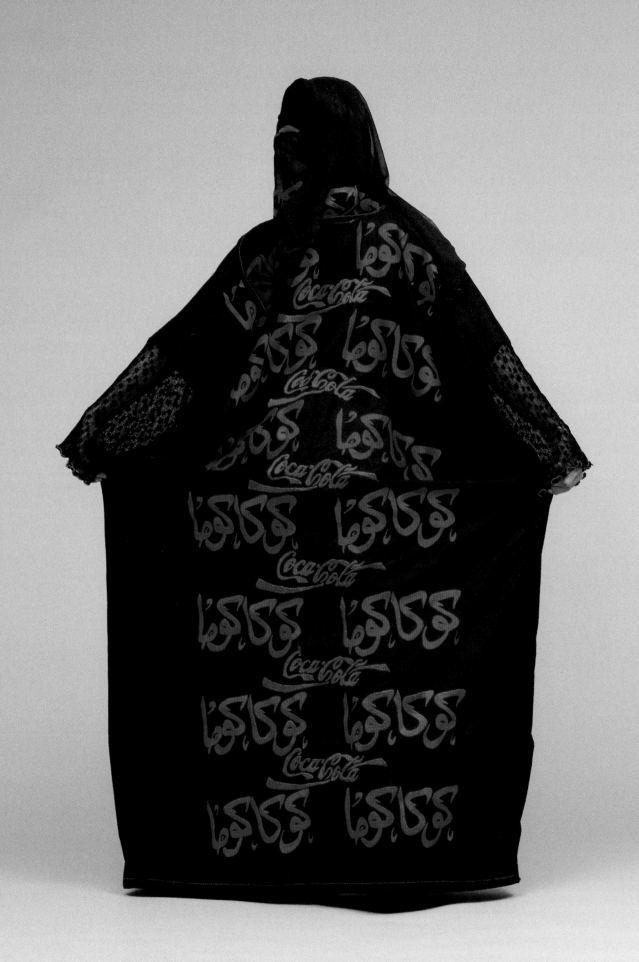

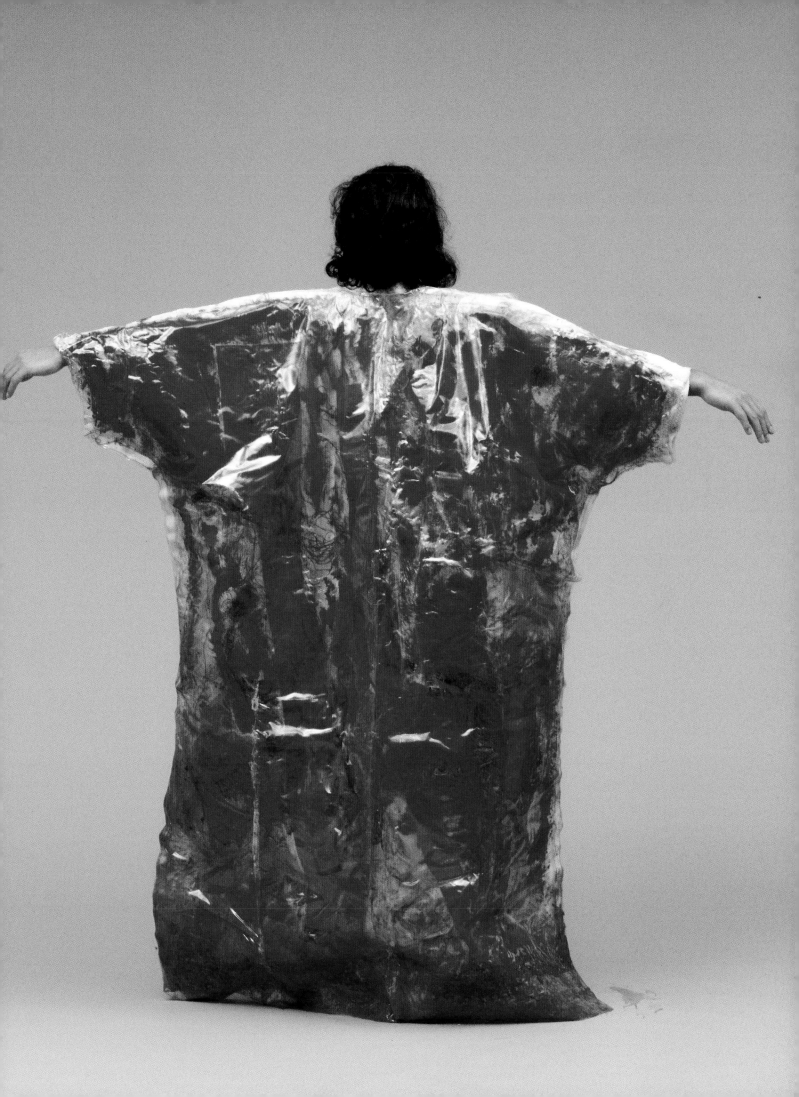

SHIRIN NESHAT

born 1957 in Qazvin/Iran, lives in New York

Solo Exhibitions (selection)

1999	*Shirin Neshat*, Art Institute of Chicago
1998	*Shirin Neshat*, Tate Gallery, London
	Shirin Neshat, Whitney Museum of American Art at Philip Morris Branch, New York
	Shirin Neshat, Maison Européenne de la Photographie, Paris
1997	*Shirin Neshat*, Museum of Modern Art, Ljubljana
1996	*Shirin Neshat*, Centre d'Art Contemporain, Kunsthalle Fribourg
	Shirin Neshat, Lucio Amelio Gallery, Naples

Group Exhibitions (selection)

1999	*Unfinished History*, Museum of Contemporary Art, Chicago
1998	*Echolot*, Museum Fridericianum, Kassel
	7th Summer of Photography, Museum van Hedendaagse Kunst, Antwerp
1997	*5th International Istanbul Biennial*
	2nd Johannesburg Biennale
	Feminine Image, Nassau County Museum of Art
1996	*Inclusion/Exclusion*, Künstlerhaus Graz
1995	*Transculture, Biennale di Venezia*, Venice
1994	*Labyrinth of Exile, Recent Works by Four Contemporary Iranian Artists*, Fowler Museum of Cultural History/UCLA, Los Angeles

Turbulent, 1998, video installation, Courtesy Patrick Painter Gallery, Los Angeles (ill. pp. 110/111)

Raised in pre-revolutionary Iran and living in New York, Shirin Neshat has the opportunity, as only few Islamic women have, to observe the culture of her origin from the outside, while at the same time being in the position to analyse it as a member of this culture. The journeys she undertakes annually to her home country are not merely a return to her own roots but, above all, a kind of sociological search for the structures which determine the transformation of Islamic society in Iran. In their hermetic complexity the works resulting from this undertaking are not to be viewed as documents, but rather as a highly sensitive perceptive instrument for a cognitive situation which reaches far beyond social structures, leading to philosophical questions regarding human existence. Shirin Neshat is particularly interested in the self-image of women in traditional as well as contemporary Islamic society. Her analysis, however, is not based upon preconceived role models, but rather verifies in her works the highly complex relationships between men and women, politics and religion, society and the individual. In photographic series and video installations she investigates, in a poetic and dramatic fashion, the inconsistencies and mysteries in which role allocations are rooted in Islam.

In this respect her attention is particularly focused on the question of the possibilities of existence for women who, hidden behind the traditional veil, lead an inner, non-public life. By doing so they incorporate a social value which in a heteronomous manner has been conferred upon them, which, however, decisively determines their self-image and the relationship they have towards their body. If the *tshador*, on the one hand, prevents free self-fulfilment, it is still considered to be a symbol of the highest respect for the authenticity and dignity of women; it is supposed to prevent a woman from becoming an object, thus taking into account the "weakness of the human will". On the other hand, women must submit to their behavioural role in the relation between "public" man and "private" woman, in order to be entitled to the protection it offers. In numerous works Shirin Neshat demonstrates repeatedly that positive and negative connotations belong together and that only an acceptance of the inherent contradictions enables a true understanding of the subject.

After women were forced in the course of increased urbanisation of Iranian cities in the 19th century to wear the veil—previously and especially in rural regions they participated actively and unveiled in public life—a social change took place in the first half of the 20th century which opened up the possibility for women to emerge from hiding. It was solely due to the Islamic revolution that women were once again forced to conceal their bodies; and in contemporary Iran only very few women have managed to obtain significant positions in public and intellectual spheres. It is obvious that here the Islamic belief is made use of by political forces, since the Koran as such does not determine woman's position in society, but rather the manner in which it is interpreted by the respective political rulers. Neshat illustrates the experience which this recognition is based upon in the work *Women of Allah*, in which Iranian women and mothers are subtly represented; they are depicted carrying guns and their skin and clothes are decorated with Islamic letters. The intellectual power of these verses, the ideal meaning of language, writing, signs and dialogue clashes here with the physical presence of the body, with the surface and violence in the form of weapons. This confrontation is compressed in intricately composed and dramatically intense details. The power of women as a vehicle for cultural values which are projected upon them through the social constraints of dress regulations and codes of conduct becomes apparent here—a power which Islamic women as supporters of the revolution are quite willing to stand up for. In the awareness of her significance for the social code, the woman confronts the man as an authentic counterpart. Her presence is freely chosen and her existence manifests itself in the fulfilment of her role. The man's existence is also a vehicle of cultural values to which he is bound by social obligation and whose fulfilment he cannot eschew. An almost tender closeness is formed between the partners involved in this dialogue, even if the scenario is staged in a dramatic manner. Just as strongly as Shirin Neshat rejects taking a clear stand in her works, questions are raised which testify to the fundamental inseparability of visible and invisible phenomena, conscious and associative notions, surface and substance. MM

JEAN-MICHEL OTHONIEL

born 1964 in Saint-Étienne, lives in Paris

Solo Exhibitions (selection)

1998 *Jean-Michel Othoniel*, PS 1, New York
1997 *Jean-Michel Othoniel*, Peggy Guggenheim Collection, Venice
 Jean-Michel Othoniel, Musée des Arts Décoratifs, Palais du Louvre, Paris
1995 *Le Ballet de l'Innommable, Les Soirées Nomades*, Fondation Cartier pour l'Art
 Contemporain, Paris/Villa Medici, Rome
1994 *Il était beau comme la rencontre fortuite d'un parapluie et d'une machine à coudre sur
 une table de dissection*, Musée d'Art Moderne de la Ville de Paris
1993 *L'Hermaphrodite*, Musée d'Art Moderne de Saint-Étienne

Group Exhibitions (selection)

1998 *Dumbpop*, Jerwood Foundation, London
1997 *Amours*, Fondation Cartier pour l'Art Contemporain, Paris
 Crossing Hawaii, University Museum, Honolulu
 Ici & Maintenant, La Villette, Paris
1996 *Arts dans la ville*, Saint-Étienne
1995 *Fémininmasculin, le sexe de l'art*, Musée National d'Art Moderne
 Centre Georges Pompidou
 Avant-garde Walk a Venezia, Venice
 National Museum of Contemporary Art, Seoul
1994 *Of the Human Condition*, Spiral/Vacoal Art Center, Tokyo
1993 *Hôtel Carlton Palace*, Hôtel Carlton Palace, Cannes
1992 *Documenta IX*, Kassel
 Istanbul Biennial
1991 *Echt Falsch*, Villa Stuck, Munich

Le Grand Collier, 1997, Murano glass, crystal, 350 x 70 x 20 cm, Courtesy Jean-Michel Othoniel
(ill. p. 116)
Le Collier Sein, blown glass, 165 x 45 x 10 cm, Courtesy Jean-Michel Othoniel (ill. pp. 114/115)
Le Collier infini, Murano glass, crystal, 400 x 80 x 20 cm, Courtesy Jean-Michel Othoniel

All the works of the artist Jean-Michel Othoniel, in whatever "materials" they are made of, are distinguished by an extremely tangible quality.

The chains and objects created in Murano glass, which Jean-Michel Othoniel commissions experienced glass blowers in Murano and Hawaii to produce according to his specifications and with his active assistance, sometimes assume gigantic dimensions, yet they always appear delicate and one has the urge to reach out and touch their surfaces. In contrast to the immaculate smoothness of customary glass products Othoniel's glass works do not evoke a sense of coolness and hardness, but rather seem warm, soft, velvety, as if they were in the midst of a permanent process of cooling and solidifying. However, they always appear authentic, powerful and accomplished rather than fragile.

The forms Othoniel's chains are comprised of integrate spheres, hearts, breasts and rings in an irregular manner and evoke a notion of something fluid, succulent and fleshy. These forms are also combined with one another as individual objects—for example in a ring from which a limp condom is suspended.

The productive conveyance of his own ideas and the creative discussion with the craftsmen is a constitutional aspect of Othoniel's artistic concept. The incorporation of the physical and psychological body into the work is decisive for the creative process and the discursive conflict with the craftsmen leads to a synthesis of the artist's ideas with those of the collective. The classical glass blower, on the other hand, always makes an effort to manufacture a product that is as immaculate and artificial as possible, whose perfection may be the basis of a decorative design and creative development. Othoniel, however, very consciously opposes this claim and attempts to let the creative partner participate in his own ideas in as far as the partner can let himself be convinced by the concept and may grant it his approval and absolution, finally enabling the work to become concrete.

This is also how Othoniel proceeded when he made negative impressions of his own body in sulphur from which a cast was made. The unusual manner of dealing with the material revealed to the workers, who beforehand had regarded sulphur only as a raw material with unpleasant characteristics, a new understanding of its qualities and potential.

However, the ideal approach in Jean-Michel Othoniel's works also is always aimed at the participation of the collective and the interactive structure of their creation. Thus in 1997, during the Europride Parade in Paris, he took photographs of roughly 750 people within only a few hours, having previously placed around their necks a chain made of Murano glass. Already the gesture of placing a glass chain around the neck of another person has a touching aspect of affection and intimacy. Putting together a series of photographs of randomly chosen persons establishes a link between all those involved, turning them into a kind of family, whose affiliation corresponds closely with the motto of the parade. Again later, Othoniel encounters the gesture of putting a chain round the neck of a visitor as a sign of welcome, joy and integration in Hawaii; here chains of flowers were placed round his neck on the occasion of an exhibition, indicating his incorporation into the community. Othoniel's latest project A shadow in your window also revolves around the formation of a virtual community, the dialogue between independent partners and individuals. It involves a CD-ROM which Othoniel has generated and with whose aid users can interrelate to and communicate with one another by feeding in their own stories or calling up the contributions of other participants that have been saved in the data bank. One can also react to these entries, refer to them by adding to them, or also by contradicting them; one can also refuse them or even ignore the whole system—in any case, a reaction takes place and an actual community is formed, not merely simulated.

Thus Othoniel's "material" works present themselves as effectively establishing affiliation, fusion, pervasion and integration in which not least the viewer participates by means of his associations. The ideal and material aspects of the work accordingly correlate with the psychological and physical states of all of those involved in the process. MM

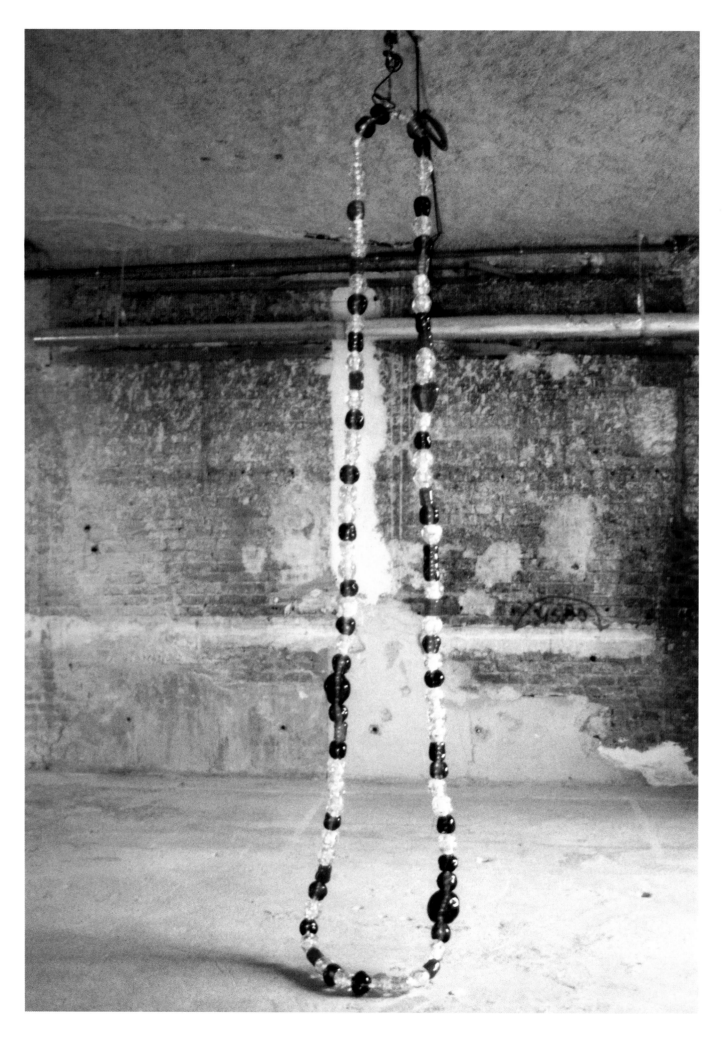

"The practices related to the production and circulation of spiritual power create structures just as much as the production and exchange of material goods. Spiritual power…can be accumulated and invested; it can be used to control other resources and bodies." Will Roscoe, "How To Become a Berdache: Toward A Unified Analysis of Gender Diversity," essay published in *Third Sex, Third Gender: Beyond Sexual Dimorphism in Culture and History*, edited by Gilbert Herdt, Zone Books, New York, 1996.

The androgyne's power and durability is shown by its lengthy and continuous association with mythologies across the world, its present day ubiquity, and its acceptance and utility in the industrialised world. Perhaps no other vision conveys such a complexity of ideas as well as a sense of the unknowable through the faculty of sight alone. Bearing both male and female characteristics, the

TRANSCENDENT FACES, MASKS OF DESIRE: ANDROGYNY AS ARTISTIC DEVICE

Wendy McDaris

androgyne signifies a primordial union of all opposites. It is a visual description of a spiritual ideal, a perfection of the soul, and carries an irresistible physical allure. The ancient origins of the androgyne can be traced to numerous creation myths that frequently describe the birth of humanity as a violent division of the primordial androgyne into two fragments—man and woman; the two sexes have since endured a terrible longing for their former state of spiritual unity and physical completeness. Artists, however, have been restoring male to female and female to male for centuries, thus providing humans with at least a vision of primordial unity, if not a spiritual realisation. Androgynous images have, in fact, proven to be some of the most arresting ever produced and appear to be particularly well suited as the focus for meditation, contemplation, or religious worship. For this reason, androgyny has been closely tied to a number of religious icons. The Buddha and Shiva, for example, are portrayed in characteristically female postures with exquisite gestures of the hands. Depictions of Christ, especially in popular art, portray him as effeminate, nurturing, his delicate features arranged in a demure expression framed by carefully coifed hair. The earliest sculptures of Venus showed her to be hermaphroditic with breasts, a beard, and a penis. Kwanon, Chinese goddess of mercy, bears a visage identifiable neither as male nor female. The viewer's gaze is riveted by these ambivalent figures that simultaneously express strength and sensitivity, power and vulnerability, mortality and eternity, sensuality and innocence, beauty and terror, and most importantly, a transcendence over opposition itself.

As an artistic device, however, the concept of androgyny has not been confined to any one particular aspect of culture including religion. Consider Donatello's *David*, Michelangelo's *Cumaean Sybil*, Caravaggio's *Bacchus*, and, arguably, da Vinci's *Mona Lisa*. Not only do the subjects of these works hold in common the characteristic of androgyny, but the works themselves share a high level of significance within the history of art; thus, they are regarded with a kind of reverence reserved for religious figures, themselves often androgynous in appearance. Andy Warhol's images of Marilyn Monroe comprise a 20th Century analogy to these historical works, expressing ambivalence, mystery, and cultural import through Warhol's signature visual economy. But there is an extraordinary investment of self within all these aforementioned works. Is *David* Donatello's personal object of desire? Is *Mona Lisa* really a man? Is the pale, blonde celebrity of Marilyn Monroe also the pale, blonde celebrity of Andy Warhol? The boundaries that define identity, whether personal, sexual, cultural, or religious, are herein blurred for the viewer. The assumed boundaries that define the identities of the artists who create such works are also obscured.

Such fluid identity on the part of the artist is indicative of a transformative power comparable to that of shaman, sorcerer, prophet, or priest. Indeed, shaman status has long been associated with persons who exhibit androgynous behaviour and dress. Native American berdaches and the hijras of India are examples of this phenomenon. In the late 20th century, practitioners of Glam rock have

demonstrated the mesmerising effect of a mixed-gender image and its utility in the marketplace. Young concert goers were enthralled in the late sixties and seventies by the overtly androgynous personae of David Bowie, Marc Bolan, Mick Ronson, Iggy Pop, Lou Reed, and The New York Dolls. About twenty years before their time, Elvis Presley began a public, albeit comparatively subtle, flirtation with androgyny, first by wearing mascara and later sporting décolleté and bejewelled jump-suits.

Though on the surface the androgyne still enjoys currency and appeal as a theatrical high priest or priestess performing rock 'n' roll rituals to ecstatic masses, contemporary use of the androgynous image has less to do with spiritual matters and more with concerns of the market place. Androgyny markets fashion, personal style, and elevated social status. Calvin Klein and Jil Sander, to name but two of many, have been wildly successful at marketing to the masses by using either models that are androgynous or male and female models that bear striking resemblances to one another in the same advertisement. Marcel Duchamp's Rrose Selavy persona, undertaken in the 1930s, foreshadowed such market strategies in her clothes and hat of the latest fashion and an expression hovering between coy and sly. The image of Rrose Selavy produces a remarkably accurate reflection of the advertising industry today. Within her visage the intangible and the material commingle seductively, cleverly marrying spiritual longing to material consumption.

The relationship between longing and consuming is intensified within the image of one of the most complex androgynous figures in recent pop history. Jeff Koons's *Michael Jackson and Bubbles* elucidates the potential to fulfil exotic, even surreal, desires through the current marketplace. Produced in the tradition of fine European porcelain figurines, Koons's portrait mirrors the infinite dissatisfaction of late 20th century humanity. Herein Michael Jackson receives the flawless porcelain skin he has long sought. His hand curves delicately around a smiling chimpanzee, a procured companion and non-judgmental human substitute. The two of them are posed in resplendent gold and white, nearly a Madonna and her child. The perfection of their figures belies Jackson's fairy tale existence that proved in reality to be as easily dismantled by the tabloids as a porcelain figurine is to shatter by a careless gesture. This shimmering portrait foretells a terrible and wondrous myth of the future where the fulfilment of any physical transformation is nearly a foregone conclusion, and bliss is sustainable without the experience of suffering for it. *Michael Jackson and Bubbles* describes popular culture as the stuff of history, and today's grotesquerie as tomorrow's myth. The image hangs between genuine innocence and gross sentimentality, between encouragement to reconcile physical inconsistency with interior identity and admonition about the cost of such a reconciliation.

Artist Vanessa Beecroft recently documented the price of maintaining the current standards of androgynous allure in her recent performance piece entitled *Show*. Such standards are based in part on the ability to erase overt signs of gender and quell typical human behaviour. Beecroft stated in an accompanying brochure that the goal of *Show* was "to create an image of liberty with no limits given in the representation of a group of women posed at attention." This "image of liberty" was as ambivalent as the genderless, naked and near-naked fashion models whose wispy physical conditions made them indistinguishable from one another. Beauty and pain became interchangeable terms as the models stood for two and a half hours in stiletto heels, some naked, some in $2,000-plus Gucci rhinestone bikinis, all were instructed not to have eye contact with or speak to the viewers. Their feet ached, they had trouble balancing, a few were eventually forced to sit on the floor for relief. Tension grew in the gallery space as viewers' expectations of beauty went unfulfilled. Beecroft's *Show* revealed the current obsession with fashion as a cult of the androgynous image. Fashion, the essence of which involves suffering, is now the most prevalent secular manifestation of the state of androgyny. Linked as it is to financial and social status, fashion is a shroud that whispers the name of the true idol, purchasing power. Fashion is about the kind of liberty that can be bought and then discarded and replaced with what's desirable next season in an unrelenting cycle; it tantalises with the possibility of masking one's own identity; it discloses financial status while it falsely implies possession of a power associated for thousands of years with spirituality.

Beecroft's androgynous models take on a uniformity of appearance somewhat reminiscent of the popular image of the extraterrestrial that gives them all the same large insect eyes, smooth white

skin, ovoid heads, and no trace of genitalia. Typically, aliens have been portrayed in Hollywood science fiction movies as malevolent. Marilyn Manson, a noteworthy shock rock androgyne, echoes this ill will in his latest persona that features a smooth, white, and relatively minimal appearance that owes something to the image of the alien from outer space. But Manson's alien has been customised with breasts and a head full of gothic hair and makeup. His new image is a transitional one that combines elements of the past and future in a clever marketing scheme. He drops the veil of allure for what always bubbles below the androgyne's skin—a monstrous, violent state of transition. Ardently adored by some and thoroughly reviled by others, Manson manages to maintain a following through Bowiesque re-inventions of himself, the result of which looks suspiciously like planned obsolescence.

The opposing view of aliens as kindly, curious, playful androgynes is also widely held, especially among the tabloid press and people who claim to have actually seen them. Cameron Jamie, an artist whose video-documented performance pieces feature himself and an opponent wrestling in a variety of residences from European castles to Los Angeles apartments, positions his own alien persona within this more benign interpretation. In an interview in the February 1999 edition of the British magazine *Dazed and Confused,* Jamie described his "apartment wrestling" persona as "something I don't quite understand yet. It is like this other personality that I take on, who doesn't have an identity or a name, who is genderless. A being that doesn't belong anywhere, he's basically an alien." Jamie's persona allows him to become a hero or a joker, to wrestle a Michael Jackson impersonator or take on a young, attractive woman with equal vigour. These matches resonate with sexual and cultural implications while Jamie's identity as an artist and as a man hides behind a leering, mysterious, slightly repugnant mask and a continuous suit of long underwear that reveals practically nothing about his physical individuality. Neither he nor his opponents appear to definitively win the matches. Instead, the endings to these contests have a conciliatory ring to them as when a young woman removes Jamie's mask after wrestling him to the floor, lights a cigarette, and prattles on in a lazy, intimate manner as if she and the mask have just finished making love. Meanwhile, Jamie himself seems to have vanished from view like a creature from outer space. He has left behind a strangely peaceful moment produced not only from physical exhaustion but also from the diffusion of a violent episode through his own distant sense of humour.

Interestingly, evidence of humour and related emotions is found in many androgynous subjects in art. A smiling androgyne evokes or describes a range of feelings from oddly pleasant to overwhelmingly ecstatic. Typical depictions of the Buddha, for example, give him an expression that could be described as blissful, peaceful, or impenetrable. Mona Lisa's sphinx-like quality is attributable in part to her smile. Marilyn Monroe baffled her public with her dazzling smile coupled with sorrowful eyes that belied her psychological androgyny a result perhaps of having been sexually molested as a child; that smile can become a snarl or a desperate plea for help in Andy Warhol's meditative appropriations of her image from Hollywood promotional photographs. Her ambivalent smile may be a contributing factor in the prevalent use of her overall image as the current embodiment of drag for many in the gay community. The aforementioned smiles, and there are many of similar cast in art history, exposed the essence and effect of unity for which androgyny is an illustration. In Sally Potter's film *Orlando,* based on the novel by Virginia Woolf, actress Tilda Swinton gives an astonishing performance in the title role in which she manages to use her smile appropriately to secure her impression of maleness or femaleness. Over a span of several hundred years, the character Orlando changes his/her sexual identity from that of a man to that of a woman. At the end of the film, Orlando has become the epitome of contemporary woman, self-sufficient, rearing a child alone, described by the narrator as slightly androgynous. She has transcended cultural labels and categories that accompany the fact of being born either male or female. In the final moments, an angel, a mythic creature historically characterised as genderless, appears in the sky over Orlando and sings in a hypnotic, falsetto voice. The lyrics of the song address the eternal themes of spiritual and physical completion while also making mention of earth and outer space as places where the androgyne dwells.

These lyrics, written by Jimmy Somerville and David Milton, provide a bridge that connects ancient and futuristic interpretations of the androgyne while disregarding its darker utility as an image.

Today the androgynous image is systematically demonised and sensationalised in the name of profit. Strategies and schemes now cloud the androgyne's countenance and it is increasingly difficult to discern which of its images is derived from a marketing ploy rather than from a challenge to critique social roles. What was once a relatively innocent masquerade for Elvis Presley comes off as epic greed in Marilyn Manson. Vanessa Beecroft's models are more like possessed zombies than paragons of beauty. Michael Jackson appears first as the most successful androgyne in the celebrity kingdom; later, he is assailed as a tormented pederast. As they lend their power to commercial and coercive efforts in contemporary culture, these figures show themselves to be artificial rather than natural constructions; they are manifestations of cultural distress and symbolise a collective outcry for spiritual renewal.

One can imagine, then, that the image of the alien from outer space constitutes a vision of the androgyne as healer and saviour, a next step towards removing the contorted mask that the androgyne has been forced to wear in the late 20th century. The uses of androgyny that span the gamut from longing to consuming and from the spiritual to the physical culminate in this sublime creature. The alien image maintains the androgyne's original meaning and its fundamentally unchangeable nature—that of radical transformation, transcendence over earthly concerns, and the condition of spiritual unity. Visual art is ideally suited to express the significance of androgyny, and therefore the alien, since art and art making can be seen as an analogy to androgyny. For instance, the creation of visual art is spiritually motivated, the artist is transformed in the process of making it, and it can produce a meditative state through the viewing of it. It is significant that evocations of aliens are widespread within the visual arts at this time. Some notable examples are Mariko Mori's childlike renditions of space hostesses and Eastern goddesses, Tony Oursler's projections of a disembodied and tightly veiled, hairless head, and Kirsten Geisler's computer animated shaved head whose expressions and perfection mimic artistic depictions of the Buddha. At the end of this millennium, the alien's image is so far one of hope. Because it is a new version, the alien image eschews cultural obfuscations, suggests a resolution of conflict, radiates the long-enduring spiritual purity of the ancient androgyne, and underscores its potency as a symbol. It signifies the restorative powers of meditation and thus, subsumes doing to being. Its appearance in art suggests a return to the natural evolutionary process that brings together the unifying elements of androgyny itself.

Madonna – Bustier worn in "Desperately Seeking Susan", 1985, autographed on the strap, mixed media, Courtesy Hard Rock Cafe International, © Hard Rock Cafe International (p. 122)

Michael Jackson – Stage Glove with "Western Costume Co., Hollywood«, woven label printed with "Michael Jackson", thought to be worn by him at 1984 Grammy Award Ceremonies, 1984, rhine-stone, Courtesy Copenhagen Hard Rock Cafe, © Hard Rock Cafe International and Christie's Images Ltd. 1999 (p. 123)

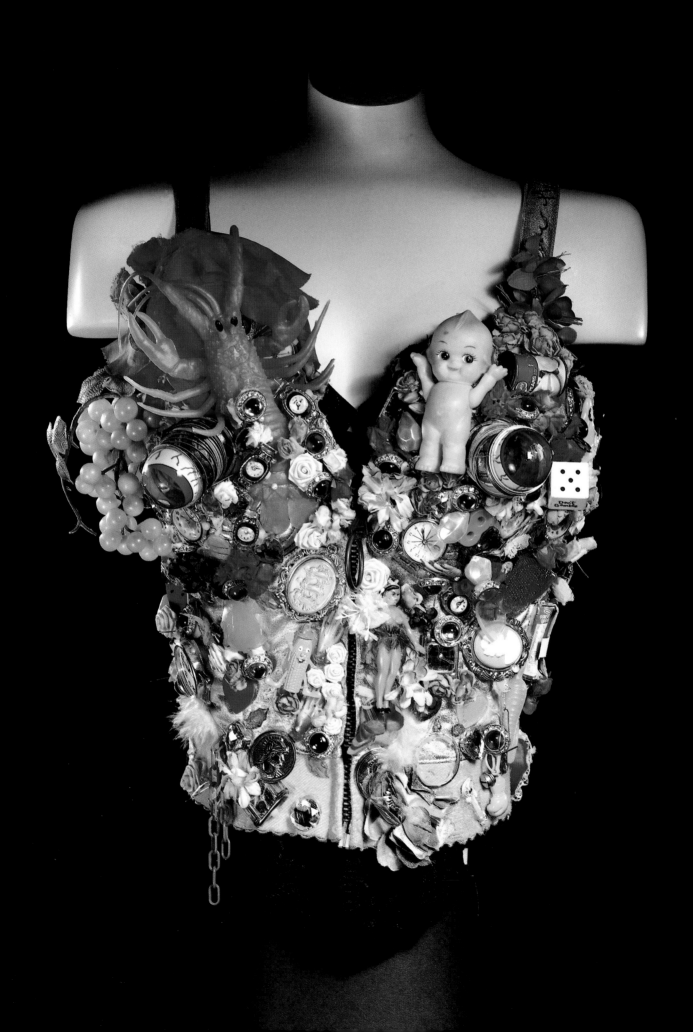

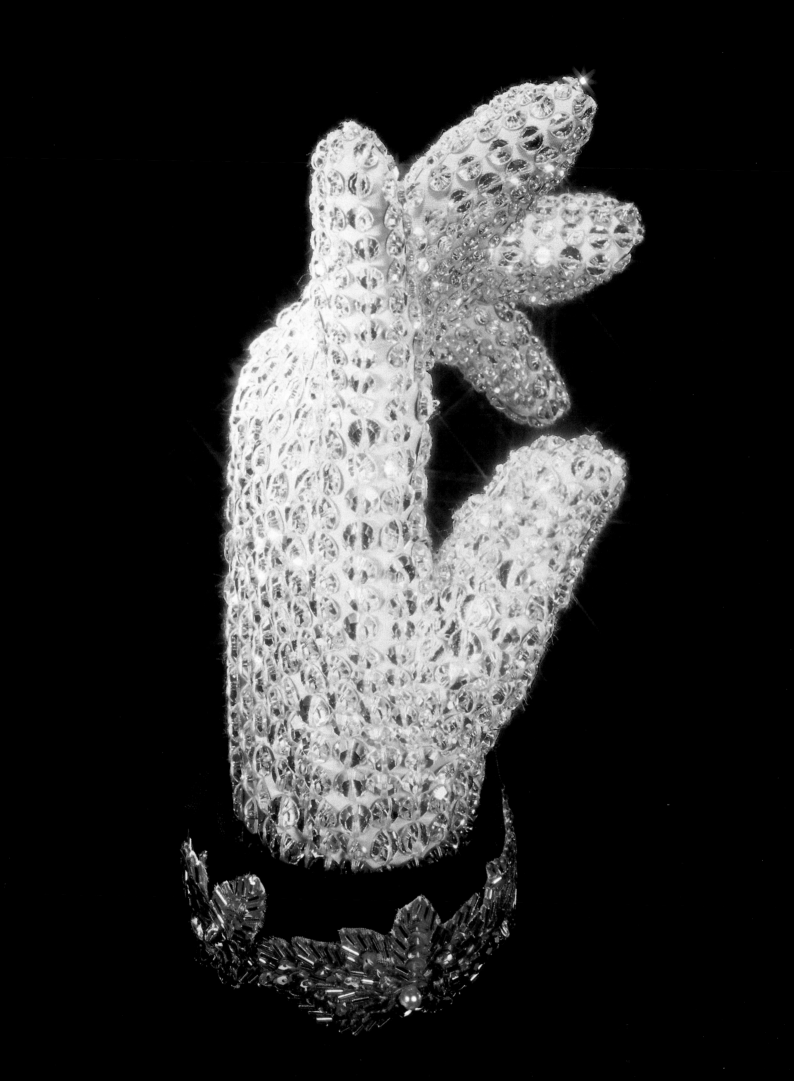

From the start, "rock" has always been more than just a particular brand of music. Not only have the major groups of rock history given the world haunting tunes and exciting rhythms, but a whole realm of attitudes, styles, values, images, opinions and desires has formed around rock music, of which the stars are an incarnation, touching on the different layers of human existence: awareness, emotions, reason, but also the unconscious, the visceral—the faculties of the instinct and intuition. Thus, the fascination of rock music is also extremely ambivalent.

From time immemorial the human imagination has created mythical worlds inhabited by gods and heroes. The life impulses and the death instinct, lust and fear, transitoriness, the desire for love and its powerlessness—all the great challenges of life have been staged in mythological narratives. The

ROCK, MYTH AND MYSTICISM

Jan Koenot

myths have never had the power to resolve the questions of life itself. But they have presented human beings with a mirror image of their communities and their history, in which every individual could recognise his life and times. Transposing human destiny to a world of gods and heroes, the myths afforded a liberating detachment from "real life". They have always pointed to a different, more free and complete, but unfathomable, reality and have related our familiar world to a mysterious unknown.

Apart from biblical themes, the renowned painters of the Renaissance and the Baroque period have all depicted mythological subject matter. For centuries Ovid's *Metamorphoses*, relating the adventures of the Greek gods and heroes, were an important source of inspiration. The strong links to ancient mythology endured well into the nineteenth century, while the symbolists employed motifs from medieval legends as well. However, only in this century has there been a major shift away from mythological content. Certainly some artists even today draw upon the old myths, but the self-projection of our society by way of TV and other mass media has created new, much more influential myths that distinguish themselves from the old myths in so far as the distancing process no longer functions in the same way. The mythological figures belonged to another world—the divine—and to another time—the past. Today's gods and heroes, however, live in our own world and time. They are athletes, politicians, actors and actresses and other public figures, whose life-stories are exposed to an imaginary magnification process by the media and become part of the contemporary collective unconscious. Examples of this phenomenon are Marilyn Monroe, John F. Kennedy, Michael Schumacher and Lady Di.

Possibly rock culture has created the most coherent and profound contemporary mythology. At least between 1954 and 1976, the history of rock music took an almost paradigmatic course (after the era of innocence with rock 'n' roll in the fifties an idealistic counterculture began to develop in the sixties, followed by the anarchistic revolution of the punk movement in the seventies). Every stage of this history has produced its own heroes (Elvis Presley, Bob Dylan, The Beatles and The Rolling Stones, The Sex Pistols...), with which the young heroes of the nineties seek to identify. The hopes and desires, personified by the divine beings in the past, are now projected into the personal destinies of the rock stars, whose experiences are brought to us by the rock magazines on a weekly basis, until they receive their final legendary impetus in the form of literary biographies and films. Journalists, photographers and TV-moderators create an image around the actual personality of the musician that connects to ancient mythological motifs such as invincibility (Oasis) or androgyny (Placebo).

At the core of rock mythology lies the victim. One expects rock stars to sacrifice their energies entirely to their music and their audience. They are worshipped like gods because music of an almost superhuman quality flows from their fingertips. Indeed, it is not their authentic personality that is an object of worship but the superhuman image that the audience has created of the stars, in which all wishful dreams are perceived to be fulfilled. If a star or a rock group should lay claim to their humanity and cease to correspond to the mythical ideal worthy of worship, this tends to pro-

voke derision and renunciation—as if the star or the group had committed a betrayal (one current example are the reactions that the development of the Manic Street Preachers has lately triggered). I have always found it somewhat surprising the extent to which disappointed fans mercilessly criticise their former idols. Rock stars are the object of positive and negative aggressive affects. In addition, some singers believe that they have to push the myth of *sex, drugs and rock "n" roll* to the limit, in order to earn their status as a "star". If they prove unable to maintain the distance between reality and myth, they can easily become entangled in the spiral of self-destruction. Many singers have fallen victim to the myth of the rock star—be it that they were murdered by a fan (John Lennon), committed suicide (Ian Curtis and Kurt Cobain), died as a result of excessive drug and alcohol consumption (Jim Morrison, Jimi Hendrix...) or suddenly disappeared without leaving a trace (Richey Edwards). Not long ago, Courtney Love, who was married to the front man of the group Nirvana and is lead singer of her own group Hole, admitted: "It isn't necessary to die in order to be a rock star, but that's something I only realised recently."[1] Singers such as Sting or Bono (U2) have been aware of the fatal effects of the "martyr-mechanism" for a long time. Successful groups of the nineties like, for example, Radiohead and Supergrass prefer to stay away from the seductions of the "star system" altogether. But exactly because of their aloofness towards the media circus certain journalists present them as limited, uninteresting characters, who have no right to partake in the pantheon of rock mythology.

According to the French researcher René Girard the "martyr-mechanism" is based on the notion of the sacred. In primeval times the first human sacrifice freed society from the chaotic violence inflicted by everyone against everybody and brought about a state of peace. This is the reason why the "scapegoat" was later worshipped and his sacrifice repeated in a number of rites. Religions, myths and the arts developed from the ritual of sacrifice. There are a number of things one might mention in regard to the "martyr-mechanism" that today functions perfectly once more in rock culture. In a way, the rock stars are "scapegoats", surrounded by a sacred aura, for which they must pay dearly. Accordingly, rock concerts are carried out like rituals (taking place in regular intervals, at specific sites, with the appropriate clothing, making use of a specific stock of gestures, and the groups acting as "priests" on stage). In the end, the principle of sacrifice defines rock culture and generates the mystery of its enormous fascination, as Claude Chastagner claims in his book *La loi du rock*.[2]

However, I would hesitate to go that far because in rock culture one does not merely find a revival of archaic instincts that are still dormant in the personal and collective unconscious, revealing themselves in an ambivalent, rapturous, dionysian mixture of (often disguised) violence and features of the sacred. Both the musicians and the audience often compare the experience of music with religion. Not unjustly so, since in rock music, like in every form of religion, one finds aspects of the absolute and of healing. Whether sitting alone in one's room or gathering with a few hundred or a few thousand fans in a concert hall, this music always has the wonderful power of liberating a person from his loneliness and insignificance. Music extends boundaries, eases tension, drives away confusion, increases the enjoyment of life and conquers the fear of death.

If one defines religion as a union with a higher and greater entity, then, in a way, one could refer to the intense experience of rock music as a religious encounter. One should not forget, however, that there are various ways to handle rock music. Often, it merely serves as soothing background music or as a trend-controlled consumer article. Only for a minority, it is an aide for dealing with existential questions of life. If rock music arouses a feeling of merging with higher forces and the community of other human beings, then it has a similar effect as certain religious rites. If, in perceiving music, the focus lies less on the rich imagery of rock mythology than on the non-verbal language of music itself, it is even possible to experience transcendence. Rock mythology is always a reflection of one's own human world. The music, though, shatters the images and words of this world and sweeps us along into the intangible, the unknown.

This is particularly apparent in the work of sound magicians such as Sonic Youth or Mogwai. Here, all familiar forms are jumbled together in a clash of extremely vital, sharp and contrasting sounds like uncanny, almost unbearable noise, until out of the ashes of the finally surmounted old world an

unprecedented, melodic and glistening new reality arises. Since in rock culture the musical experience is always mediated through the relationship to a singer or a group, a personal and human dimension is maintained. I should like to point out that exactly this dimension threatens to disappear in today's techno-culture. Here, the relationship to the name, voice and history of a singer or a group, as well as to the literal content of a song, becomes obsolete. Here, the audience's objective is rather to become immersed in the waves of anonymous, electronic rhythms, in which every personal aspect—individual faces or stories—is neutralised. This is why, in my opinion, there is a gulf between rock and techno one must keep an eye on, now, at a time when traditional rock culture still continues, but techno-culture is spreading enormously among young people.

Electronic rhythms and personal awareness, however, must not exclude one another. One pertinent example for this is the Asian Dub Foundation, an Indian-British group that seasons a mixture of rap, drum 'n' bass and rock with elements of traditional Indian music. The Asian Dub Foundation seeks to combine the joyfulness of today's dance culture with socio-critical commitment. They strive to turn every appearance on stage into a "conscious party", at which the partying, dancing crowd becomes aware of the challenges involved in today's necessity of forming a multi-cultural society. Because this is exactly where the power of music lies, as the song "Dub Mentality" expresses[3]:

"Listen to the sound of the drum and the bass / Different communities meet up in the same place / We are mixing the flavour to suit every taste / This music has the power for all the human race."

In a way, this notion runs all the way through rock culture. While politics, economics and religion divide humanity and lead to discrimination, exploitation, abuse of power and finally to wars, only music might be able to reunite human beings—because music does not effect us on a rational level, on which economic considerations and philosophical or ideological legitimations are constructed, but rather on the level of our deepest emotions, on which we have not yet acquired the ability of speech or forget all our arduously acquired languages again and are all equally vulnerable and mortal, seeking salvation and love.

In Western culture, rationality and effectivity have successively dissolved. The critical mind has unmasked the old theological and metaphysical world views as a mistake, delusion or superfluous hypothesis. The sciences are now in a position to explain how all living beings function, in order to present solutions for social, psychological and other human issues. However, science has no answer to the ultimate questions. Why is life often so painful? Why do we let ourselves become entangled time and time again in our desires? Why is love so complicated? As critical rationalism has discredited the traditional religious treatment of these questions, today, in the face of our own inescapable existence, we are left with only the naked emotions. Romain Rolland, a rationalist, who distanced himself from Christianity, defended his experience of a religious dimension in his correspondence with Freud. He called it an "oceanic emotion" that he described as a simple and direct sense of the eternal.[4]

It appears to me that this is an attitude that today is very much prevalent: a combination of rational agnosticism or atheism and an emotional, almost mystical religiousness. For some contemporaries, rock music is the scene where this kind of religiousness takes place. Thus, Jason Pierce, the singer and guitarist of a group, not coincidentally called Spiritualized, claims that he is not bound to any religious faith and confronts issues of life on the basis of empirical results. The music he produces with Spiritualized, however, is often described as "sacred". A number of songs are composed like prayers, in which consolation and recovery are sought. Spiritualized performed with gospel singers various times,[5] which inspired a critic to use the formula "gospel for atheists"[6]—an appropriate characterisation for music that expresses devotion to a higher unknown and in which a sense of the very source of reality, based on love, is revealed—on a deeper level, on which an illumination or denial of this "religious" experience is not, or no longer, questioned.

In this context, Bob Dylan may also serve as an interesting example. Dylan, who in the course of his life became involved with the Jewish and Christian traditions and even temporarily belonged to a Christian sect, never gave up his belief in an "invisible Being", but today—at least in public—does not wish to specify his religious convictions more precisely. In contrast, he directly claims of his music: "That's my religion." The singer believes in the truth of his songs (otherwise he would not

find the energy to sing them night after night), and he believes in the effective power of the concert, on the occasion of which he forgets everything else and devotes himself to performing with the musicians in his band in front of an audience. Bob Dylan wrote the wonderful song "Blind Willie McTell".[7] In this song a disintegrated, bleak world is described, in which God has to stand by and watch humanity driven solely by the lust for power, greed and sin. Only one bright spot remains: the incomparable blues of blind Willie McTell.

NOTES

1 *Les Inrocktubiles,* No. 164, September 9, 1998. On her latest CD, *Celebrity Skin,* Courtney Love sings: "It's better to rise than to fade away." This is a meaningful reply to the famous comment by Neil Young, "It's better to burn out than to fade away", cited by Kurt Cobain in the farewell note he wrote before committing suicide.
2 Cf. Claude Chastagner, *La loi du rock,* Editions Climats, Castelnau-e-Lez, 1998.
3 CD R.A.F.I., 1998.
4 Cf. Michel Hulin, *La mystique sauvage,* Presses Universitaires de France, Paris, 1993, pp. 24–25.
5 The "historical" concert of the group on October 10, 1997, in the Royal Albert Hall in London has just appeared on a live CD. I specifically referred to Spiritualized in my book *Hungry For Heaven, Rockmusik, Kultur und Religion,* Patmos Verlag, Düsseldorf, 1997, pp. 207–209 et al.
6 Cf. John Mulvey, in *New Musical Express,* June 28, 1997.
7 This song is included on the third CD in the *Bootleg Series* 1961–1991 (1991). Greil Marcus dedicated an essay to this song ("Dylan as Historian. On 'Blind Willie McTell'", in The Dustbin of History, Harvard University Press, Cambridge, Massachusetts, 1995).

GIL SHACHAR

born 1965 in Tel Aviv, lives in Worpswede/Bremen

Solo Exhibitions (selection)

1999 Forum für zeitgenössische Kunst, Worpswede
 Von-der-Heydt-Museum, Wuppertal
1998 Wilhelm Lehmbruck Museum, Europäisches Zentrum moderner Skulptur, Duisburg
 Galerie Löhrl, Mönchengladbach
1996 The Artist's Studio Gallery, Tel Aviv
1992 Artist's House, Jerusalem

Group Exhibitions (selection)

1996/97 *Desert Cliché*, Arad Museum, Arad
1994 *Separate Worlds*, Tel Aviv Museum of Art
1993 *In the House, in the Courtyard*, Israel Museum, Jerusalem
1992 *Skulptur der Gegenwart*, Tel Aviv Museum of Art

Untitled, 1998, synthetic resin, wax, industrial paint, pigment, 50 x 40 x 15 cm,
Courtesy Gil Shachar (ill. p. 131)
Untitled, 1999, synthetic resin, wax, industrial paint, pigment, 48 x 40 x 14 cm,
Courtesy Gil Shachar (ill. p. 130)
Untitled, 1999, synthetic resin, wax, industrial paint, pigment, 55 x 40 x 15 cm,
Courtesy Gil Shachar (ill. p. 132)
Untitled, 1999, synthetic resin, wax, industrial paint, pigment, 50 x 40 x 30 cm,
Courtesy Gil Shachar (ill. p. 133)
Untitled, 1999, synthetic resin, wax, industrial paint, pigment, 50 x 40 x 30 cm,
Courtesy Gil Shachar

There is a great discrepancy inherent in the works of Gil Shachar. In a general sense, when looking at works of art, the viewer has the possibility to either appreciate the work or to avert his/her gaze, while the object itself is always there, destined to be seen or ignored, being devoid of any prerogative of choice. In Shachar's work this process is reversed. Here the choice lies on the side of the art objects and they systematically avoid making eye contact with the viewer. The usual rules of the game are invalidated.

In many of Shachar's wax portraits the eyes are closed or the face is covered. Objects are concealed, wrapped and enshrouded. In some cases the work represents veils held by hands coming out of the wall. Shachar's objects refuse to reveal themselves, evading the establishment of an interrelationship with the viewer who might provide the key to their meaning. They avoid the illusory statute involving the viewer's gaze of recognition and the submission of the exhibited object. The relation between beholder and phenomenon is disturbed. Shachar's works deny themselves to the public to the extent that the overall theme becomes blindness. The discrepancy between the tendency of the work to ignore its viewers and the wealth of realistic details it offers creates a rift, where things taken for granted must be reconsidered.

In this process the images take on new implications. They cease to be realistic simulacra of the initial person or object they represent, but are realised as metaphors for death. The "self-induced" blindness testifies to the fact that in order for these art works to exist, a prior process which imitates death has to take place. What dies is the source, the original model from which the art work was cast.

Gil Shachar's works revolve around two notions. On the one hand, they deal with the difference between copy and simulation; after the pseudo-death of the original has taken place and the copy no longer has a reference, it becomes a simulation which stands for a rebirth of the primal source. This leads to the second notion, namely, that of the "New" and its role as the decisive creative impulse in the history of art. Shachar negates this supposed power of the "New", regarding it as an illusory condition. The last thing he is interested in is to participate in a futile attempt to create it, for the "New" has a tendency to dispose of its creators at the very moment in which it is granted its formulation. Therefore, representing objects and persons which already exist as realistically as possible is less an affirmation of than a protest against a tendency he discards as a manifestation of hybris.

In keeping their eyes closed, the images of Shachar are sustained in a state of hibernation reminiscent of the Fayum sarcophagi, where the deceased "live" through their semblances with eyes wide open, yet pointing towards the death of those that they represent. The death-like state opens up a space of contemplation which permits the viewer to catch a glimpse of the existence of this other sphere, arousing the desire to transcend its boundary. DLH

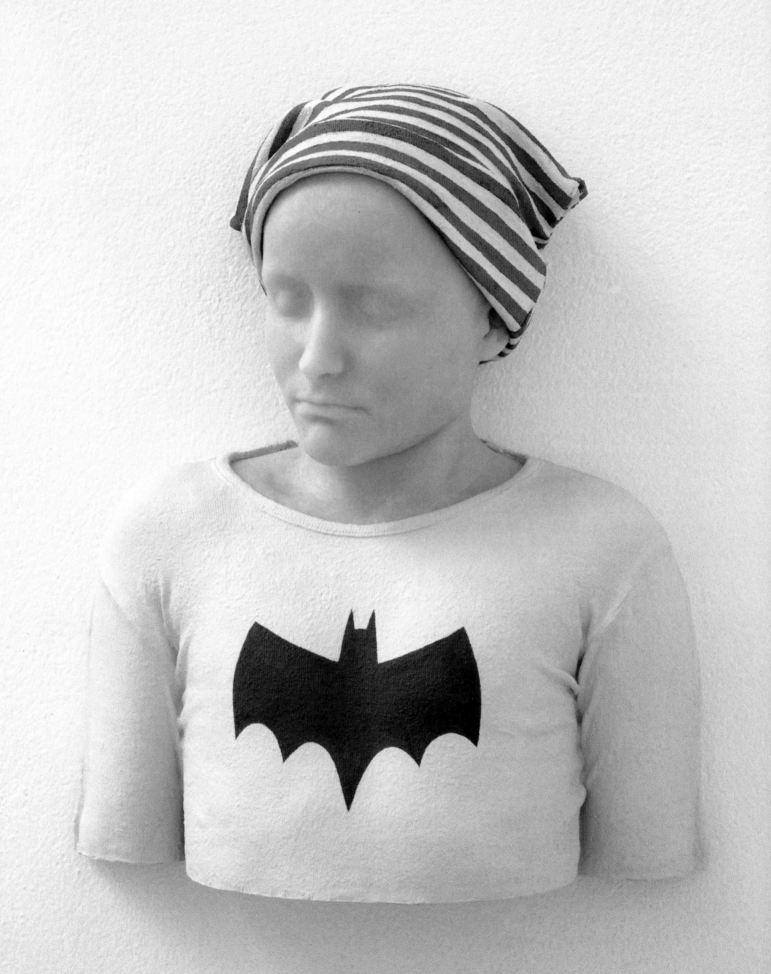

JEFFREY VALLANCE

born 1955 in Torrance, California, lives in Las Vegas

Solo Exhibitions (selection)

1998 *Jeffrey Vallance/Drawings*, y1!, Stockholm
1995 *The World of Jeffrey Vallance*, Santa Monica Museum of Art, Santa Monica
1994 *The Nixon Museum*, Praz-Delavallade Gallery, Paris
1993 *Three's a Shroud*, Rosamund Felsen Gallery, Los Angeles
1992 Museo Del Centro Internazionale Di Sindonologia, Turin
1991 *Jeffrey Vallance Presents The Richard Nixon Museum*, Rosamund Felsen Gallery,
 Los Angeles/Marc Jancou Gallery, Zurich
1989 *A Journey to Extremes*, Venice Art Walk, Venice

Group Exhibitions (selection)

1998 *Deluxe: Who and What's HOT in Las Vegas*, SITE, Las Vegas
1997 *At the Threshold of the Visible*, Herbert F. Johnson Museum of Art/Cornell University,
 Ithaca, NY
 Anomalies, Contemporary Art Collective, Las Vegas
1996 *Popocultural*, South London Gallery, London
1995 *Elvis + Marilyn: 2x Immortal*, ICA, Boston/Contemporary Arts Museum,
 Houston/The Cleveland Museum of Art e.a.
1994 *Facts and Figures*, Lannan Foundation, Los Angeles

Elvis Sweatclothe I, 1993, satin, 55.8 x 55.8 cm, Courtesy Jeffrey Vallance and Rosamund Felsen
Gallery, Santa Monica (ill. p. 136)
Elvis Sweatclothe II, 1993, satin, 55.8 x 55.8 cm, Courtesy Jeffrey Vallance and Rosamund Felsen
Gallery, Santa Monica (ill. p. 137)
Elvis Sweatclothe III, 1993, satin, 55.8 x 55.8 cm, Courtesy Jeffrey Vallance and Rosamund Felsen
Gallery, Santa Monica (ill. p. 137)

Jeffrey Vallance lives in California, where history loses its linear character and a synchronisation of events—whether having taken place in the far past or still suspended in the future—seems to apply, letting incidents appear as if juxtaposed to one another, transcending the barriers of time. This may imply that either the Europeanisation of America never really took place or at least never reached the Western coast. Dave Hickey, a true missionary of an unhistorical America, describes Vallance in relation to the mythical detective-figure Phillip Marlowe, who adheres to tracing the outlines and investigating the surface of a mystery rather than revealing its secret. Adopting the same strategy, Vallance is most at ease when he compares relics rooted in the Christian tradition with similar phenomena he finds in the more secular domains of life, doing so with an ironical stance that conceals a serious approach towards practising art in a country where the space for all kinds of fantasies is provided, but where a respectable historical tradition is lacking, at least from a European point of view.

The three satin scarves with sweat stains presented in the exhibition refer to the scarves Elvis Presley distributed to fans during his concerts. Presley owned an abundance of these scarves and it is rather doubtful that he was sweating enough to supply all of them with sufficient moisture, but it was a ritual of such importance that it was always part of the agenda. It goes without saying that Elvis played a quasi-religious role and that he was an *ersatz*, i.e., a replacement for a figure of salvation. Presley's sweat-stained scarves, Veronica's veil and the Shroud of Turin have much in common. They are all relics with physical traces of a revered God or idol. Vallance meticulously seeks these similarities in his writing and his art. The veil was said to belong to a woman named Seraphina, who wiped the sweat off of Jesus' face on His way to the cross. According to another legend, a woman named Veronica bade Jesus to give her an image of his face, whereupon he obliged and pressed His face to the linen cloth—some claim to her cloak. Veronica's veil supposedly bears the true image of Jesus, as the one on the Shroud of Turin in which the suffering face of Christ, who was allegedly wrapped in the shroud when lowered from the cross, is imprinted.

In regard to Elvis Presley the "true" relic is not the real scarf but the one Vallance made, for it is the virtuality of the Christian relics that lend them their authentic aura. In the same manner in which the original cloth of Veronica was imitated numerous times by artists authorised to reproduce it and was than labelled as the miraculous original, the work of Vallance obtains its authoritative power by transforming the original Elvis-scarf into an object of art worthy of imitation. The real relic is replaced by its fake replica so that its value will be sustained.

It has been written that Elvis died on the toilet while reading a book about the shroud of Turin. This story has the same fascination as the stories surrounding both Turin and the veil of Veronica, for it turns the narrative into a relic without a physical substance, thus coming full circle due to a wealth of associations which will make the Christian devotee of Elvis Presley a happier person. DLH

Vallance 1993

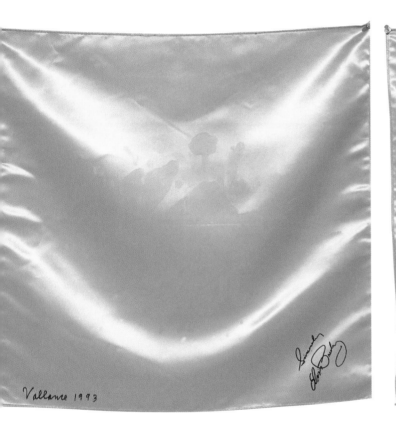
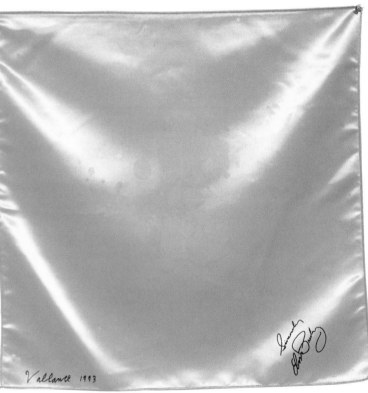

JESSICA DIAMOND

born 1957 in New York, lives in New York

Solo Exhibitions (selection)

1999 Ota Fine Arts, Tokyo
1997 *Tributes to Kusama*, Le Consortium, Dijon
1996 *Tributes to Kusama*, Deitch Projects, New York
1994 Ynglingagatan 1, Stockholm
1991 Jablonka Gallery, Cologne

Group Exhibitions (selection)

1998 *De beurs van Judocus Vijdt, Kunstkapital in Gent*, Bijlokemuseum, Gent
1997 *Heart, Mind, Body, Soul: American Art in the 1990s, Selections from the Permanent Collection*, Whitney Museum of American Art, New York
1997 *Partito Preso Internazionale*, Galleria Nazionale d'Arte Moderna, Rome
1995 *Am Rande der Malerei*, Kunsthalle Bern
1994 *The Century of The Multiple, From Duchamp To The Present*, Deichtorhallen Hamburg
1994 *Wall to Wall*, Serpentine Gallery, London
1993 *Vierkant*, Museum van Hedendaagse Kunst, Gent
 Aperto, Biennale di Venezia, Venice
1991 *Whitney Biennial*, Whitney Museum of American Art, New York

Elvis Alive, 1989/90, gilded bronze, 6.35 x 16/17.27 x 3.5 cm, Courtesy Jessica Diamond, © Kevin Noble (ill. p. 140)

Embossing the words "Elvis Alive '94" on a gold bar may have various implications. For one, it could imply that Elvis, in having gained currency as a commodity, is more alive today than he was when still actually alive. It could also imply that Elvis as an "eternal" phenomenon parallels the permanent quality of gold, both being "lasting" values; or it might imply that images live through their ability to "sell"; or that possibly Jessica Diamond is presenting the negation of all of these notions, because what seems to be a gold bar is in fact a bronze object imitating gold—the artificiality of the bar thus being synonymous to the fake quality of Elvis, insofar as his image has been manipulated and exploited as a consumer product since his death.

In her works Diamond focuses on various symbols for money. She has produced murals depicting barbed wire in the shape of a dollar—suggesting the notion that society is a prisoner of the cash system—and has devised slogans referring to Wall Street "ethics" and power strategies. In *Elvis Alive* she contrasts the credo printed on a dollar bill with the actual significance of money. The dollar bears the words "In God we trust" as a lip-service mantra to a set of values missing in the system the dollar represents. The phrase "Elvis Alive" negates the death of the rock star and at the same time sustains him as a form of currency.

But the gold bar indicates more than merely a critique of the relation between the icon and its incorporation into the economy. Together with Marilyn Monroe, both personalities have become multi-million dollar enterprises and as such are manipulated within the capitalist system. Their iconic power thrives through the fact that their image is multiplied by their being placed on more or less banal objects and gadgets as well as by their being omnipresent in the media. But capitalism alone does not explain their status. Why is it that so many years after his death, the image of Presley attracts millions of people? What exactly is it that this image mediates and channels? Might it be that, contrary to the above-mentioned notion, it is not used by the system but indeed represents the system as its ideological envoy?

It goes without saying that Elvis Presley embodies the "American Dream". Leaving his body and entering the world of the media, he becomes part of a mythological sphere where all dreams and desires may find virtual fulfilment.

His death functions as a mechanism that keeps him alive, lending him an immortality independent of human existence. As a fantasy figure he lives forever in the ethereal, virtual space mediating between ideal and actual states. His gaining a currency value may be viewed as a sacrifice for becoming immortal, not as the essence of his being. Elvis might be understood as a cultural rather than a monetary currency.

It is impossible to specify whether Elvis is "alive" because he is such a marvellous product or whether he is a marvellous incorporation of all that is American, but it is clear that he is a sign, moreover, a core symbol within a network in which religious impulses are related to the economic system. His posthumous career shows that he fills a gap and a need in creating a community and a sense of belonging.

Dead Elvis is more alive and in *medias res* today than he was while still in the actual sense alive.

DLH

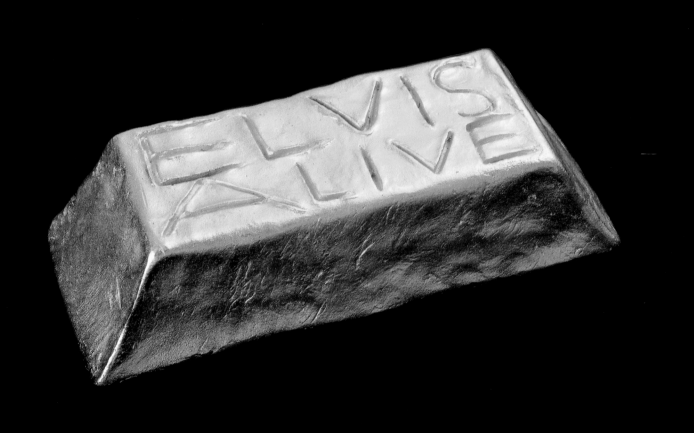

RALPH BURNS

born 1944 in New Orleans, lives in Asheville/North Carolina

Solo Exhibitions (selection)

1999 Orange County Museum of Art, Newport Beach, CA
1998 San Jose Museum of Art, San Jose, CA
1996 California Museum of Photography, Riverside, CA
1995 Cleveland Museum of Art

Group Exhibitions (selection)

1998 Mitsukoshi Museum of Art, Fukuoka, Japan
1997 Honolulu Academy of Art, Honolulu
1996 Contemporary Arts Museum, Houston
1995 ICA, Boston

How Great Thou Art, (selection), 1978–1998, photograph, each 27.94 x 45.56 cm, © Ralph Burns
(ill. pp. 144–147)

Ralph Burns documented Elvis Presley Memorial Day at Graceland, home of the "King", in photographs over a number of years, accumulating in the *How Great Thou Art* series. Not being a fan himself, Burns would have found himself in the safe position of being able to relate the story of the annual fan meeting in Graceland in an ironic manner, putting himself above the notion of "white trash" which is attached to the fraternity of Elvis-fans. Burns, however, chose to relate the story devoid of cynical insinuations, gaining insight into the gestures and codes surrounding the Elvis-devotees who, in keeping with the parameters that conventionally constitute a religious fellowship, form a kind of religious community.

Burns's photographs are full of compassion for the people who participate in the Elvis-myth. He regards them in the same manner as he might regard the pilgrims at Lourdes—people from the lower middle class setting out on a quest to encounter the sublime in the humid climate of Memphis, seeking redemption and grace—finding nothing hilarious about people going on a pilgrimage to find a deeper truth.

This insight into the religious character of the Graceland pilgrimage makes Burns's works, apart from their aesthetic qualities, into documents of anthropological significance. It is quite simple to ridicule the cult around Elvis and to view it as a lowbrow manifestation of a society without a history. Doing so, however, would be totally missing the point; for America, being short on historical myths, produces its own histories drawing upon the present, and the lacking but strongly desired patina of time is created by imbuing mundane objects and subjects with a mythical dimension, thus compensating for the shortcoming in regard to historical scope. Elvis Presley, whether one particularly cares for him or not, is one of the central figures America has produced in the 20th century. Not only does he embody the American dream, he even triggered an aesthetic revolution in the fifties which had an impact that politicians, philosophers or artists were unable to match.

Possibly Elvis has been endowed with a religious role because of a lack of contemporary sacred figures, yet he also appears to fulfil the basic requirements associated with this role. He did good deeds, he was an avid donor to various causes; he died at an early age; he was deeply religious; he believed he could cure the ailing who were brought to his concerts; he had both feminine and masculine features and he invented a new body language. John Strausbaugh in his book *Reflections on the Birth of the Elvis Faith* even compares him to Antinous, Hadrian's lover, who was deified after his death in 130 (AD), in spite of the appalling prosperity of the Roman world. Accordingly, Elvis' death is viewed by his disciples as following along the same lines of sacrifice and apotheosis.

Burns's depiction of the Memorial Day at Graceland as a religious event may therefore be seen as a journey into the very heart of the American culture, into its authentic core beyond re-created European notions. Burns documents the ceremonies, homilies and the absolution accompanying the pilgrimage, the rites of the pilgrims and their high priests. America's *locus sanctus* lies in Graceland.

DLH

"I think we all talk to someone we love after they're dead. We talk to our moms, we talk to our dads that have died, our grandparents. We talk to God. Now, I'm not saying Elvis is God, please understand that, but everybody, in a quiet moment … I believe in an afterlife … I find it very hard to believe we just live and then stop…

Yes, I've sat and talked to him. I've sat and talked to my grandmother and grandfather. If you want to call me insane then fine, I'm insane. But when that love is there you're connected and that love doesn't die because the body dies, and anybody that's lost somebody has got to realize that."

Louise Wilson
Rutherford, New Jersey
August, 1992

■

"I just keep coming back. I love him so much. I miss him so much. I know when I was working I used to be so tired and I'd get off work and I'd put his tape on in my car and play his music and I felt so much better going home. I'm just lost without him."

Cathy Walden
Lawrenceburg, Indiana
1988

■

"This is what it's all about—love. Religion is all about love. Love. That's it. Love.

My first experience by the gravesite—it was 6 a.m. and I was really by myself, my knees were shaking because this was very important, it was my first time there—a gentleman comes over and puts his arm around me and says, 'I know how you feel. I love Elvis, too.' And he just stood there and held me as long as I needed to be held, and then he walked his way and I walked my way. The following morning I came up and there was a woman from France who did not speak any English. Her knees were knocking. I went over there and put my arm around her and I guarantee the following morning she was there doing that for someone else.

Like I said, and we're going to keep repeating this word, it's love. Love thy neighbor as thyself. Love."

Louise Wilson
Rutherford, New Jersey
August 1992

■

"I feel his presence all the time. I feel it at home. A lot of times, if I'm feeling real depressed about something, I play his music and it's like a tranquilizer to me. It just soothes my mind. It's great meditation.

I feel that Elvis is alive in the spiritual way and I feel that he's looking down upon all of us. He's crossed over. He's not dead, he's crossed over to a better place where he's not suffering with pain anymore."

Ronnie Bussey
Wilmington, Illinois
1988

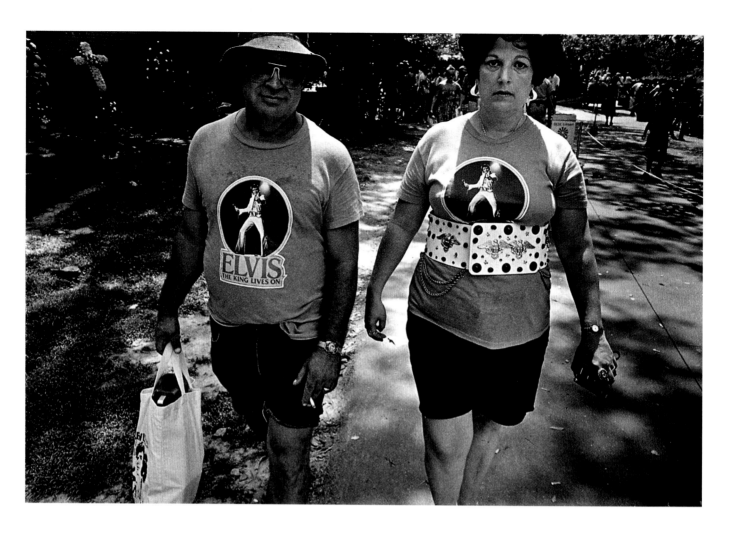

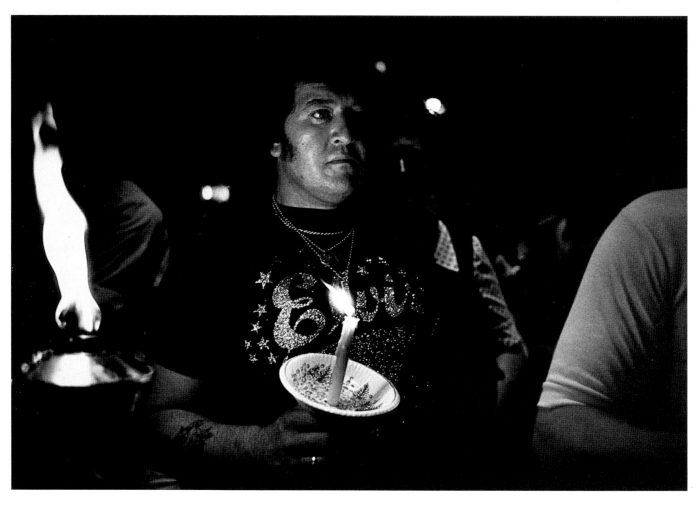

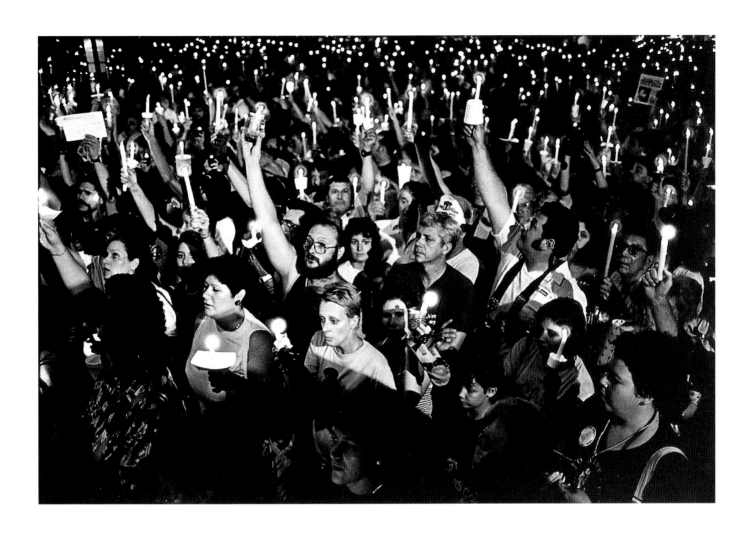

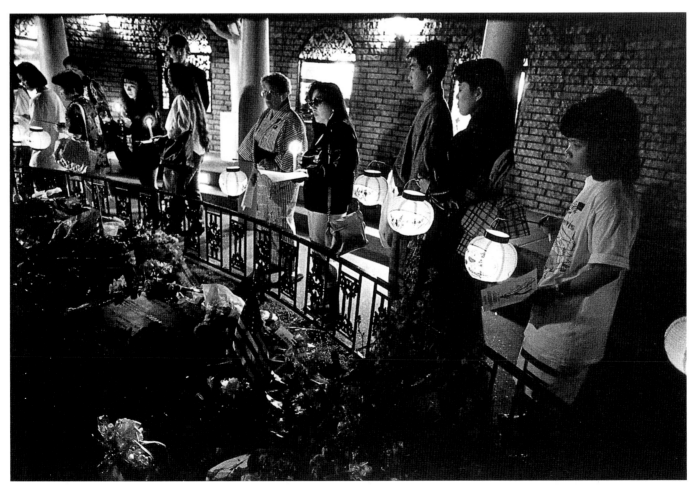

147

The Christian pilgrim not only took (and takes) something away from the holy site (a relic, some blessed oil or water, a medallion), he usually left something behind. It might be an elaborate, custom-made image set up in a prominent place in the *locus sanctus* (Latin = "holy place") to acknowledge publicly the pilgrim's encounter with his spiritual patron, it might be an anonymous personal item, or it might be a simple greeting or prayer hastily carved into any available surface. Indeed, votive inscriptions are common at Christian pilgrimage shrines, and in some instances they simply record the name of the pilgrim, or of friends or relatives of the pilgrim who were unable to make the journey. The latter was true of the sixth-century pilgrim from Piacenza, when he arrived at the *locus sanctus* marking the spot of Christ's first miracle (*Travels*, 4):

WRITING TO THE KING

Gary Vikan

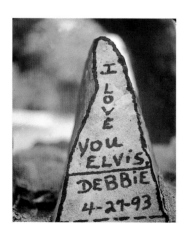

"We came to Cana, where the Lord attended the wedding, and we actually reclined on the couch. On it—undeserving though I am—I wrote the names of my parents..."

Even today, on the columns flanking the entrance to the Holy Sepulchre in Jerusalem, one can find scores of pilgrim inscriptions in dozens of languages, some dating back centuries (fig. 1). Each is a votive, and in its various forms a votive could serve at once as a record of the pilgrim's visit, as a perpetuation of his devotional contact with his patron, and as a thank-you for a blessing received or anticipated.

At Graceland there are two main type of Elvis votives, and each has its own characteristic setting. The first is found mostly in the Meditation Garden; its primary medium is the flower, and it usually is based on an iconographic conceit evocative of an Elvis quality, motto or event, or of the geographical origin of the pilgrim who dedicated it. The second type of Graceland votive is the graffito message. The rules laid down by Elvis Presley Enterprises are explicit and strict; nothing can be touched, and graffiti is of course forbidden, except in one location: The Fans' Memorial Wall (fig. 2). Here messages are not merely tolerated, they are actively encouraged, by occasional sandblasting, which frees up the limited writing space, and by the frontage road off Elvis Presley Boulevard, which allows the mobile pilgrim to pull off in his car and scrawl his message in magic marker without upsetting traffic. The Wall is simply that: a pinkish-yellow fieldstone barrier, about two meters high and 175 meters long, setting off the Graceland complex from the road. It is illegal to scale this barrier, but one is encouraged to write on it, and at least 10,000 Presleytarians do every year.

Graceland graffito messages fall into several major categories, the largest of which constitutes simple declarations of affection, ranging from tepid (fig. 3: "I love you Elvis, Debbie") to 50s-style hot (fig. 4: "Elvis, My creamy Love thing—Take me! xxxoo Susie"), to simple, raw emotion ("El, You were once in a lifetime, glad it was mine, T-Bird Huck"). Many use words from famous songs for added potency ("I'm so lonesome I could cry—KB"), and there are some, usually unsigned, that are intentionally irreverent ("Elvis *is* alive, and living in my underwear drawer!"). Nearly all of the 700,000 yearly Graceland visitors stop to read, and many provide commentary on what they find. Indeed, there is occasional evidence of what might be called "Elvis graffito dialogue," with Elvis-affirmation sometimes deflated with the cutting humour that the King and his memory seem to invite:

ELVIS YOU CAME YOU SAW YOU CONQUERED

ELVIS YOU CAME YOU SAW YOU OVERDID IT

And nearby, some cynical *ex post facto* advice:

ELVIS—JUST SAY NO

Countered, finally, by the comforting denial-dictum of the true

Presleytarian:

THE KING NEVER DID DRUGS

With some cynical exceptions, like those, Elvis graffito votives carry heartfelt conviction. Some, echoing the *vitae* (Latin = "lives," referring to the saint-like narratives concocted for Elvis), are angry and

combative, and addressed to the "other", but most are sweet and sentimental, and addressed to the King. Beyond the hundreds of simple confessions of eternal love and devotion, there are scores of messages carrying profound, seemingly spontaneous evocations of sorrow or loss:

8-16-77 IS THE SADDEST DAY OF MY LIFE.

I WAS TOO YOUNG TO REALIZE IT AT THE TIME.

I WAS TEN. LOVE RALPH

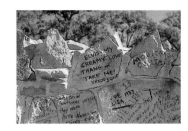

Others, in much the same tone, offer thanks for Elvis' spiritual intervention:

ELVIS THANKS FOR ALL YOU HELPED ME THROUGH.

I WOULDN'T BE ME WITHOUT YOU.

SEE YOU IN HEAVEN. I LOVE YOU CARLA

And there are many that evoke the very act of pilgrimage:

FM LONDON—MEMPHIS

TOO YOUNG TO REMEMBER

HERE TO RESPECT

ALAN, TIM, LISA & BEV

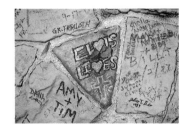

Within just a few feet of one another are messages in Japanese, Spanish, French, German, Greek, and Russian, as well as those written in English by pilgrims identifying themselves as Swedes, Austrians, and Brazilians. And everywhere, there is reference to multiple visits, either promises to return or, more frequently, allusions to past pilgrimages.

There are votives with overt religious messages, like "ELVIS LIVES" above a radiating Calvary Cross (fig. 5), and finally, there are votives that capture the very essence of pilgrimage piety, and of Graceland (fig. 6):

I HAVE SEEN GRACELAND, MY LIFE IS COMPLETE, MISS YOU TERRIBLY SOREN SKOVDAL

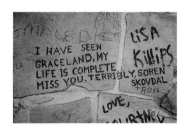

Although the August 1989 Sotheby's auction catalogue of *Rock 'n' Roll and Film Memorabilia* pictured Elvis on its cover, it included relics of many other celebrities, including even Sunny Bono, whose '60s sheepskin waistcoat, with requisite letter of authentication, was offered at £ 400 to £ 600. Elvis's charisma-infused corpse, like that of some Christian saints, required special security, but this has been true as well of all sorts of famous figures in modern times, including dictators: in 1987, on the 13th anniversary of his death, thieves broke into Juan Perón's locked tomb and surgically removed his hands.

Over the last two decades thousands have made the pilgrimage to gather sanctified soil from the gravesite of Jim Morrison in Père-Lachaise cemetery in Paris, and many have left votive messages of the Elvis sort ("Jim is our King, not Elvis"). And in Dallas, Texas, just above the grassy knoll where the conspiracy theorists believe the second assassin of President John F. Kennedy stood, there is a simple wooden fence which offers the opportunity for the expression of long-held, deeply felt conviction (fig. 7: "How long do we wait for the truth? How long?"). And most recently, there are the devotees of Princess Di, who brave the heavy traffic at the fateful Place de l'Alma underpass (fig. 8)—now "Place Diana"—to scribble an appropriate message on any handy surface ("Ce n'etait pas un accident").

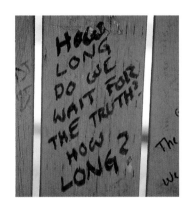

Insofar as the cult of the dead Elvis differs from these, it probably differs more in degree than in kind: 50,000 gathered at Graceland for the tenth anniversary of Elvis Presley's death, whereas just a few hundred gathered at the Dakota Hotel for the tenth anniversary of John Lennon's death, and by all accounts, Princess Di's first anniversary was a disappointment for her followers. On any given day, 2,000 or more will pass through Graceland's Meditation Garden, whereas just a couple dozen Morrison pilgrims per day will find his grave in Père-Lachaise. And who among these modern pop-culture saints can claim a counterpart to the "Elvis is Alive Museum" along Interstate 70 between St. Louis and Kansas City, wherein one finds an Elvis-dummy in an Elvis-coffin (fig. 9), matching exactly the infamous funeral photograph of Elvis lying in state published by the *National Enquirer*? The analytical model of the Center for Disease Control may be useful here, since it differentiates among *aetiology* or "cause", *phenomenology*, which is the aggregate of symptoms as presented in the individual, and *epidemiology*, which is the pattern of distribution among the general popula-

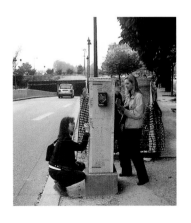

tion. What sets the Elvis "condition" apart is its epidemiology, its sheer scale, and probably also its phenomenology, its intensity as presented in the individual. For an excellent primer in the extremes of the latter, one need only check out Rhino Video's *Mondo Elvis: The Strange Rites & Rituals of the King's Most Devoted Disciples*, and therein meet Artie "Elvis" Mentz, the EP-Impersonator who equates his relationship to the King to that of a priest to God.

As for aetiology, whether the case study be Graceland or Jerusalem, the question of root cause lies beyond the scope of comparative religion and this talk, in the realm of social anthropology and psychology. That the idiom of Elvis' charismatic performance might be like that of a pentecostal evangelist, and that the idiom of Graceland pilgrimage might be like that of a medieval *locus sanctus* should not be taken to imply and certainly does not require that there be a genealogical link between the cult of Elvis and contemporary or historical Christianity. On the contrary, such resonances suggest that the predisposition toward "charisma objectification" that is their shared inspiration is primal and ahistorical, and that over time and across cultures this predisposition will tend to manifest itself in similar though potentially fully independent ways.

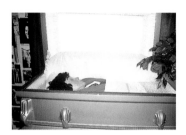

Finally, it is striking that among the inscriptions at Graceland, and in Elvis *vita* and tabloid literature generally, there is seldom any hint of Elvis-as-intercessor, even when he is clearly the proximate source of the miraculous, and even when the context is richly flavoured with conventional religion. Rarely is God or Jesus ever mentioned, and rarely is there any talk of Elvis as being the recipient of prayer. In this respect, Elvis' sainthood is strikingly different from the conventional Christian sort, wherein the role of one's spiritual patron as one's advocate before God is always central.

Though of course sainthood, either as performed or as acknowledged, is not a constant, even in Christianity; the great martyrs mostly date from before the Peace of the Church, and retreating-into-the-desert as an expression of saintly piety went out of fashion more than a millennium ago. As the early Christian saint was a product of and a window upon his world, so also is Elvis Presley. And so, in the words of "Sam," on the Fans' Memorial Wall:

GIVE US THIS DAY OUR DAILY ELVIS

HAIM STEINBACH

born 1944 in Rehovot/Israel, lives in New York

Solo Exhibitions (selection)

1997 *Haim Steinbach*, Museum Moderner Kunst Stiftung Ludwig, Wien
1995 *Haim Steinbach*, Castello di Rivoli, Turin
1993 *Osmosis (with Ettore Spalletti)*, Guggenheim Museum, New York
1992 *no rocks allowed*, Witte de With, Centre for Contemporary Art, Rotterdam
1991 *Haim Steinbach*, Palais des Beaux Arts, Brussels
1988 *Haim Steinbach*, CAPC Musée d'Art Contemporain, Bordeaux

Group Exhibitions (selection)

1998 *René Magritte and contemporary art*, Museum voor Moderne Kunst, Oostende
 Fast Forward, Kunstverein Hamburg
1997 *Biennale di Venezia*, Venice
1996 *NowHere*, Louisiana Museum of Art, Humlebaek
1993 *Tutte le Strade Portano a Roma?*, Palazzo delle Esposizioni, Rome
 Biennale di Venezia, Venice
1992 *Documenta IX*, Kassel
1991 *Objects of the Ideal Home/The Legacy of Pop Art*, Serpentine Gallery, London
 Metropolis, Martin-Gropius-Bau, Berlin
1990 *Art et Publicité*, Musée National d'Art Moderne Centre Georges Pompidou, Paris
1989/90 *Wittgenstein: The Play of the Unsayable*, Wiener Secession, Vienna/Palais des Beaux Arts,
 Brussels
1989 *Horn of Plenty*, Stedelijk Museum, Amsterdam
 A Forrest of Signs, Museum of Contemporary Art, Los Angeles
1988 *The BiNational, American Art in the Late 80s*, ICA, Boston/Museum of Fine Arts,
 Boston/Kunstverein für die Rheinlande und Westfalen, Düsseldorf
1986 *Endgame: Reference and Simulation in Recent Painting and Sculpture*, ICA, Boston

Untitled (breast mugs, Marilyn guitar) I–1, 1990, synthetic covered wood, mixed media, Courtesy
Sonnabend Gallery, New York (ill. p. 153)

The mugs in breast form and the guitar with Marilyn Monroe's features imprinted on its surface display two of America's most powerful icons. Elvis Presley is represented by the instrument which, in turn, features a representation of Monroe. Both representations merge together to form an image of a truly androgynous nature, creating the essence of the American dream. Monroe and Presley are figures whose commodity value surpasses any other virtues they might have; they are hybrid-crossings of human beings and products, forever doomed to be projected on different surfaces, donning their aura in a futile attempt to gain meaning in the guise of household objects.

The supplementary nature of the everyday object fascinates Steinbach. He repeatedly presents objects which aesthetically may be defined as gaudy or tasteless. Both the mugs and the guitar are not trivialised through their function, but rather because an attempt was made to conceal their function and to offer an apology for their real existence. The breasts in the case of the mugs, like the face of Marilyn on the guitar, fuse two notions of seduction—the element of seduction involved in elevating an object to the order of gadgets, which is the same as an indication of its originality, and the seductive power derived from the sexually charged images which were mercilessly adapted to accompany it.

In his particular way, Steinbach is ordering in a grand encyclopaedic manner all rejected and uncanonised expressions of his culture. He assembles them like a patron of the poor leading the homeless to the temple. By elevating the banal through the act of placing it into the museum space, he takes on the role of an archaeologist who does not place his found objects into a co-ordinate system of taste, but rather poses the question as to which function this aesthetic system entails. Once the banal is relocated in the sacred space of the museum, serialised and severed from its context, it acquires a new aura. Removed from the short span of existence that it is granted in the everyday world, it obtains immortality in the context of the museum.

Reordering values brings about a new grammar. The syntax Steinbach employs changes the text the viewer would expect or like to read. It requires a new manner of reading because the objects he chooses are now spelled differently and taken out of the context of their original expectant existence.

The mug which is shaped like a breast may metaphorically and virtually contain milk. If the notion of a breast containing milk is related to the figure of Monroe, which is united with the figure of Presley through the guitar representing both, the work ceases to be an exercise of the banal and becomes an archaeological site. It is an altar depicting a mythological scenario revolving around fertility and sacrifice, at the same time re-creating the theme of *Maria lactans*. The fusion of Monroe and Presley also mirrors the notion of the Janus-figure, the very image of a primordial androgynous God before dualism broke up the unity of paradise. They are both bestowers of life, nourishing their followers with milk, and they are also the objects of sacrifice who will die for them. DLH

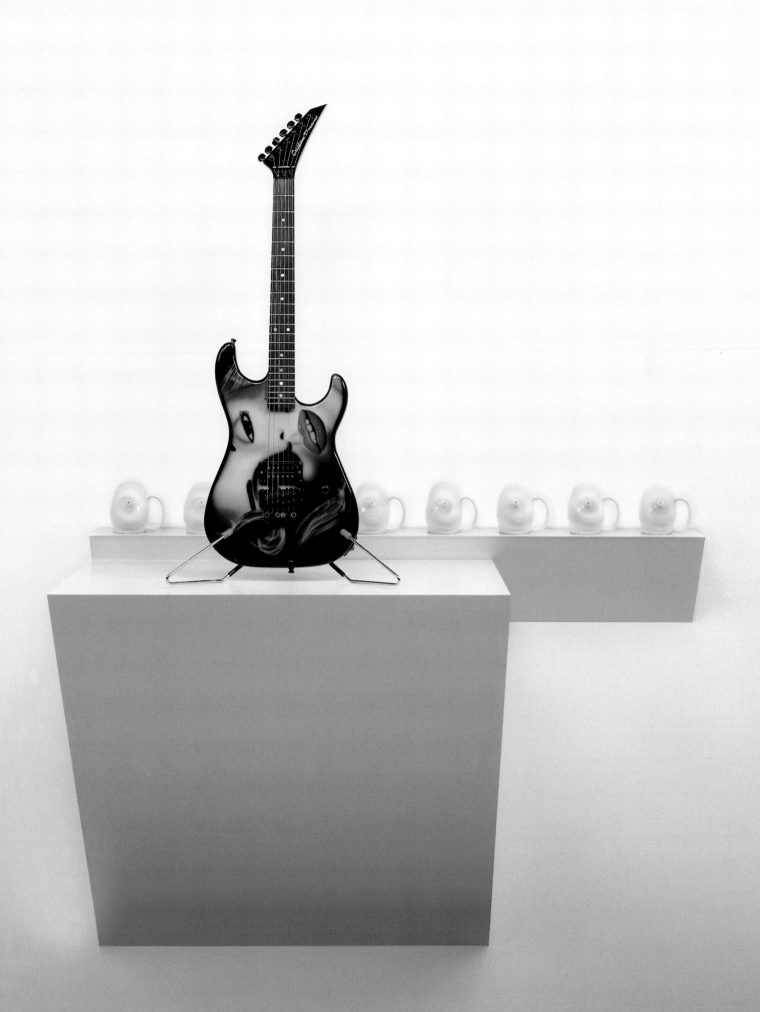

THIERRY MUGLER

born in Strasbourg, lives in Paris

1995	*Cirque d'Hiver* show, Paris
1992	*Too Funky*, collaboration with George Michael
1987	*L'Antimentale*, TF1
1984	*Super Show*, Paris
1977	first *Show-Collection*
1973	*Café de Paris* Linie

Chimère Couture, 1997/98, feathers, metal, precious stone trim, embroidery, 240 x 120 x 80 cm,
Courtesy Thierry Mugler, © Patrice Stable (ill. p. 156)
Manteau du soir en marabout sur corps astral constellé diamants blurs, 1995/96, embroidery,
incrustation, marabout feathers, Courtesy Thierry Mugler, © Patrice Stable (ill. p. 157)
Robot Couture, 1995/96, metal, Plexiglas, Courtesy Thierry Mugler, © Patrice Stable

The dresses designed by Thierry Mugler epitomise "the woman" in all of her iconic transformations, be it in her angelic, fatalistic or demonic manifestations. The woman inside the garment is non-existent insofar as she has already been allegorised by it, making her presence optional if not obsolete. What remains is an image of utopian dimensions.

Mugler carefully devises the designs for his clothes, reworking them until their appearance corresponds to the status assigned them. By emphasising wasp waists in his designs, the body is intentionally de-humanised in opposing ways. On the one hand, its human shape is replaced by an insect-like morphology through the extreme emphasis on the waist and by almost eliminating the centre part; secondly, the body is dematerialised, transcending its physicality as if the flesh were to be transferred onto a spiritual plane. It is at this point, when the body is in the process of disappearing, that a religious canon is constituted. Mugler's *couture* acts as a surrogate. It becomes the essence of the woman wearing it, a surface form which has taken control over its content, a herald of things to come.

Most of Mugler's creations are glamorous. Glamour replaces in secular terms what the Holy Spirit represents in a religious sphere. It is comparable to a disproportionate abundance of grace bestowed onto one person, so that the viewer experiencing it is filled with both awe and terror.

Glamour is a difficult quality to define. It is associated with women, never with men, whose parallel characteristic would be denoted as charisma; but unlike the charismatic person the glamorous woman is viewed as an accumulation of surfaces rather than as the bearer of an inner quality. Glamour is also not synonymous with seduction as is beauty. The gaze that is focused on glamour does not relate to it in terms of desire, since glamour draws its power from blinding the person subject to it. However, because it blinds rather than seduces, it contains a sacred component, similar to the experience of the sublime. The glamorous woman is not desired but admired by the viewer's gaze, thus becoming a quasi-religious object.

Because essences must be emphasised through fabrics, cuts, and textures, in order to substantiate the aural quality that the "heraldic" dress entails, a certain degree of grotesqueness is required and represented in Mugler's robes. Larger than life, the creations move within a magnified world, as ethereal as a Gothic space, operating on a grandiose scale. Their original function to clothe a person is shifted towards another objective. These are not dresses designed for humans, but for heavenly beings belonging to a celestial order. DLH

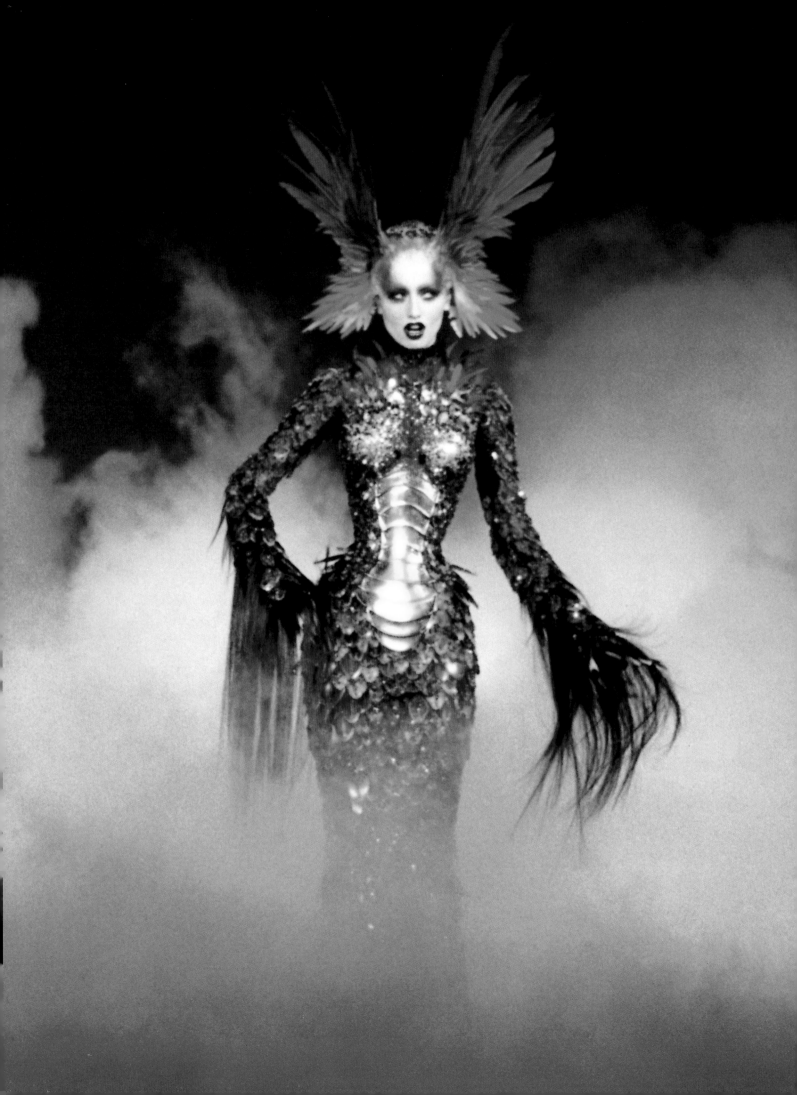

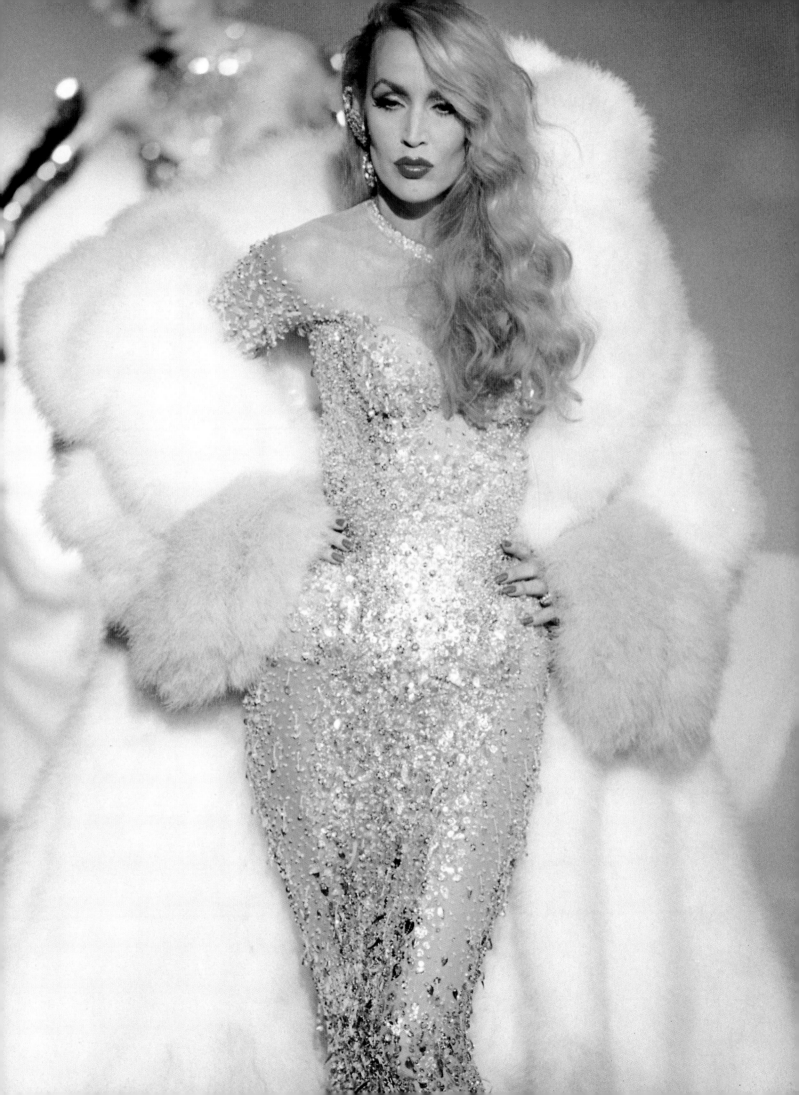

SYLVIE FLEURY

born 1961, lives in Geneva

Solo Exhibitions (selection)

1998/99 *Hot Heels*, Museum für Gegenwartskunst, Zürich/Villa Merkel, Esslingen
1998 *24th International Biennale Sao Paulo*, Sao Paulo
1996 *First Spaceship on Venus*, Musée d'Art Moderne et Contemporain, Geneva
1994 Galerie Philomene Magers, Cologne
1993 *The Art of Survival*, Neue Galerie am Landesmuseum Joanneum, Graz

Group Exhibitions (selection)

1998 *Auf der Spur. Kunst der 90er Jahre im Spiegel von Schweizer Sammlungen*,
 Kunsthalle Zürich
1997 *P.O. Box*, Museum für Gegenwartskunst, Basel
1997 *Home Sweet Home*, Deichtorhallen, Hamburg
1996 *Doppelt Haut*, Kunsthalle zu Kiel
1995 *Fémininmasculin. Le sexe de l'art*, Musée National d'Art Moderne
 Centre Georges Pompidou, Paris
1992 *Art meets Ads*, Kunsthalle Düsseldorf

Glamour, 1994, acrylic, Courtesy Galerie Philomene Magers Cologne/Munich (ill. pp. 160/161)
Masked Maniacs, in collaboration with Sydney Stucki, 1997, vinyl, compressor, cassette recorder, diameter 500 cm, height 200 cm, Courtesy Galerie Philomene Magers (ill. pp. 162/163)

In her works Sylvie Fleury uses materials that are considered typically feminine and devotes her attention to a subject matter which, on the one hand, depends on the consumer-oriented stance taken by Western society and, on the other, penetrates into the domains of masculine role identification.

Spaceships, UFOs and rockets are a major focus in her sculptural installations. Sylvie Fleury counters this largely male-dominated area, based on notions of science, research and expeditions and nourished by utopian dreams, visions and fantasies, by coating the exterior of the rockets and constructive elements with a plushy fur fabric whose disfunctionality forms a stark contrast to the streamlined functional orientation of the actual machines. The fleecy skin of the rocket is opposed to the notion of a phallic missile with its coat bordering on the ethereal in such a manner that it appears as if it were this coat that prevented its launching into outer space (and not the obvious fact that this is a sculpture and not an actual rocket). The primary form covered by a fleecy condom transposes the plushy atmosphere of dubious professions and ambitions to the domain of a forced machismo whose objects of identification are placed at disposal for investigation. The silver and gold tones of the inflated material, from which further rockets and UFOs are fashioned, equally caricatures the notion of efficiency, in contradiction to an attitude based upon the extensive consumption of luxury goods. The art scene, which has been dominated by males for a long time, with its sovereign claim to purism, essence and cleanness, is also not spared when Sylvie Fleury designs a field in red plush, imitating Mondrian.

The monopolisation of areas of existence distributed according to role-specific criteria, as is the case of the first *Spaceships to Venus*, which draws upon comic strips, films and pop music, is intended as a feminine reaction to aggressive male mechanisms of dominance and suppression. This becomes particularly clear in the photos which Sylvie Fleury presents as dramatised, close-up details of irritating scenarios: a pair of female legs in leather boots in front of the bumper of a flashy American car. Of course, the nostalgia of early TV-images as well as the fascination with aggressive, stimulating practices enters into such images of inherent aggressiveness and latent brutality. The fact that Sylvie Fleury supposedly employs specifically feminine means bears witness to her intellectual seriousness and the self-ironic capacity for perception with which she pursues the development of her works. The glossy paper bags of elegant brand names or a silver-coated Kelly bag placed in front of a white fleecy background create the altars of femininity and of the extensive consumption of luxury goods, which, oddly enough, is particularly ascribed to women. The propagandist guideline is determined by the glossy lifestyle magazines, the society and gossip columns of the yellow press; it becomes the essence of life which one cannot refuse, since one is inevitably subject to it even in offering one's refusal. Through the distance that Sylvie Fleury achieves in identifying with the incunabula of this notion of society and life, she documents the omnipresence and omnipotence of this system as well as her fascination of and participation in it. The fact that a critical distance is impossible and that a determination by the system may also be part of the critique becomes clear in her work. MM

GLAM

YINKA SHONIBARE

born 1962 in London, lives in London

Solo Exhibitions (selection)

1999 *Dressing Down*, Ikon Gallery, Birmingham/Henie Onstad Art Centre, Norway e.a.
1998 *Diary of a Victorian Dandy*, site-specific project for the London Underground, London
 Alien Obsessives, Mum, Dad and the Kids, Tablet, The Tabernacle,
 London/Norwich Art Gallery
1997 Stephen Friedman Gallery
 Present Tense, Art Gallery of Ontario
1995 *Sun, Sea and Sand*, BAC Gallery, London
1994 *Double Dutch*, Centre 181 Gallery, London

Group Exhibitions (selection)

1999 *In the Midst of Things*, Bourneville Village, Birmingham
 Secret Victorians, Ikon Gallery, Birmingham
1998 *Cinco Continentes y una Cuidad*, Museo de la Cuidad de México, Mexico City
 Crossings, National Gallery of Canada
 Beyond Mere Likeness: Portraits from Africa and the African Diaspora,
 Duke University Museum of Art, Durham, North Carolina
1997/98 *Sensation, Young British Artists from the Saatchi Collection,*
 Royal Academy, London/Hamburger Bahnhof, Berlin
 2nd Johannesburg Biennial
 Pictura Britannica, Museum of Contemporary Art, Sydney
1996 *Inclusion:Exclusion*, Steirischer Herbst,Graz
1992 Barclays Young Artists Award, Serpentine Gallery, London
1991 *Interrogating Identity*, Museum of Fine Arts, Boston/Walker Art Center,
 Minneapolis/Goldsmiths College, London e.a.

Alien Obsessives, Mum, Dad and the Kids, 1998, textile, dimensions variable,
Courtesy Yinka Shonibare and Stephen Friedman Gallery, London (ill. pp. 168–171)
Untitled, 1998, emulsion and acrylic on textile, diameter 70 cm,
Courtesy Yinka Shonibare and Stephen Friedman Gallery, London (ill. p. 166)
Untitled, 1998, emulsion and acrylic on textile, diameter 70 cm,
Courtesy Yinka Shonibare and Stephen Friedman Gallery, London (ill. p. 167)
Untitled, 1998, emulsion and acrylic on textile, diameter 70 cm,
Courtesy Yinka Shonibare and Stephen Friedman Gallery, London

The two families of aliens presented by Yinka Shonibare could easily be interpreted as standing for the "other", whatever the term implies in any post-modern or post-colonialist jargon or context. However, I believe that these works are in fact much more enigmatic, containing an inherent trap in regard to their perception, and that their appearance as "figures of breach" is thus misleading. Alienation, a familiar concept used to describe anything which is "other" than us, does not mean by necessity that differences contain an essence. Differences on the whole are trivial, but out of convenience if not hubris, they are emphasised to benefit one side or the other. Shonibare, an Englishman of Nigerian descent, knows exactly what is being required of him in his role as an African in Europe, and he reacts to the rules of the game by exaggerating and blowing them up out of proportion, putting the "informed" viewer at ease concerning the authenticity of his origin, which is then equated with the authentic quality of his artistic work.

The fact that the "other" is indeed a virtual classification is elucidated by Shonibare's alien figures, who manifest a non-existent "otherness". On the one hand, they are clothed in some kind of supposedly African fabric which in fact is not African but is manufactured in England; on the other hand, these figures are doubly alienated by the fact that in the work two species of imagined aliens are combined, revealing the latent irony in Shonibare's concept.

This does not imply that it is easy to be an African in Britain or a Turk in Germany or an Arab in Israel, or for that matter, that it is easy to be an Englishman in England etc. And it does not suggest that the myth of globalisation can be an intelligent answer to banal differences. It may, however, imply that such categorisations are useless because it is impossible to truly grasp Shonibare's artistic approach along these lines.

The focus in Shonibare's work lies on codes of appropriation. Incorporating overlapping indexes, such as the "African" fabric worn by aliens, inconsistent settings, Victorian ladies, or a single androgynous person, into his work, the images reflect codified stigmas as surface emblems, while the artist avoids treating them in a critical manner, as if they were victimised. It is rather a game based upon social oscillations, where each image masks itself and assumes another persona, so that for a brief moment, endeared or ridiculed, it might ensnare the viewer, becoming an object of desire. All the while, Shonibare is quite aware of the inherent implications regarding colonialism, racism and prejudice, all of them being challenged and overcome through the medium of art. By creating parallel histories, he points to the arbitrary nature of the disguise, celebrating its claim to be the essence; for the disguise does not stop at servants playing masters, or aliens having families, but extends to the very presumed origin one would like to imagine actually exists. DLH

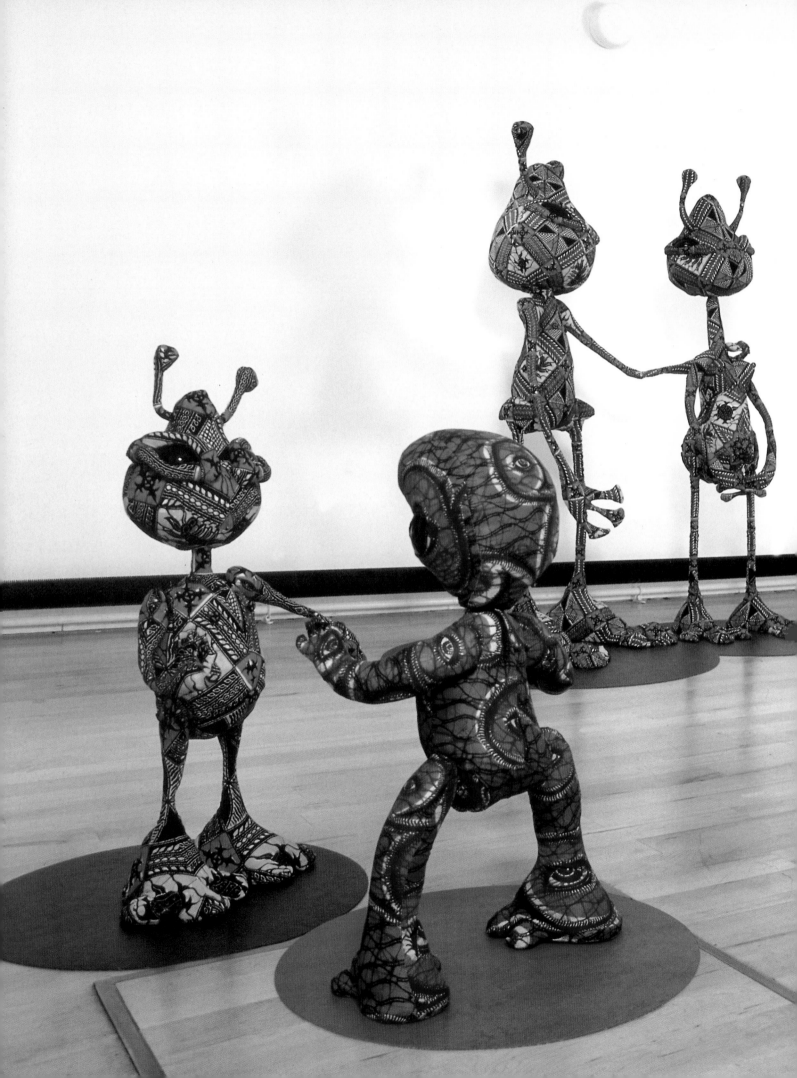

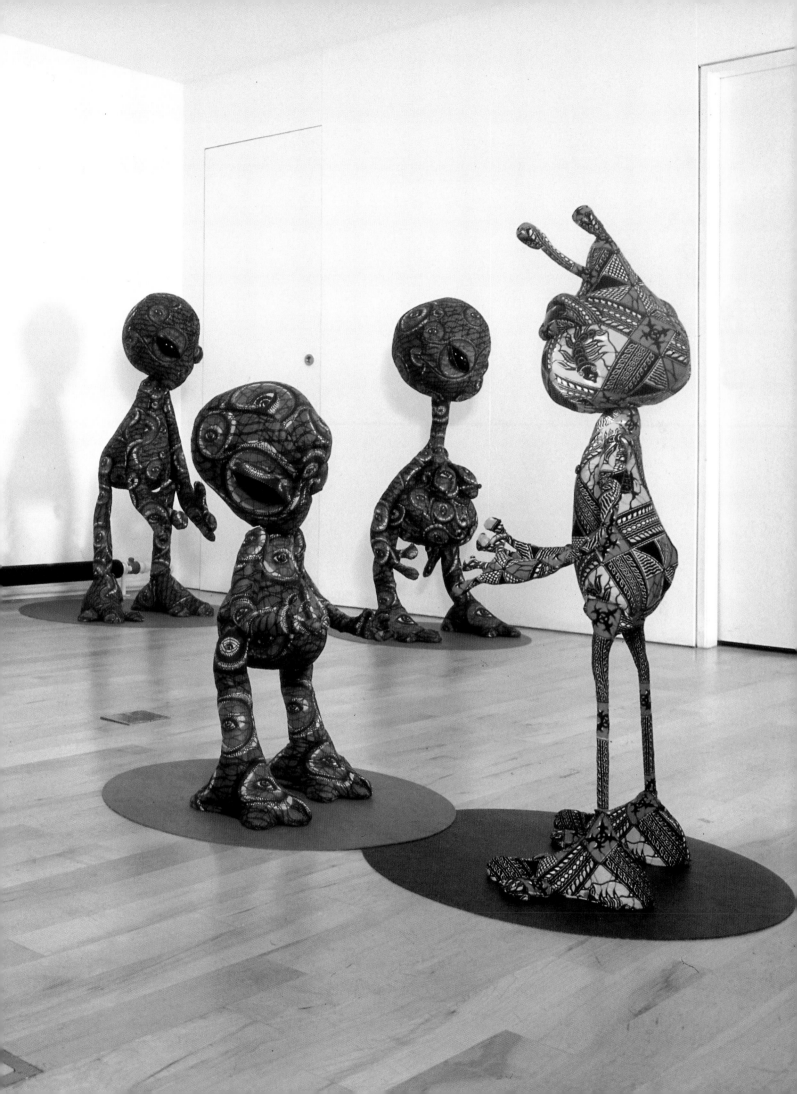

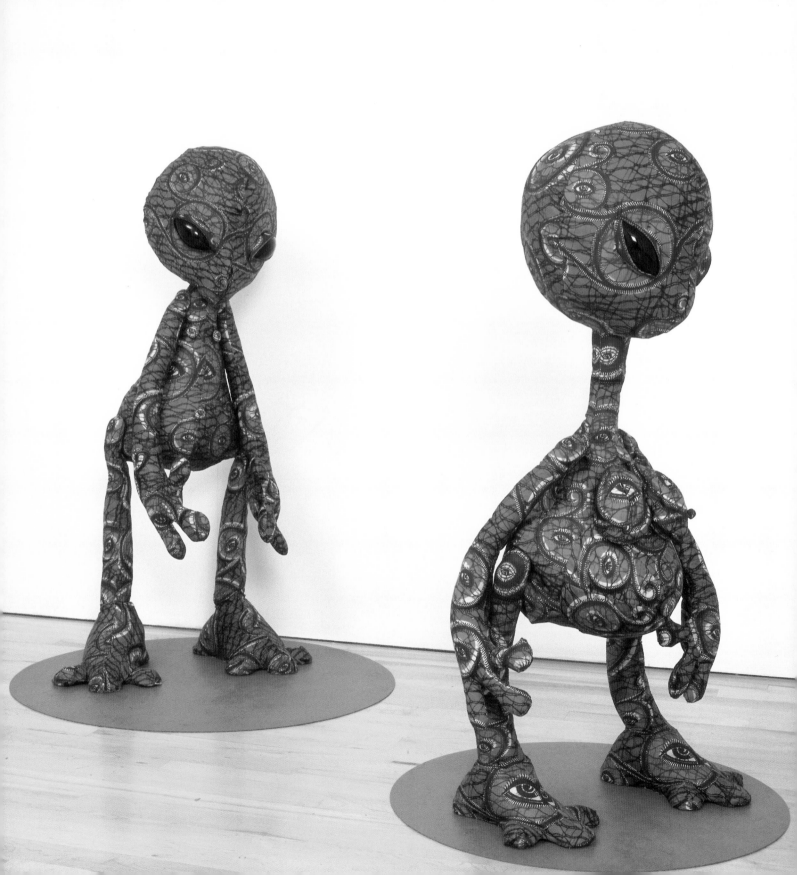

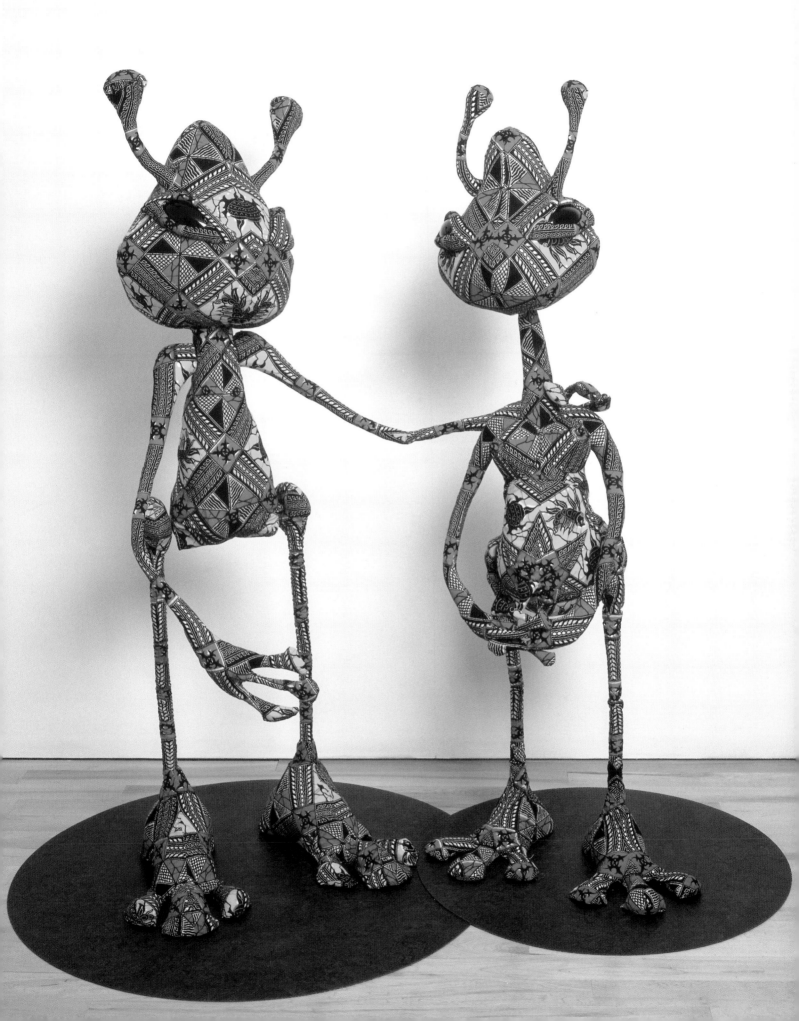

TONY OURSLER

born 1957 in New York, lives in New York

Solo Exhibitions (selection)

1999	*Tony Oursler*, Tel Aviv Museum
1998	*Tony Oursler*, Kunstverein Hannover
1997	*Judy*, Institute of Contemporary Art, Philadelphia
	Tony Oursler, CAPC Musée d'Art Contemporain, Bordeaux
1996	*Tony Oursler*, Museum of Contemporary Art, San Diego
1995	*System for Dramatic Feedback*, Porticus, Frankfurt/Les Musées de la Ville de Strasbourg/Centre d'Art Contemporain, Geneva
1986	*Spheres of Influence*, Musée National d'Art Moderne Centre Georges Pompidou, Paris

Group Exhibitions (selection)

1999/98	*I Love New York*, Museum Ludwig, Cologne
1998	*Video: Tony Oursler, Bruce Nauman, Sam Taylor-Wood*, Museum of Modern Art, San Francisco
1997	*Worldwide Video Festival*, Stedelijk Museum, Amsterdam
	:Engel: Engel, Kunsthalle Wien
	Documenta X, Kassel
1996	*ID*, Van Abbemuseum, Eindhoven
	New Persona, New Universe/Biennale di Firenze, Florence
1995	*Passions Privées*, Musée d'Art Moderne de la Ville de Paris
	Biennale d'Art Contemporain de Lyon, Lyon
1989	*Whitney Biennial*, Whitney Museum of American Art, New York
1988	*The BiNational: American Art of the Late 80s, German Art of the Late 80s*, ICA, Boston/Kunsthalle Düsseldorf/Kunsthalle Bremen/ Württembergischer Kunstverein, Stuttgart

Separation, 1999, video, mixed media, synthetic material, wood, 143.5 x 50.8 x 25.4 cm, Courtesy Tony Oursler and Metro Pictures, New York (ill. pp. 174/175)

The video works, environments and sculptural ensembles which Tony Oursler stages in particular spatial situations, installing them accordingly, encroach immediately on the viewer's space. In contrast to early video art, which was limited to its projection surface or appeared as a film in the encasing of the monitor, in Tony Oursler's works the projection becomes a constituent element of an extended scenario, dominating the space acoustically as well. The viewer is no longer a mere recipient confronting the work, but rather, in entering the scene of action, becomes a partner and victim of the expressiveness of the work.

The early versions of the *Dummies* were identifiable at first glance as arranged bundles of cloth but still one could hardly elude their disturbing effect, as if they held a secret whose exposure was pressed for by the viewer's curiosity. When the *Dummies* were additionally animated through video projections and speech, a distanced contemplation became utterly impossible. Even though Oursler's figures appear evil, aggressive and menacing, they have such a captivating effect that viewers find themselves helplessly surrendering to the verbal attacks and psychopathic outbursts. The physical disposition of the *Dummies* forms an odd contrast to the aggression and the angry gaze the figures direct towards the viewer. They are either lying with their head stuck under a mattress or an overturned chair or are suspended high above the viewer's head, or are minutely small and helplessly trapped inside a suitcase or on top of a mountain of pillows; finally, they may even be reduced to an egg-shaped figure, submerged under water in the form of a head, split in half or mounted onto a thin rod as a floating eye, a mere organ of sight, which is at the mercy of pitiless examination by the viewer and the incident of light. In spite of these precarious positions and modes of appearance these beings—and doubtlessly this is what they are—radiate a high degree of aggressiveness and belligerence, which is confirmed by their acoustic utterances. All of this combines to transfix viewers in such a way that we are drawn to them, both startled and fascinated.

The recipient familiar with today's constitution of reality through the media experiences here for the first time the virtuality of the media breaking free. If the medium traditionally remains in the background behind the message it conveys, then in Tony Oursler's video installations the construction and artificiality of the staged situation is almost shamelessly revealed. Often the small projector which allows the heap of cloth to spring to life is clearly to be seen placed at close proximity to the object. It is this obviousness that one finds difficult to believe. The mystery that appears to be hidden in these beings must lie beyond the visible installation. However, it is the outrageously evident effect of the medium as such that triggers the fascination and makes apparent to the viewer the extreme influencing control, the inescapability of the media dream/nightmare. The gaze, the sound, the tone and the language exist like a being independent of its creator. It expresses itself in the shape of speaking lanterns—even the glow of the bulb is capable of articulating itself verbally. The naked eyes contemplating their own characteristic feature, the object of perception, "register the world from which they nourish themselves" (T. N. Goodeve).

The divine essence in its contemporary manifestation is the (white) noise of the media. Materialised in the shape of a human figure, it becomes perceivable for the viewer and in a quasi-religious reflex he/she is unable to elude the effect of the divine commandment, even if it is voiced as the order to "Getaway!" On this level, existential questions regain relevance to the present and become the basic material and theme of the artistic work. Tony Oursler's linguistic and visual approach in staging his works creates a cosmos which, while being derived from the Western civilisation of the late 20th century, is at the same time transcended. MM

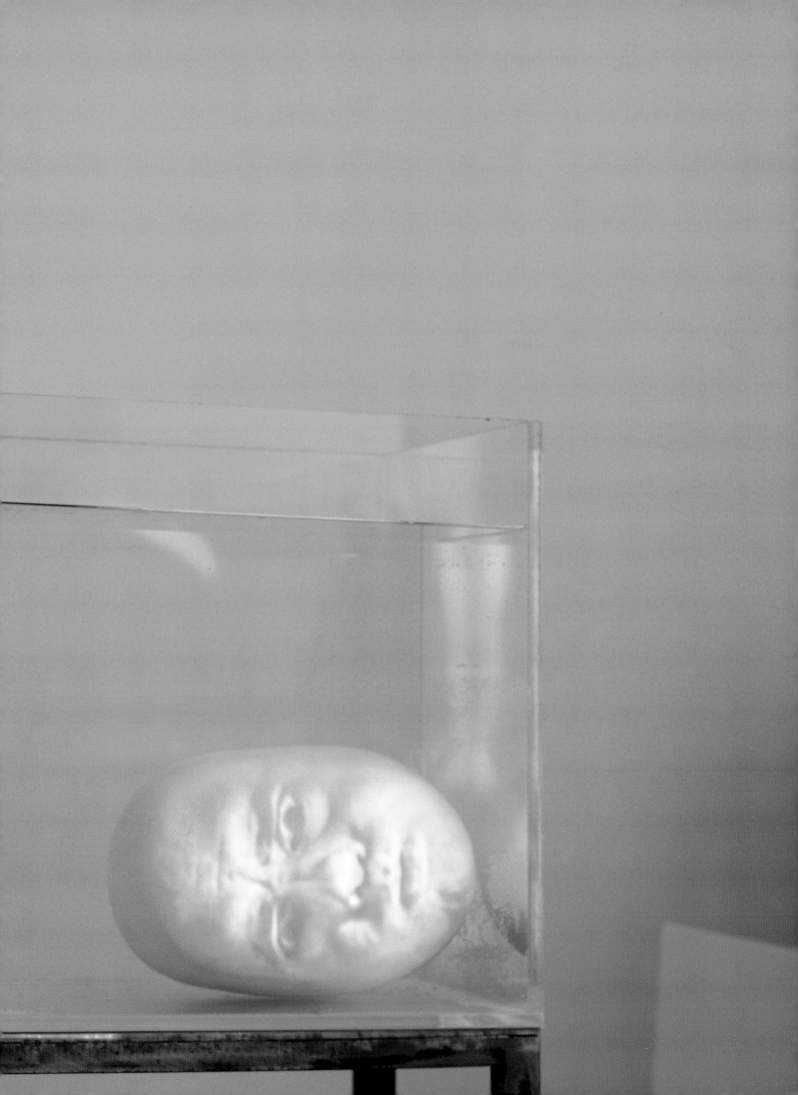

QIN YUFEN

born 1954, Qingdao/China, lives in Berlin

Solo Exhibitions (selection)

1998 *Xing yin (Walking Sound)*, Stadtgalerie Saarbrücken
1997 *Wu Yan de Feng (Schweigender Wind),* fine art Rafael Vostell, Berlin
1996 *Qing Zhou (schwebende Boote)*, Interventionen 5, Sprengel Museum, Hannover
1994 *Fang He*, Sommerpalast, Peking
1986 Kunstverein Heidelberg

Group Exhibitions (selection)

1998 *Echolot*, Museum Fridericianum, Kassel
 New Direction of Chinese art, Guggenheim Museum, New York
1997 *In Medias Res,* Istanbul
1996 *Um Fontana*, Schirn Kunsthalle, Frankfurt a.M.
1995 *Leiblicher Logos*, Staatsgalerie Stuttgart/Altes Museum, Berlin/Sara Hilden Art
 Museum, Tampere
1993 *Qing Yi*, Haus der Kulturen der Welt, Berlin
1991 *Kunst gegen Gewalt*, Stiftung Starke, Berlin
1987 *Zwei Künstler aus Peking*, Künstlerhaus Bethanien, Berlin

Chan Juan—Mondfrauen, 1998, glazed silk, CD, six channel composition, Courtesy Qin Yufen
(ill. pp. 178/179)

The work *Moon Women* presented by Qin Yufen is comprised of a series of very long identical gowns varying in number from one installation to the other. In all of Qin Yufen's works serialisation plays a major roll inasmuch as one chosen object is recursively repeated, manifesting form as the essence. In conformity with the Chinese culture of her origin, for her it is the mould that must be maintained and distilled rather than the singularity of its content. From a non-Western perspective serialisation as an artistic mode of expression is a gesture of great respect, which formulates the primary relation to the world as a place which already contains the ideal forms. Serialisation also implies a particular form of rhetoric and as in speech the matter which is repeated gains greater attention. As the garments emerge before the viewer's eye, looming suspended, it becomes clear that the celestial figures that inherently dwell in them are real presences because they are embodied in the form of the robes themselves and thus beyond this do not require a physical manifestation. It is what is not there, the missing element of content, that governs the work, displaying a minimalist attitude through the strength of the form. In contrast to the notion that clothes indicate the social order, the simplicity of the garments' design is negated by their length and rich colour, bringing into conflict both the social and the mythological orders, so that the identity of the representation is blurred.

Yufen entitled the work *Moon Women* in correspondence to a myth based on the story of two sisters who initally live on the moon, but who, being tired of people constantly watching them, exchange places with their brother, who lives on the sun. From now on those who dare to look at them are punished by the blinding force of the sun's rays. In the same manner as in the myth the "Moon Women" are not to be seen in Yufen's works, but may only be suspected by the viewer to be there, forcing the avoidance of a direct confrontation. As they refuse to be subject to the gaze, they are scopophobic to the degree of murder. In this sense they may be viewed as the very first feminists, destroying the gaze by blinding, i.e., castrating the viewer. Yet, the moon in the same myth is described as a symbol of nuptial harmony, and thus the translocation of the "Moon Women" to the sun is a story about a rebellion without tragic consequences, so unlike the situation in similar Western myths.

The work is accompanied by the verses of Sushi, a poet of the Sung-dynasty, which allude to the moon and the stars and the deep space surrounding them. Qin Yufen recites the poetry of the great Chinese master, telling of the price paid for solitude and dislocation. DLH

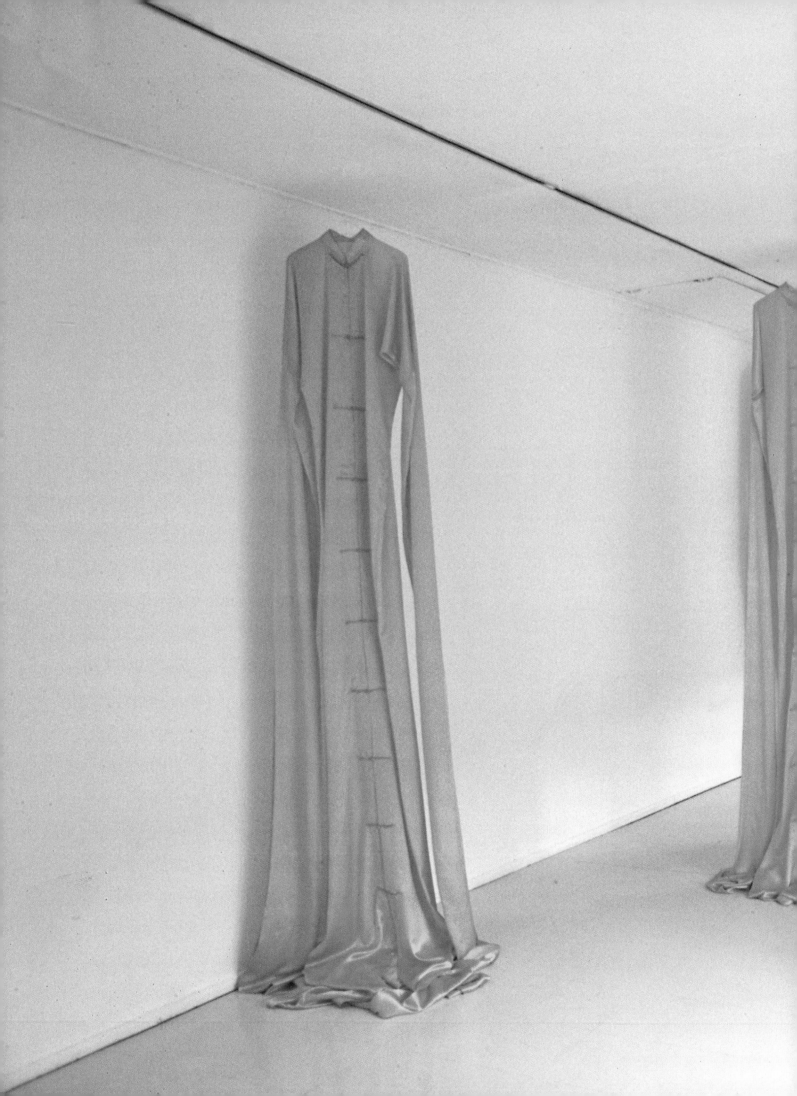

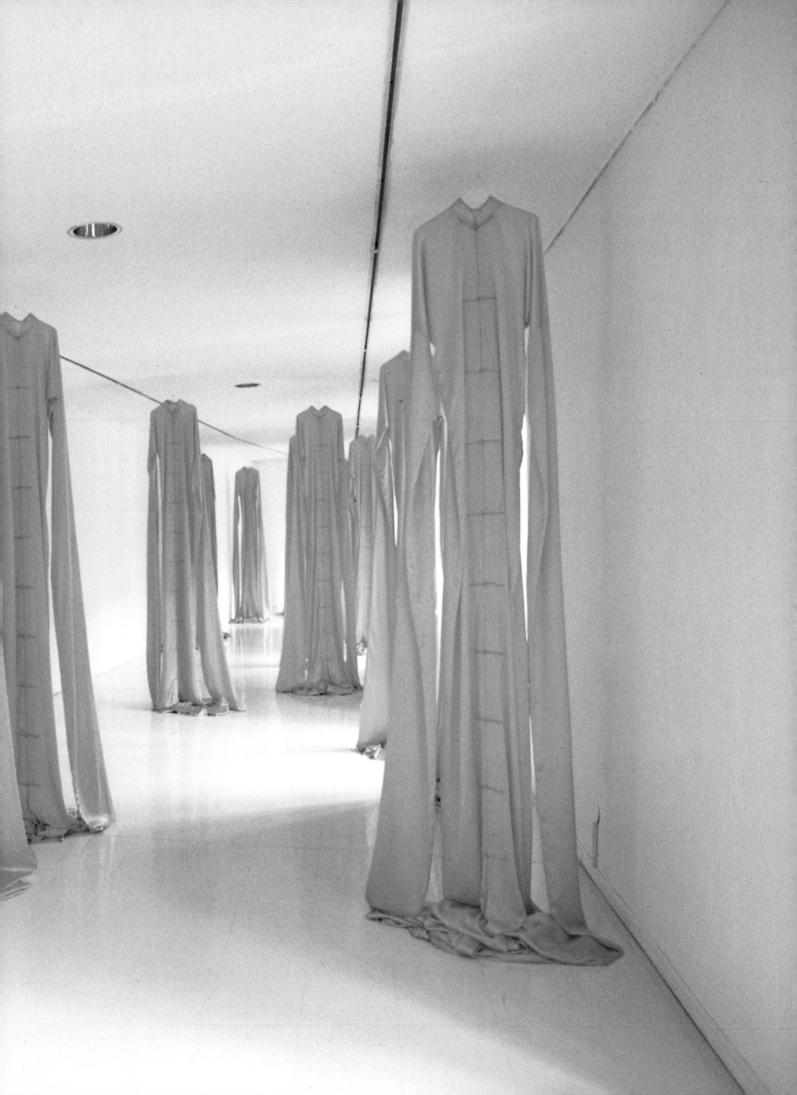

JEFFREY SHAW

born 1944 in Melbourne, lives in Karlsruhe

Solo Exhibitions (selection)

1997 *Place, A User's Manual*, Kunst- und Ausstellungshalle der Bundesrepublik Deutschland,
 Bonn
1989 *The Imaginary Museum of Revolutions* (with Tjebbe van Tijen), Brucknerhaus, Linz
1988 *The Legible City* (with Dirk Groeneveld), Bonnefanten Museum, Maastricht
1986 *Inventer la Terre*, La Villete, Paris

Group Exhibitions (selection)

1997 *conFIGURING the CAVE*, ICC, Tokyo
1994 *Ars Electronica*, Linz
 MultiMediale 3, ZKM Karlsruhe
1992 *The Binary Era*, Musée d'Ixelles, Brussels
1989 *Video-Skulptur 1963–1989*, Kölnischer Kunstverein, Cologne

Heaven's Gate, 1987, video and sound installation, Courtesy Jeffrey Shaw (ill. pp. 182–185)

The video projections and computer-generated, interactive installations of Jeffrey Shaw focus on the principles of perception and representation, indication and cognition. Perception is non-existent as a collective experience; it is constituted by an individual act. This realisation is conveyed in Shaw's works by means of novel visual and acoustic techniques. In the interaction with the screen, joystick, mouse or speech recognition system, the user is alone; communication with a machine remains an illusion. Still, the system reacts to the initiative of users, allowing them reflexively to experience themselves as members of a group, because communication takes place in the form of choices and progressions which, even though being governed by individual decisions, must be related to the decisions of other individuals as well. In *Narrative Landscape* the user, by choosing a certain position, works from the highest level down to the vertical depth of this installation, while the term "vertical depth" remains virtual; in fact, the different levels exist on one plane and the surface which emerges due to the defining of one's position is contained in the place where this decision is made. The "highest" level is comprised of a satellite picture which is completely covered by cabalistic signs. However, what are cabalistic signs in comparison with the pixels of the projected satellite picture structure? Neither is provided with a literary representation. The following levels which correspond to a linear sequence, even though they are not vertically structured, consist of landscapes and urban maps, supposedly objective systems of orientation, which, however, in the same manner as the third or fourth level—everyday scenarios and situations of dialogue as well as symbolic images and linguistic signs—are results of communicative agreements. To pass from one level to the next, the user must make an individual decision, determining the point at which to enter the surface, by clicking the mouse in order to proceed to the next image. The fact that all images are accessible from all levels is an experience which can be made only in the process of collective application and which becomes concrete through the ultimately logical return to the starting position or level. In the work *Heaven's Gate* the projection is independent of interventions by the viewer, since it generates images of Baroque domes and ceilings, romantic visions and satellite pictures of the surface of the earth independent from one another. Similar to *Narrative Landscape* the progression of images corresponds to the traditional notion of a hierarchical gradation, comprising the individual image, the collective image and the omnipotent image. Each is contained in the others, namely the place of the preceding image in the linear sequence. However, it is completely impossible to distinguish here at which point one image ends and the next one begins. In a virtuosic ballet of constant motion the domes and visions of outer space, the cosmos and the planets are generated apart from one another, certainly in an irreversible progression, but potentially permanently present.

As in the ceiling paintings of the Renaissance and the Baroque periods whereby the view into the heavens connected the individual with the divine cosmos, here the individual perceives a satellite picture or viewing of the surface of the earth or the heavens as a celestial being. Accordingly, the identity of the individual with the cosmos is a linear continuity which is expressed in *Heaven's Gate* without a relational manifestation being necessary. The visual realities are equal to one another and serve to integrate the viewer; the projection reflected by the mirrored floor, transposes the thematic component of the image sequence to the individual viewer. On the one hand, the recipients are aware of themselves as viewers of the work; at the same time, however, they are participants in the visual phenomena, aware of themselves in the role of visual phenomena. MM

OLGA TOBRELUTS

born 1970 in St. Petersburg, lives in St. Petersburg

Solo Exhibitions (selection)

1996 Art Kiosk Gallery, Brussels
 Olga Tobreluts, Computer Photographs, Sketches, New Academy of Fine Arts,
 St. Petersburg
 Photocentre, Copenhagen
 Aidan Gallery, Moscow
1994 *Computer Photographs*, Russian Ethnographic Museum, St. Petersburg

Group Exhibitions (selection)

1997 *Kabinet*, Stedelijk Museum, Amsterdam
1996 *Metaphern des Entrücktseins. Aktuelle Kunst aus St. Petersburg*, Badischer Kunstverein
 Karlsruhe
 Photobiennale, Moscow
1994–96 *Self-Identification. Positions in St. Petersburg Art from 1970 until Today*,
 Kunsthalle Kiel e.a.
1994 *III St. Petersburg Biennale*, Central Exhibition Hall Manege, St. Petersburg

Kate Moss, from: *Sacred Figures*, 1999, mixed media on watercolour paper, 100 x 70 cm,
Courtesy Art Kiosk Gallery and Foundation Brussels (ill. p. 188)
Linda Evangelista, from: *Sacred Figures*, 1999, mixed media on watercolour paper, 100 x 70 cm,
Courtesy Art Kiosk Gallery and Foundation Brussels (ill. p. 189)
Naomi Campbell, from: *Sacred Figures*, 1999, mixed media on canvas, 140 x 80 cm, Courtesy Art
Kiosk Gallery and Foundation Brussels (ill. p. 190)
Leonardo di Caprio, from: *Sacred Figures*, 1999, mixed media on canvas, 166 x 80 cm,
Courtesy Art Kiosk Gallery and Foundation Brussels (ill. p. 191)
Elvis Presley, from: *Sacred Figures*, 1999, mixed media on canvas, 166 x 100 cm, Courtesy Art
Kiosk Gallery and Foundation Brussels
Michael Jackson, from: *Sacred Figures*, 1999, mixed media on watercolour paper, 100 x 70 cm,
Courtesy Art Kiosk Gallery and Foundation Brussels
Morrison, from: *Sacred Figures*, 1999, mixed media on watercolour paper, 100 x 70 cm,
Courtesy Art Kiosk Gallery and Foundation Brussels
Claudia Schiffer, from: *Sacred Figures*, 1999, mixed media on watercolour paper, 100 x 70 cm,
Courtesy Art Kiosk Gallery and Foundation Brussels

When Olga Tobreluts mounts the faces of famous models and stars onto ladies and knights of a by-gone past and reshapes a persona through digital computer techniques, she creates a pastiche which indicates the emergence of a virtual figure highly in demand, namely, the avatar.

Avatars are imagined or virtual personae, to be encountered for example on the Internet. In the coming millennium, when cyberspace technology is sophisticated enough, the avatar might well replace the real figure and become a representation of the "ideal" self. It is the ultimate role-game, the absolute scenario of dramatic staging, the place where everyone may turn into the persona he secretly dreams to be, thus replacing, if not sacrificing his subjectivity, which will be buried once and for all in the matrix, that digital womb where the embryonic 'I' achieves its ideal formation.

Tobreluts belongs to the school of Neo-Academism which is centred in St. Petersburg around the charismatic figure of Timor Nobikov. Neo-Academism calls into question the hegemony of the avant-garde, viewing it as just one more trophy of the Western victory over a different ethos. It claims that the avant-garde movements were possibly unable to acquire the profile as codes of identification attached to them by the West. Thus, when Tobreluts combines the aesthetics of the classical tradition with strategies of sales promotion, she participates in a revival which employs sentimentality as a tool and which defines the "New" as a modification of the "Old", claiming a post-modern attitude which at the same time functions in a conservative and subversive manner. In this sense Tobreluts and her colleagues are the last bastion against the Western hegemony, in turning to the codes that hegemony regards as tactics of the past. It is against this background that her use of figures whose sole significance is to enhance Western ethics, capitalist as they may seem, such as Leonardo di Caprio or Kate Moss, or of icons relocated into a historical time before Western economics became decisive, appears in an ironical light and is justified. For those figures, shallow and sleek as they may seem, obtain an aura or "patina" which lets them appear almost as real icons in the manner of the saints and holy figures in the Russian tradition of iconic art. Those symbols of the Western system negate its values once they are reconstructed and incorporated into an older aesthetics.

Olga Tobreluts' divergent forms may also be regarded as transubstantiation simulacra, where the search of an identity is either a religious process or a terminal one which determines its total disappearance. The hybrid that she focuses on in her art works may be the true Narcissus, but it might also indicate that the avatars we dispatch to represent us are more real than we would like them to be; if, however, the representation becomes more real than the phenomenon it is supposed to represent, it may be high time to reconsider the options and change some principles. DLH

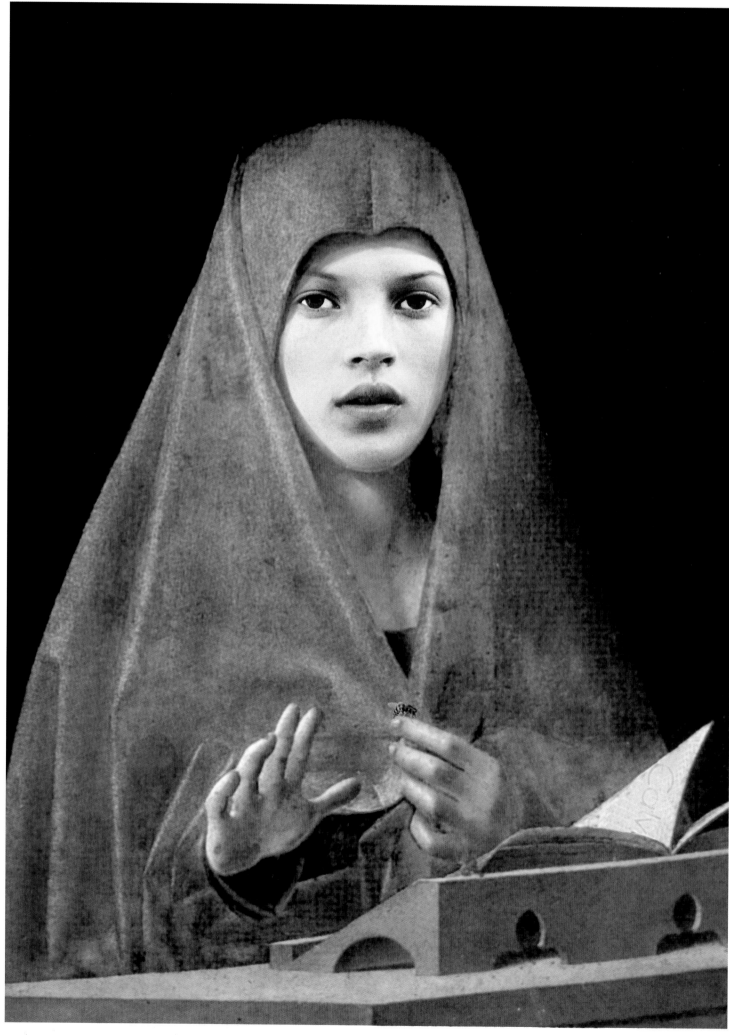

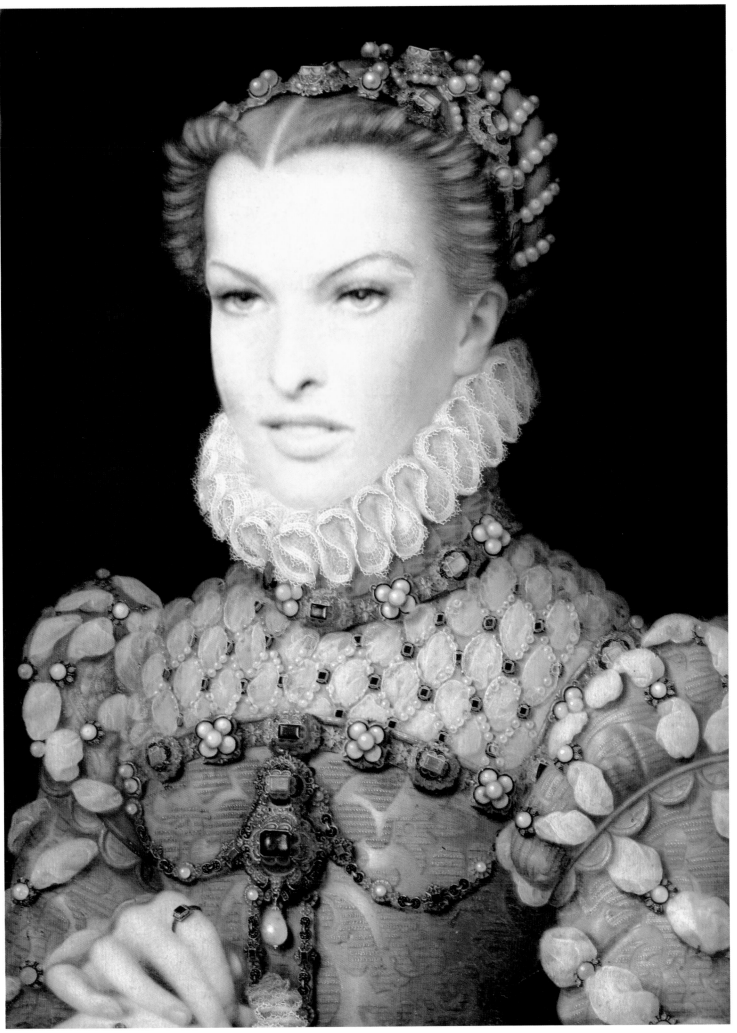

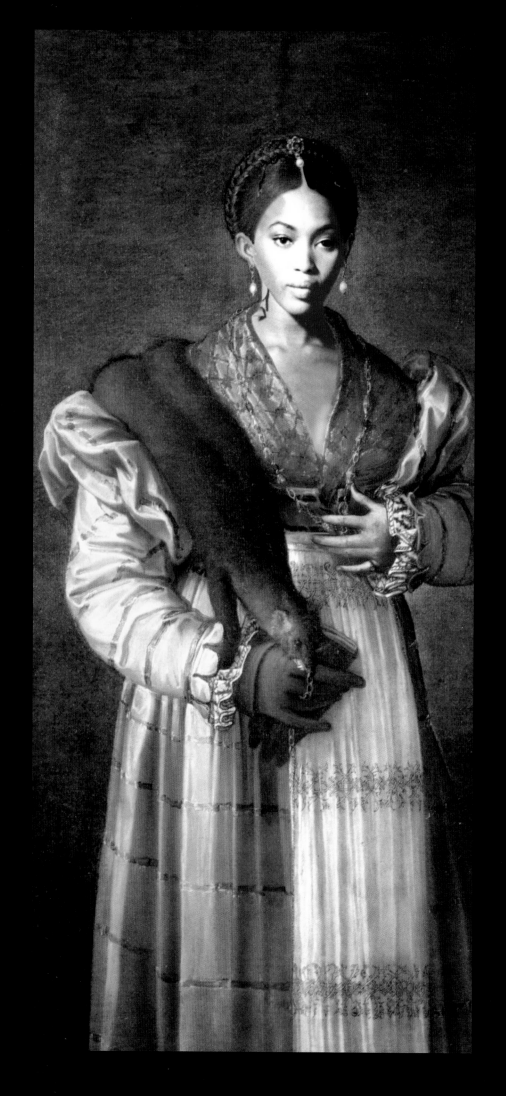

One functional description of a religion useful in distinguishing it from a philosophy is that it is a system of thoughts and images in which elements of the human body combine with elements of animal bodies to produce a conjunction before which people must reconsider their behaviour. Such a description suggests that, in Christianity at least, the bird wings on angels and the horns, hooves, tails, and goat-eyes in devils and demons are more to the point than the preaching of the insistently human Jesus and his disciples.

1885 gave us, in whole or in part, three great critiques of bourgeois morality, critiques that suggest their own alternatives without recourse to the notion of a personal afterlife to provide either ultimate rewards or ultimate punishments:

Friedrich Nietzsche's tract *Also sprach Zarathustra*, Walter Pater's novel *Marius the Epicurean*, and

Samuel R. Delany

HIS WING, HIS CLAW
BENEATH THE ARC OF DAY

George Seurat's great painting *La Grande Jatte*. All three lean on those human/animal correspondences that suggest religion. In all three, images of humans and animals—horses, serpents, monkeys, wolves, dogs—threaten to conjoin in some proto-religious figure.

Heaven can be menaced by a tower—by the concerted work of mankind speaking some prelapserian language of political unity.

The sky cannot.

Among contemporary U.S. English language writers of science fiction and fantasy, by far the most interesting to take on the Judeo-Christian kerygma as his field of interrogation is James Morrow. But in the range of that work, heaven gets fairly short shrift: in *Towing Jehovah* (1993), God has fallen *out* of the sky and his tremendous carcass floats in the sea, waiting to be pulled by a steamship to its Antarctic burial site. Whether it be the material air of Robert Boyle (1627–91) or in the air of the spirit, in the sky of early meteorologists, or in the skies of today's airline companies, in the space of the astrophysicist and rocket scientist, or in the universe of the theoretical physicist, the concept of "heaven" (along with that of "paradise") gets bypassed somewhere along this conceptual measure. In English, the terms "heaven" and "heavenly" carry a huge connotation of the feminine and femininity—and in a patriarchal society such as ours, often that is a sign that such concepts have moved wholly into the superstructure of discourse to become all but conceptually irrelevant, unless their use remains that of lying about something darker and less pleasant in advertising and popular songs.

A good deal of 19th century Romanticism (and that of its forerunners in the 18th) was a matter of coming to terms with the common-sense and scientific improbability of any sort of personal afterlife, realisations that went hand in hand with the expanding concept of the sky, the atmosphere, the space of the solar system, the deployment of stars in the galaxy and the range of galaxies in our corner of the universe: in short, the hugely extended concept of the night. Novalis introduced it into the gallery of romantic images. Wagner (in Act II of *Tristan*) set it to music. Indeed romantic night can be seen to displace a pre-romantic heaven.

The older theological question about where to pull all those bodily resurrections is displaced by the scientific realisation that there are simply no material relations either to translate or sustain them. Here heaven withers and, if it does not die, at least grows moribund.

Today, as the world becomes smaller and smaller and falls increasingly under the control of unconscious forces, heavenly and demonic chimera in their intermediate position between human and animal (and many others between human and machine) have increased in comic books and other popular iconographies, where they function as signs (rather than metaphors) of impossibility, paradox, contradiction, and negation: operations that alone make logic and reason possible, but which, as Freud reminded us, do *not* exist in the unconscious. These marvellous monsters depict the power,

the mystery, the incomprehensibility of those symbolic logic-facilitating operations unique to consciousness. These creatures inhabit a set of narratives that are open to an all too easy system of deconstruction; brawn standing for brain and brain standing for brawn. That such apparitions are often pictured in the sky should not, I think, be taken as a sign of their heavenly numinosity; rather their location makes them part of a pre-enlightenment image of materiality: they inhabit fire, water, earth *and* air.

For almost as soon as the sky grows any larger than the local arc of light or dark that stretches from horizon to horizon, heaven (as it were) collapses, tears loose from it, and falls in fragments to the earth.

New York City, February 1999

SYLVIE BLOCHER

born in Morschwiller/Alsace, lives in Paris

Solo Exhibitions (selection)

1998 *Living Pictures*, York Gallery, Toronto
1997 *Gens de Calais*, Le Chanel, Calais
1996 *Warum ist Barbie Blond?*, Der Kunstraum, Düsseldorf/Centre International d'Art
 Contemporain, Montréal
1995 *Living Pictures/L'Annonce Amoureuse*, Chapelle des Carmélites,
 Musée d'Art et d'Histoire, Festival du Cinéma, Saint-Denis

Group Exhibitions (selection)

1997 *P.S.1 open october 1997*, P.S.1, New York
1995 *Fémininmasculin. Le sexe de l'art*, Musée National d'Art Moderne
 Centre Georges Pompidou, Paris
1992 *French Window*, Chisenhale Gallery, London
 Viewfinder, Stichting De Appel, Amsterdam
1988 *Construction Image*, ARC, Musée d'Art Moderne de la Ville de Paris
 Aperto, Biennale di Venezia, Venice

Living Pictures/Are You a Masterpiece?, 1999, video istallation, 18 min., television screen, monitors, with the team *The Tigers,* Princeton, New Jersey, USA, Courtesy Galerie Art et Public, Geneva. With generous support from Philips France (ill. pp. 196–199)

Since Sylvie Blocher began to focus on video art, she has been working on a series of independent, but, thematically interlinked video works bearing the project title *Living Pictures*. Her overall approach regarding the project is the attempt "de rendre la parole aux images"—to reinstate speech in pictures. First of all, Sylvie Blocher investigates the formal, theoretical aspect of the contemporary art work and the process of its creation. After the increasing relativity and the ultimate dissolution of the consensus on the narrative and representational structures constituting a picture in the 20th century, the emergence of video art has opened up the possibility of countering the traditional model of the picture of an illusory three-dimensional space with a reflexive character through a highly technical and sophisticated medium acknowledged as innovative. In the conception of her works, however, Sylvie Blocher consciously rejects any kind of representative character to the work in favour of a form of presentation which she grants the highest possible amount of independence. Even though entering into a direct confrontation with her counterpart, i.e., the person that finally appears and acts in the video film, the criteria of selection are chosen according to non-artistic standards. The social, functional or institutional role which is conferred upon a particular circle of individuals fuses this circle into a pseudo-group, creating a community that lets itself be socially monopolised. Giving this community a voice is the thematic counterpart to the formal approach of reinstating speech in pictures. Every member of the pseudo-group individually gets a chance to speak and to articulate their own views, the refusal of making a statement always being an articulation in the sense of communication as well. The factor uniting these articulations is a basic question posed, or the request to comment on a particular thematic complex. This thematic complex may be linked to the assumed circumstances surrounding the life of the given community, to which it is causally related but from which it is definitely not derived, being rather of a more general significance and having a content that goes beyond the specific group or topic.

For her work *Living Pictures/Are You a Masterpiece?* Sylvie Blocher lets stars and heroes of the professional sports world answer essential questions regarding life. She gives them the opportunity to take a stand on philosophical subjects, letting them do their justice to the social position they hold on the grounds of their exceptional athletic and physical achievements. The sociological shift as well as the shift concerning the media has led to the phenomenon that, because of the global extent of their fame, personalities from the world of sports, music and media have replaced the role models in the fields of philosophy, religion and politics in regard to their significance in establishing a social value system. Since however, their contextual origin differs from those of the traditional role models, the content and focus of this value system has also shifted. In *Living Pictures/Are You a Masterpiece?* these individuals are now confronted with questions regarding life and death, belief and meaning, art and religion, philosophy and society, i.e., questions derived from the traditional value system of the Western world. The personalities, worshipped by their fans as god-like stars, are asked to make statements on a value system which is not at all questioned in regard to its social relevance, whose presence in the media and its dominance in establishing orientations, however, are increasingly being superimposed by the presence of a context in the media, whose creations are the heroes being asked to state their views. The discrepancy that becomes obvious here between status and claim, on the one hand, and expectations or rather idealisation, on the other is characteristic of the prevailing shift of relevance and the irritations in regard to social models, political value systems and communicative contexts. Sylvie Blocher is opposed to a misdirected and misunderstood brand of feminism that confuses authority and a specific goal with power and control, forgetting its actual sources in the process and overlooking its specific core, putting itself on one level with the dominance of machismo instead of developing its potential in favour of a visionary social model. In Blocher's project *Living Pictures* she turns against the identity of image and representation and the misunderstanding it gives rise to regarding the information conveyed by the media and its relevance as far as content is concerned, i.e., between image and presence. Moreover, Sylvie Blocher's *Living Pictures* enable the presentation of a picture as an appearance identical to itself, whose existence is considered to be a primary element under the contemporary conditions of reality. The fact that this phenomenon and not the represented individual is the subject of expression belongs to the major realisations of video art as a communicative factor of the media age. MM

Wer haßt Künstler? Haben Sie einen Stil? Ist Schönheit teuer? Was ist gute Technik? V
kopulieren Götter? Gehört Ihnen Ihr Körper? Gibt es ein Bild über Ihrem Bett? Wann füh
Sie sich weiblich? Warum Feigenblätter vor den Genitalien? Sind Sie Muskelmasse oc
Fleisch? Haben Götter Angst vor Sex? Warum gibt es mehr Bilder nackter Frauen als nack
Männer? Wie sieht das Haus Ihrer Träume aus? Benutzen Sie Ihre Muskeln um anzugebe
Sollten Maler sich mit Anatomie auskennen? Was sammeln Sie? Sind Sie ein Meisterwer
Sind Sie stolz auf Ihr Image? Was ist der Unterschied zwischen einem Gott und einem Ha
gott? Ist Sport eine Kunst der Droge? Mögen Sie lieber Marilyn Monroe oder die Jungfr
Maria? Was ist eine verbotene Geste? Warum träumen Faschisten von großen Stadien?
es besser reich oder gutaussehend geboren zu werden? Sollte ein Mann seine Gefü
zeigen? Ist Pornographie Kunst? Stehlen reiche Länder Kunst aus ärmeren? Woran erkenn
Sie einen Künstler? Gibt es so etwas wie eine Kunst für die Oberklasse? Körperhaare si
schön oder häßlich? Gefällt es Ihnen, wenn jemand Sie anschaut? Was ist ein guter Betrad
ter? Passen Kunst und Religion zusammen? Was ist puristische Kunst? Welcher Künst
wären Sie gerne gewesen? Wer gerät schneller aus der Mode, Künstler oder Athleten? Si
Sie ein Original oder eine Kopie? Sind Sie ein Meisterwerk? Gehört Kunst allen? Sind Rass
ten gegen Kunst? Sind Stadien Museen? Ist Kunst Wettbewerb? Macht Ruhm verrück
Sind Künstler beispielhaft? Wird jemand Künstler, weil er mit seinen Eltern nicht zurec
kommt? Wieviel verdienen Sie? Ist Sensibilität gefährlich? Wann nutzt Kunst Not zu ihre
Vorteil? Ist Schönheit ein Luxus? Sind Gefühle was für Frauen? Haben Sie Erfolg wegen Ih
Technik oder wegen Ihres Talents? Sind Athleten Künstler des Körpers? Retten Athleten c
Welt? Athleten nehmen Drogen, tun Künstler das auch? Kennen Sie die Macht Ih
Images? Was akzeptieren Sie nicht als Kunst? Mögen Sie Kunst? Wer haßt Kunst? Was
schlechte Kunst? Muß man ehrlich sein, um Kunst zu machen? Besitzen Sie Möbelimitat
Haben Sie einen Stil? Ist Michael Jordan ein Gott oder ein guter Verkäufer? Wen bevc
zugen Sie, Madonna oder Mona Lisa? Wie sieht Ihre Tapete aus? Ist kalifornischer Cha
pagner ein Ready-made? Was ist ein schöner Athlet? Was ist ein mangelhafter Körpe
Sehen Athleten besser aus als andere Leute? Was ist Lebenskunst? Was ist Kampfkuns
Warum sagt man "schön wie ein griechischer Gott"? Warum sagt man "häßlich wie ei
Kröte"? Was ist ein perfekter Körper? Welche Art Bilder hassen Sie? Gibt es etwas Kün
lerisches in Ihrer Arbeit? Was ist ein Amateur? Wie erkennt man einen Profi? Können S
den bestaussehenden Teil Ihres Körpers beschreiben? Ist Schönheit teuer? Ist Schönh
nützlich? Ist das Himmelreich ein Museum? Können Sie eine häßliche Frau beschreibe
Warum hat Barbie keine Geschlechtsteile? Machen Sie einen Unterschied zwischen Warh
und Picasso? Ist ein Poster ein gedrucktes Gemälde? Sind Athleten reicher als Künstler? W
ist ein Halbgott? Was steht bei Ihnen auf dem Fernseher? Was ist der Unterschied zwisch
hübsch und schön? Was ist das Sublime? Sehen Sie besser von vorne oder von hinten au
Ist Publicity eine Propagandakunst? Was ist "entartete Kunst"? Können Sie den häßlichst
Teil Ihres Körpers beschreiben? Was ist Zensur? Wer zensiert Kunst? Macht Kunst Sie ziv
sierter? Mögen Sie die Bilder von Sylvester Stallone? Wen tadeln Sie? Beurteilen Sie Leu

ch ihrem Aussehen? Sollten männliche Geschlechtsteile dargestellt werden? Was ist Ihr

l? Was ist wahre Schönheit? Ist Größe gleichbedeutend mit Qualität? Ist Stierkampf eine

t von Perfektion? Ist eine Hinrichtung ein ästhetisches Spektakel? Haben Sie Geschmack?

ben Frauen soviel Technik wie Männer? Sollte Vergnügen geteilt werden? Bevorzugen

abstrakte oder figurative Malerei? Was ist ein schlechtes Bild? Sagen Sie, "mein Kind

lte das werden"? Sagen Sie, "Kunst ist zu teuer"? Sagen Sie, "das verstehe ich nicht"?

ngt Kunst Sie zum Weinen? Haben Sie jemals nackt posiert? Ist Fernsehen Kunst für die

assen? Warum werden Künstler getötet? Wie sehen Götter aus? Ist Ihre Mutter ein Meis-

werk? Benutzen Sie Ihre Muskeln um anzugeben? Sollten Maler sich mit Anatomie aus-

nnen? Welche Strategie benutzen Sie um zu verführen? Sind Künstler Schwächlinge?

ögen Sie lieber Lady Di oder Claudia Schiffer? Warum sagt man "hübsch, aber dumm"?

nd Strumpfbänder schön oder praktisch? Was ist nationalistische Kunst? Ist ein Auto eine

ulptur? Ist Kunst eine Macht? Was ist das Geschlecht von Emotionen? Was erwartet

nst von uns? Kann Kunst beeinflußt werden? Worin besteht der Unterschied zwischen

nst und Kommunikation? Ist Kunst frauenfeindlich? Was ist eine Muse? Passen Kunst

d Sex zusammen? Sind Schauspielerinnen Jungfrauen? Gibt es in der Kunst Machtphan-

sien? Woran erkennt man ein Meisterwerk? Ist Zerbrechlichkeit Schwäche? Ist Kunst das

heime Objekt der Begierde? Welche Bilder sammeln Sie? Sind Sammler besessen? Ge-

ren Museen allen? Warum sind Gedenkstätten an die Gefallenen des Kriegs Kunst-

erke? Stehlen reiche Länder Kunst aus ärmeren? Was ist erotische Kunst? Was ist ein

bu? Gibt es so etwas wie Kunst für die Oberklasse? Gibt es so etwas wie Kunst für das

lk? Ist Körperbehaarung schön oder häßlich? Ist ein Penis ein Schönheitsideal? Wann

werben Museen geraubte Kunst? Sind Künstler schuldig? Passen Kunst und Religion

sammen? Was verbergen Sie? Wie achtet Kunst auf Begierde? Was ist Mutwille? Ist der

ifall der Menge etwas religiöses? Woraus bestehen Ihre künstlerischen Frustrationen?

er gerät schneller aus der Mode, Künstler oder Athleten? Sind Sie ein Original oder eine

pie? Sind Götter sublim? Sollten wir Landschaften oder Stilleben malen? Ist es leichter

sus zu malen als Gott? Wann geben Sie an? Gehört Kunst allen? Ist Ihr Vater ein Gott? Ist

unst Wettbewerb? Ist Sport die erste der Künste? Sind Athleten große Künstler? Wären

e lieber eines der Spice Girls gewesen oder Lou Reed? Was ist amerikanische Kunst?

acht Ruhm wahnsinnig? Erzeugt Kunst Begierde? Ist Jazz Kunst armer Leute? Schafft der

n den Künstler? Schafft der Fan den Gott? Was ist teuflische Schönheit? Was ist Zügel-

sigkeit? Gibt es Kunst für Götter? Ist Kunst eine Ware? Ist Kunst obszön? Ist Sensibilität

efährlich? Ist Erfahrung notwendig? Wann sind Sie entblößt und wann sind Sie nackt?

orrumpiert Geld die Kunst? Ist der Künstler ein Diktator? Sind Götter schlechte Künstler?

das Himmelreich gut gestaltet? Zieht Kunst aus Not ihre Vorteile? Bevorzugen Sie

, eine Ikone oder ein Halbgott zu sein? Könnte ein Künstler Präsident der Vereinigten

aaten sein? Müssen Künstler leiden, um wahrhaftig zu sein? Sind Götter im Himmel

cher? Träumen Künstler davon, Helden zu sein? Wer ist der größte Künstler der Welt?

nd Sie erfüllt? Glauben Sie, daß Künstler die Welt retten können? Sind Götter Vergangene

Are stadiums museums ?

Do you have a style ?

What is a good technique ?

Who hates art ?

Are you a god or a demi-god ?

Is fragility a weakness ?

Is beauty expansive ?

Are you an original or a cop...

Is art competiti...

Are you going t...save

Are you a masterpiece ?

world ?

Living Pictures / Are you a masterpiece ? Sylvie Blocher

Simulation of the installation with international athletes › Video projection 3,50x2,75m in a blue room › Questions on TV › 1995-99

ORLAN

born 1947 in Saint-Étienne, lives in Paris

Solo Exhibitions (selection)

1999 Galerie Yvonamor Palix, Paris
1996 *J'ai donné mon corps à l'art*, Zacheta Gallery, Warsaw
 Orlan, Contemporary Art Center, Cincinnati
1995 *Rétrospective Vidéo Performance*, Musée National d'Art Moderne
 Centre Georges Pompidou, Paris
1993 *Orlan*, Rijksakademie van Beeldende Kunsten, Amsterdam

Group Exhibitions (selection)

1999 Israel Museum, Jerusalem
1996 *Hybrids*, Stichting De Appel, Amsterdam
 Totally Wired, ICA, London
1995 *Art Futura*, Museo Reina Sofia, Madrid
 Biennale d'art contemporain et des nouvelles technologies, Lyon
1994/95 *Positionen zum Ich*, Kunsthalle Kiel
1994 *L'Art Français de 70 à 90*, Galleria d'Arte Moderna, Bologna
 The Body as Site, ICA, London
1993 *Ars Electronica*, Landesmuseum Linz
1990 *Biennial of Innovative Visual Art*, Glasgow/London
1989 *Bilderstreit*, Art Cologne, Cologne
1986 *Biennale di Venezia*, Venice

Opération réussie, 1990, video, Courtesy Stephan Oriach, Paris (ill. pp. 204/205)
3 Reliquaires: Happening au bloc opératoire, 1993, metal, glass, synthetic resin, body tissue,
30 x 30 x 5 cm, Courtesy Galerie Yvonamor Palix, Paris
3 Reliquaires: I gave my body to art, 1993, metal, glass, synthetic resin, body tissue,
30 x 30 x 5 cm, Courtesy Galerie Yvonamor Palix, Paris
3 Reliquaires: This is my body, this is my software, 1993, metal, glass, synthetic resin, body tissue,
30 x 30 x 5 cm, Courtesy Galerie Yvonamor Palix, Paris
4 Reliquaires: My flesh, my text and the languages, 1993, metal, glass, synthetic resin, body tissue,
100 x 90 x 12 cm, Courtesy Galerie Yvonamor Palix, Paris (ill. p. 202)
4 Reliquaires: My flesh, my text and the languages, 1993, metal, glass, synthetic resin, body tissue,
100 x 90 x 12 cm, Courtesy Galerie Yvonamor Palix, Paris (ill. p. 203)
4 Reliquaires: My flesh, my text and the languages, 1993, metal, glass, synthetic resin, body tissue,
100 x 90 x 12 cm, Courtesy Galerie Yvonamor Palix, Paris
4 Reliquaires: My flesh, my text and the languages, 1993, metal, glass, synthetic resin, body tissue,
100 x 90 x 12 cm, Courtesy Galerie Yvonamor Palix, Paris

Orlan's body is the arena in which her artistic work takes place. She has undergone plastic surgery numerous times, the sole purpose of these operations being their significance as art performances. She had her face and her body transformed, even having artificial bumps added above her eyes, touching a nerve of the art public, which despite having seen most everything, had seldom experienced such an extreme incorporation of the artist into a work of art. Orlan is both the sacrifice and the priest of a ritual sublimated in the course of time into a work art. The operations Orlan has carried out on herself bear traces of Mayan rites of sacrifice, in which Bataille saw an act of supreme identification and continuity, involving masters and victims and showing parallels to erotic practices, where the notion of suffering is secondary to the ideas of union and concomitance.

The similarity between Orlan's performances and the Mayan human sacrifice rite goes beyond the identification process inherent in both events. The analogy has to do with the notion of suffering, which is formulated in a reverse manner by the Mayan ritual and by Orlan's art practice. Whereas in the Christian ethos suffering is a virtue and a means of salvation, i.e., the very *raison d'être* of God in relation to his believers, in the Mayan procedures and in the art concept of Orlan it ceases to be a valid currency and turns into a by-product of a process whose methods of purification have nothing in common with purgative aims.

On the operation table the body becomes meat. It even loses its dignity as human flesh, moreover, ceasing to exist as a counterpart to the spirit. Its immanence at this moment is bought at the cost of its spirituality, its suffering at the price of an aware consciousness. During Orlan's operation, however, it is not the sleep of reason that is taking place. Locally anaesthetised, she continues reading her credos, conversing with her doctors, commanding her surroundings, while her body is tortured, reshaped and re-formed. Taking up this stance, Orlan stages her body as a site of revolution and her operation becomes a crusade against religious and social dogmas, for her manner of protest inverts the notion of the body as a holy image. It is not the image of God which it reflects but the transformed image. It is not the humanity of the body which represents God. In fact, the body represents an abundance of metaphors far removed from God, thus becoming the rhetorical venue of the secular domain.

Today, people transform their bodies in many ways; particularly women do so in order to adapt it to and integrate it into the system of power relations it represents. For the body to become a commodity, it must fulfil a certain number of specifications which the social system can accept. Critique against the mutilation of the body is rooted in both secular and religious dogmas, both regarding the image of the body as distinguished from its immanent status. Orlan, aware that the image is more important than the reality it represents, offers another perspective, employing metaphors which dignify the substance itself, reinstating it in its prior role of serving as the habitat of change rather than as the sphere of acceptance. DLH

".....'' ΤΟ ΚΟΙΝΟ ΤΕΡΑΣ, ΜΕ ΤΑΤΟΥΑΖ, ΑΜΦΙΔΕΞΙΟ, ΕΡΜΑΦΡΟΔΙΤΟ ΚΑΙ ΜΙΓΑΣ, ΤΙ ΘΑ ΜΠΟΡΟΥΣΕ ΝΑ ΜΑΣ ΔΕΙΞΕΙ ΤΩΡΑ, ΚΑΤΩ ΑΠΟ ΤΟ ΔΕΡΜΑ ΤΟΥ, ΝΑΙ ΤΟ ΑΙΜΑ ΤΟΥ ΚΑΙ ΤΗ ΣΑΡΚΑ ΤΟΥ. Η ΕΠΙΣΤΗΜΗ ΑΣΧΟΛΕΙΤΑΙ ΜΕ ΟΡΓΑΝΑ, ΛΕΙΤΟΥΡΓΙΕΣ, ΚΥΤΤΑΡΑ ΚΑΙ ΜΟΡΙΑ ΓΙΑ ΝΑ ΜΑΡΤΥΡΗΣΕΙ ΣΤΟ ΤΕΛΟΣ ΟΤΙ ΕΔΩ ΚΑΙ ΠΟΛΥ ΚΑΙΡΟ ΔΕΝ ΓΙΝΕΤΑΙ ΠΛΕΟΝ ΛΟΓΟΣ ΓΙΑ ΖΩΗ ΣΤΑ ΕΡΓΑΣΤΗΡΙΑ. ΑΛΛΑ Η ΕΠΙΣΤΗΜΗ ΠΟΤΕ ΔΕΝ ΧΡΗΣΙΜΟΠΟΙΕΙ ΤΗ ΛΕΞΗ ΣΑΡΚΑ, ΠΟΥ ΑΚΡΙΒΩΣ ΔΕΙΧΝΕΙ ΤΟ ΣΥΝΟΛΟ, ΣΕ ΚΑΠΟΙΟ ΣΗΜΕΙΟ ΤΟΥ ΣΩΜΑΤΟΣ ΕΔΩ ΚΑΙ ΤΩΡΑ, ΜΥΩΝ ΚΑΙ ΑΙΜΑΤΟΣ, ΔΕΡΜΑΤΟΣ ΚΑΙ ΤΡΙΧΩΝ, ΝΕΥΡΩΝ ΚΑΙ ΔΙΑΦΟΡΩΝ ΛΕΙΤΟΥΡΓΙΩΝ, ΠΟΥ ΕΠΟΜΕΝΩΣ ΠΕΡΙΛΑΜΒΑΝΕΙ ΑΥΤΑ ΠΟΥ Η ΕΙΔΙΚΗ ΓΝΩΣΗ ΑΝΑΛΥΕΙ ''

..."WHAT CAN THE COMMON MONSTER, TATTOOED AMBIDEXTROUS, HERMAP HRODITE AND CROSS-BRED, SHOW TO US RIGHT NOW UNDER HIS SKIN? YES, BLOOD AND FLESH. SCIENCE TALKS OF ORGANS, FUNCTIONS, CEL LS AND MOLECULES TO ACKNOWLE DGE THAT IT IS HIGH TIME THAT ON E STOPPED TALKING OF LIFE IN THE LABORATORIES ● BUT SCIENCE N EVER UTTERS THE WORD FLESH WH ICH, QUITE PRECISELY, POINTS OU T THE MIXTURES IN GIVEN PLACE OF THE BODY, HERE AND NOW, OF MUS CLES AND BLOOD, OF SKIN AND HAI R, OF BONES, NERVES AND OF THE V ARIOUS FUNCTIONS AND WHICH HENC E MIXES UP THAT WHICH IS ANALYZED BY THE DISCERNING KNOWLEDGE" ...

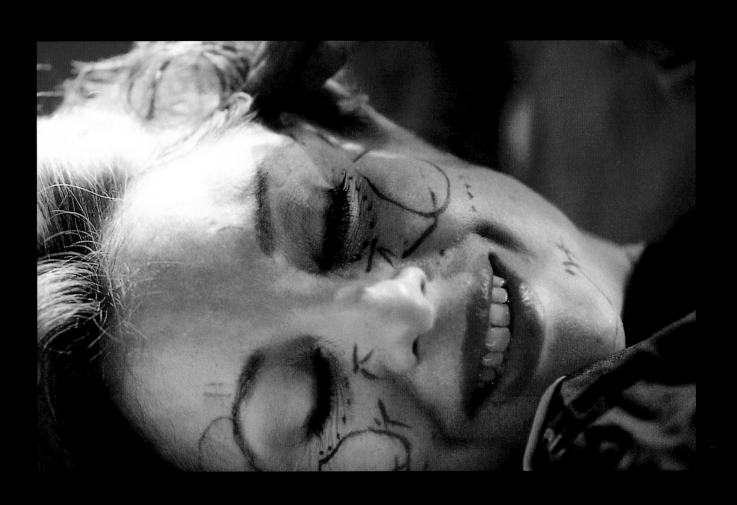

GILBERT & GEORGE

Gilbert, born 1943 in the Dolomites/Italy, George, born 1942, in Devon/England, live in England

Solo Exhibitions (selection)

1998	*New Testamental Pictures*, Museo di Capodimonte, Naples
1997	*Gilbert & George*, Musée d'Art Moderne de la Ville de Paris
1996	*The Naked Shit Pictures*, Stedelijk Museum, Amsterdam
1992	*The Cosmological Pictures*, Kunsthalle Zürich
1990	*Pictures 1983–88*, Central House of the Artists, Moscow
1987	*Pictures 1982 to 1985*, The Hayward Gallery, London
1985	*Gilbert & George*, The Solomon R. Guggenheim Museum, New York
1981	*Photo-Pieces 1971–1980*, Kunsthalle Düsseldorf

Group Exhibitions (selection)

1998	*Art Treasures of England*, Royal Academy of Art, London
1995	*Attitudes/Sculptures*, capc Musée d'art contemporain, Bordeaux
1994	*Couplets*, Stedelijk Museum, Amsterdam
1991	*Metropolis*, Martin-Gropius-Bau, Berlin
1989	*Bilderstreit*, Art Cologne, Cologne
1987	*British Art in the 20th Century*, Royal Academy of Art, London
1984	*Content*, Hirshhorn Museum and Sculpture Garden, Smithsonian Institution, Washington D.C.
1981	*Westkunst*, Cologne
1978	*Documenta 6*, Kassel
1976	*Arte Inglese Oggi*, Palazzo Reale, Milan
1972	*Documenta 5*, Kassel
1971	*Prospect 71*, Kunsthalle Düsseldorf

Bend It, from: *The World of Gilbert & George*, 1981, video, The Arts Council of England, Courtesy Gilbert & George/The Arts Council of England (ill. pp. 208/209)

The world of Gilbert & George rotates around individualism, social dispositions and moral categorisations from which the artists attempt to free themselves. This attempt is intended as an act of liberation from established and traditional social norms, comparable to the feminist emancipation movements or pacifist social models in the 20th century.

The duo presents itself as a living art work in performances or as singing sculptures. Book editions and publications in magazines, photo-series and films complete the holistic approach characteristic of their artistic concept in which, drawing upon their own personal environment, they investigate the psychological, social and political situations that are increasingly recognised as being causally linked to one another. In a paradigmatic analysis Gilbert & George establish their own environment and the experiences relating to this personal world and to themselves as an absolute, enabling the recipients through experiencing the works that emerge from this analysis to relate to it on their own terms.

The extreme compulsiveness of moral canonisation and basic social standards becomes explicit in their works. As Gilbert & George themselves report, many of their works are regarded by the viewer as a liberation and salvation from a condition which is experienced as a conflict between personal, emotional needs and the social claims postulated by the environment. They present an alternative and subversive possibility of dealing with and defining social constraints in the extremely ritualised form they render their own lives and in the corresponding staging of their performances. By focusing on the exceptional social situation and by explicitly and consequently celebrating this state, Gilbert & George conquer the normative canon, opening up an ideal vacuum which offers the recipient a space for reacting and in the case of social victims even a means for identification.

The fact that the number of these victims is much higher than appears to be alleged by the social canon of moral and traditional norms is a fundamental conviction conveyed in the works of Gilbert & George. Corresponding totally in their outward appearance to the image of bourgeois propriety and inconspicuousness, Gilbert & George do not rely in their performances, photographic works and films on the explosive and spectacular effect, but rather make use of the methods of subversion and irritation. In the process they let the realisations and experiences drawn from their own emotional and psychological situation appear in an exaggerated manner as a general state of sociological and human normality; and in their ostentatious acceptance of society the artists' statements develop a far higher amount of emotional and ideal persuasiveness than mere shock effects would achieve. The continuity and persistence of the works of Gilbert & George as a whole prove this method to be feasible.

In the works of Gilbert & George the world of art as an instrument of the traditional power of social standards constitutes, so to speak, the battlefield of the analysis. In their large tableaus the images derived from the microscopic and photographic investigation of body fluids and excrements are juxtaposed to words and images on a traditional scale, creating an allegory on the human condition in the same manner as the ritualised dialogues, motions and scenes of action that are staged in films and photo-series. The dramaturgical coherence which is inherent in all of the artists' work, as well as the conceptual cohesiveness of these works, generates a quasi-religious, quasi-psychological parallel world, whose laws, course of events and values appear like the rites, cults and allegories of a myth of creation. In this fundamental meaning and the powers of persuasion that result from it, the promise of a vision fulfils itself for the artists as well as for the viewers, particularly for those who recognise themselves in the situations evoked and in their ideal impulses, comparable to the hope and faith that accompany a religious outlook on life. MM

VIKTOR & ROLF

born 1969, live in Amsterdam

Solo Exhibitions (selection)

1999 Defilé couture summer 1999, Espace Carole de Bona, Paris
 Fashion exhibition, Brooklyn Bridge, New York
 Mariage, Musée Galliéra, Paris
1998 Défilé couture winter 1998/1999, Musée Galliéra, Paris
 Défilé couture summer 1998, Galerie Thaddaeus Ropac, Paris
1997 *Biceps & Bijoux*, Villa de Noailles, Hyères
 Le regard noir, Stedelijk Museum, Amsterdam
1996 *Launch*, Torch Gallery, Amsterdam

Group Exhibitions (selection)

1998 *New Acquisitions*, Groningen Museum
 Roommates, Museum van Loon, Amsterdam
1994 *Winter of Love*, PS1, New York
 L'Hiver de L'Amour, Musée d'Art Moderne de la Ville de Paris
 L'Ecole d'Aeole, Institut Néerlandais, Paris

Spring/Summer Couture 1999, 1999, video, silk, silk gauze, Courtesy Viktor & Rolf (ill. pp. 212/213)

For a number of years now, following the cycles of the fashion season, Viktor and Rolf from the Netherlands have been designing collections which they present in spectacular *haute couture* shows. Still, their collections cannot be acquired by interested customers, they are not offered for sale in exclusive shops and are not manufactured. Serial production would anyhow not correspond to the principle of *haute couture*, which contrary to *prêt-à-porter* designs, is made-to-measure. The respective model is custom-made for the prospective owner according to the designs of the *couturier*. This traditionally very complex, expensive and ultimately also rather dated method is increasingly going out of fashion. After the dictates of fashion and a uniform style of clothing have been replaced by a large variety of styles and a notion of fashion which bears more similarities to an image campaign than to the creation of a valid design, many fashion houses have decided to abandon this highly unprofitable line of business. Others attempt to lend *haute couture* a new thrust through scandalous dramatic stagings and innovative designers. But the profits of their brand name are also gained through products other than those of *haute couture*.

Viktor and Rolf produce installations, video films and photo-series for exhibitions in museums and galleries, employing the image machinery of the fashion world, the mechanisms of achieving brand awareness and the instruments of a global media apparatus. Thus, in 1996 they launched the perfume *Viktor & Rolf Le Parfum*; a bottle was manufactured, a label designed, an advertising campaign carried out without, however, actually putting a new perfume onto the market. The result of this work is a series of editions and the virtual existence of a brand name which is identical with the product. In the same manner both artists conceive of themselves as a creation as well, whose identification with the name is proof of existence in itself.

While numerous avant-garde fashion designers attempt to achieve an innovative, modern and socially conscious image for their profession, Viktor and Rolf question the essential features and mechanisms of the fashion industry, using the criteria of artistic methods. They lend their collections, shows and individual works, installations and photographs a unique character by incorporating the media. Fashion shows which are recorded on video and are celebrated with spectacular performances are viewed by Viktor and Rolf as an artistic analysis of genre-specific characteristics whose references are derived just as in art from various social systems and notions of reality. As an inherent part of this reference system their collaboration, for example, with Inez van Lamsweerde or their contact to stars of the music, film and art world belong to the conceptual structure of the artists' work in which the articulation is both the subject as well as the result of the analysis. The fact that the virtual production and the authentic claim are indistinguishable is intentional, the self-stylisation of the creative act is identical with the devotion to the conception of the work. MM

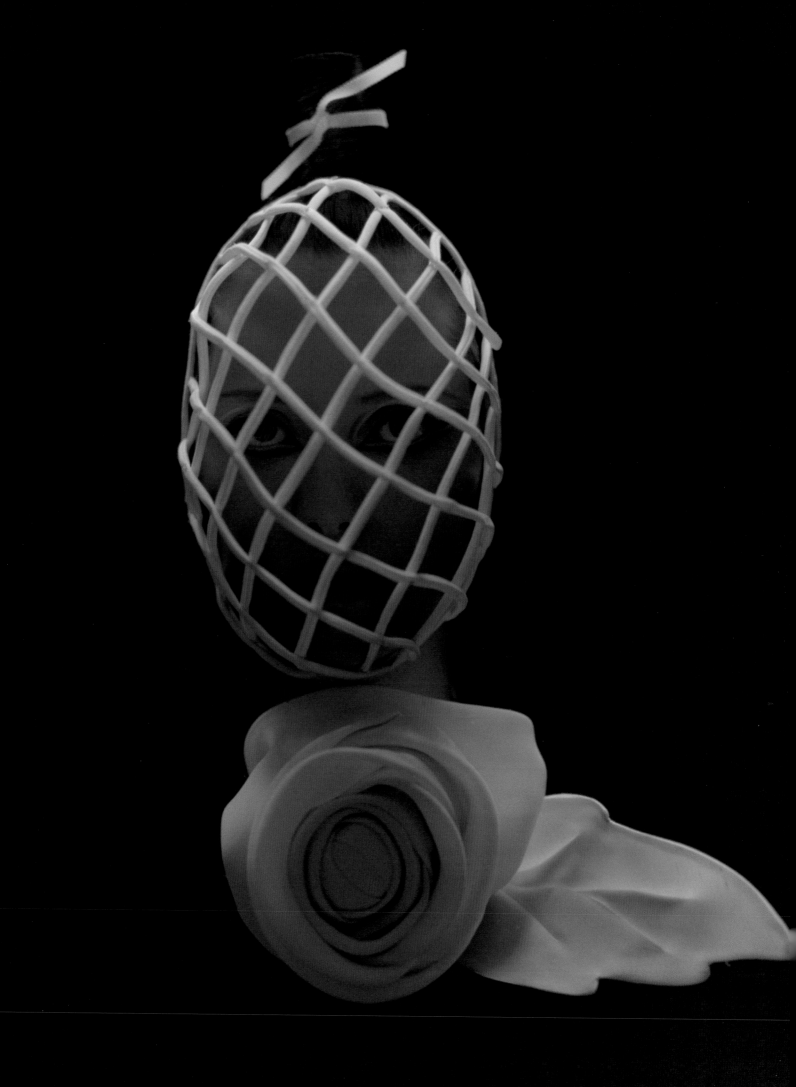

EDDO STERN

born 1972 in Tel Aviv, lives in Los Angeles and www

Solo Exhibitions (selection)

1999 *Runners*, A402 Gallery, Valencia, CA
1999 *French Philosophers Protest Dinner*, Works Gallery, San Jose, CA
1996 *Land Control Structure: Hexagon*, Bridge Gallery, Santa Cruz, CA

Group Exhibitions (selection)

1999 *I.M.L.A Group Show*, Bradbury Building, Los Angeles
1997 *Irwin Scholars Group Show*, J.B. Hall Gallery, Santa Cruz, CA

Runners, 1999, computer installation/internet performance, mixed media, computer projections, software, Courtesy Eddo Stern, illustrations from: Dark Vengance™ © Reality Bytes Inc., 1998; Everquest™ © Sony Computer Entertainment America Inc., 1999. With kind support of Intergrated Media Department, California Institute of Arts (ill. pp. 216–219)

Eddo Stern presents three projection screens, each depicting a character borrowed from and operating in the virtual space of *Everquest*, a highly sophisticated online game set in virtual reality, where participants can act out different roles. With a mouse participants can control all three characters, who simultaneously navigate a separate area of the game world respectively. Thus, at any given moment one character can be located in a medieval city, another may climb a mountain and a third might be prowling a dungeon. The participant is forced to make a decision about which character to embody and which to abandon, while a varying web-audience of thousands follows his or her performance in the game online.

It is amazing that the narrative unfolding in the virtual space has a closer affinity to phantasm than to science fiction. The whole paraphernalia of fairy-tales, heroic deeds and mythological figures are based on a world view that places magic before science and prejudice before fact. Science in its most progressive stage, bearing information on outer space, is inverted to serve under the spells of magic. William Gibson documented this tendency in his trilogy as well as Neil Stephenson or John Varley and the numerous games based on such narratives testify to a deep need for the unexplainable sustained through rational means.

The archetypes of the virtual world may be banal and rooted in a collective memory that persistently continues to exist, yet they may all be classified under the generic term of the "avatar". He is at the centre of the game's attraction, the figure to fulfil the dream.

Avatars are representations of the self participating in the game. The self is omniscient, concealed and imperfect. Through the figure of the avatar the self can express its ego, id and superego. It has an omnipotent sense of vision since it sees all, or has the illusion of seeing all, but has no co-ordinates to locate itself in real space. The avatar, the other side, represents nothing beyond himself. He is located at point zero, a myriad of surfaces that have no depth. As the body disappears in Cyberia, thus achieving an ideal long strived for in the West of freeing the spirit from the flesh, the avatar roams the matrix, dissolving himself, but at the same time extending his range by permeating the whole world. He becomes a total public phenomenon among many others. Cyberspace is the place where, since all can be seen and everything is on display, a kind of blindness results from the increasing annihilation of the distinction between the observer and the observed. In this psychological Eden the self can maintain its reality only within an unfulfilled condition—it is a fallen Lucifer whose return to Arcadia is dependent on time and money.

The matrix, then, is a kind of womb (whereas the term "virtual" etymologically designates a male kingdom). In this great mother space all kinds of mythologies can be rephrased and modified. Entering the matrix is an act of rebirth. A new beginning where the body, like the body without organs that Deleuze and Guattari have discussed, is devoid of the idea of depth, i.e., of value, and begins to lead an eternal life. Its hyper-rhetoric past is left behind. It mirrors nothing and represents no personality as it was "born" as an archetype and not as the form giving shape to the individual. Its nostalgia is more of a reflex and the manifestation of a lack rather than a real impulse. Avatars have no history, for they are beyond it at the very moment when they leave the human domain.

DLH

INEZ VAN LAMSWEERDE

born 1963 in Amsterdam, lives in Amsterdam and New York

Solo Exhibitions (selection)

1997 *The Widow*, Matthew Marks Gallery, New York/Johnen & Schöttle Gallery,
 Cologne/Torch Gallery, Amsterdam/Victoria Miro Gallery, London
1996 *Inez van Lamsweerde*, Kunsthaus Zürich
1995 *The Forrest*, Johnen & Schöttle Gallery, Cologne/Grazer Kunstverein, Graz/
 Torch Gallery, Amsterdam
1993 *Heaven*, Centraal Museum, Utrecht
1992 *Vital Statistics*, Center for Architecture and City Planning, Groningen

Group Exhibitions (selection)

1998 *Disidentico—maschile-feminile*, Palazzo Branciforte, Palermo/Palazzo delle
 Esposizioni, Rome
1997/99 *Invisible Light*, Museum of Modern Art, Oxford/Museum Villa Stuck, Munich/Moderna
 Museet, Stockholm e.a.
1997 *:Engel: Engel*, Kunsthalle Wien
1995/96 *Images of Masculinity*, Victoria Miro Gallery, London
1995 *Der zweite Blick*, Haus der Kunst, München
 Album, Museum Boymans van Beuningen
 Biennale di Venezia, Venice
1994/95 *L'Hiver de l'Amour*, Musée d'Art Moderne de la Ville de Paris/PS1, New York
 Spellbound, Centro Cultural de Belem, Lisbon/Asociación Cultural Cruce, Madrid

Inez van Lamsweerde/Vinoodh Matadin:
Joanna, 1995, photograph, 185 x 140 cm, Collection Bernd F. Künne, Hannover,
© Torch Gallery Amsterdam (ill. p. 222)
Kirsten, 1996, photograph, 50 x 50 cm, Collection KPN, Netherlands,
© Torch Gallery Amsterdam (ill. p. 223)

Inez van Lamsweerde works as a photographer in the intermediate zone between applied fashion photography and free artistic photography. Her work is based upon a concept that follows standards different from those of the photos produced for the fashion business which are intended for publication in professional journals and serve to enhance the image of specific brands. By focusing her attention on both areas equally and playing with and violating their inherent laws, Inez van Lamsweerde creates the intermediate zone in which her works unfold.

The works of Inez van Lamsweerde are charged with erotic tension and incestuous desire. By subjecting viewers defencelessly to this subject matter with no possibility of retreat she touches upon secret wishes and arouses socially ostracised desires to which the clinical atmosphere in which these scenarios are staged forms a strong contrast. This, however, allows for openly viewing the scene whose content would otherwise only be conceivable in a diffuse sphere.

The protagonists in the photographs of Inez van Lamsweerde in any case are immaculate, perfect and pure. They stand in a striking, yet ambiguous, opposition to the content conveyed by them and enacted in the depicted scenarios. The demonic, evil, threatening effect that many of the performers radiate correlates with the clinical pureness of their presentation; and yet, they form an irritating contrast to the depicted subject matter. How is this possible? The contrast is hardly obvious, but rather the strong irritation which the pictures evoke is due to the strange coherence of the picture content, the form of presentation and the manner in which the scenarios are designed. Pureness and immaculateness appear to be of paramount importance—whether in regard to the high-class prostitutes, the proclaimers of a better, i.e. cloned future, in regard to the transformed children whose frightening facial features do not at all correspond to the classical notion, or in regard to the paedophiles who are subject to the dictates of their dependence. Since the works are focused absolutely on sexuality, the coherence of representation and subject matter leads to such a strong irritation regarding the viewer's patterns of reception that in the harsh light of the staged scenario the supposedly clear categorisations can neither be postulated nor maintained. An obvious ambiguity that is traditionally associated with taboos, suppression and disapproval replaces the generally accepted notions of good and evil, right and wrong, normal and perverse. The feeling of unease appears to be solely on the viewer's side since the performing figures seem to act within their immaculate surroundings in a self-assured and superior manner. Even though the form of presentation and the way in which the subject matter is staged appear up-to-date, their effect is still not at all consumer-oriented. On the contrary—the subject matter in the photographs of Inez van Lamsweerde only gains artistic significance through the form in which it is staged: form and content are inseparable here; they are mutually conditional. It is precisely by depicting a theme in a seemingly obvious and ostentatious way that Inez van Lamsweerde avoids making an unequivocal statement, while at the same time heightening the intensity. Making use of this effect of commercial fashion photography is a result, not a reason for this artistic approach. MM

"Softly, violins sing the Great Mass by Wolfgang Amadeus Mozart in C minor. 'Turn it up, sweetie', says the man in the blue surgeon's coat and lowers the knife, The nurse hurries to the CD-player. The surgeon closes his eyes for a moment, swinging the scalpel almost tenderly in rhythm to the music ... Joram Levy, 52, takes hold of the cheek muscles with his instruments, lifts up the red flesh and stitches it a few millimetres higher onto the layer of tissue. The choir resounds from the loudspeaker. 'This is art', says Levy, 'I am shaping her face.'... Levy rocks his head in time to the music. Shortly before putting the skin-stapler into position ... the cosmetic surgeon grasps the patient's earlobe. He bends it backwards slightly and fastens it there. 'An angle of ten, twelve degrees', says Levy, 'this is a young earlobe. Just a minute alteration, the syncopation between beauty and decay, freshness and old age.'" (*Der Spiegel*, No. 32/1992)

Angelica Ensel

RITUALS OF CREATION IN COSMETIC SURGERY

With accounts such as these the media stage the celebration of cosmetic operations as creative acts. In their own descriptions cosmetic surgeons speak of "turning back the clock of life," of "meddling in God's affairs," of "rejuvenating humanity" and of "creating masterpieces". What is hidden behind images such as these? Which meaning does cosmetic surgery have in our culture and which cultural implications does this type of self-dramatisation reflect? The analysis presented below is an invitation to focus, from an ethno-medical perspective, on the dramaturgical aspects and rituals which present themselves within the phenomenon of cosmetic surgery.

Cosmetic surgery is a booming industry. The constantly increasing numbers of operations,[1] as well as the strong presence of the topic in the media, aptly conveys this. Not only is cosmetic surgery a new form of shaping the body in a way specific to the culture and a medical branch of business which is buoyed up at present in a considerable upward trend. It is also a reflection of the power constellations between the genders that reveal themselves in specific dramatic staging patterns and rituals. A body that is not appropriately shaped is considered to be in need of cosmetic surgery. This applies to (often only subjectively perceived) imperfections and irregularities detected on the healthy, functioning and untreated body. In this respect, the margin to what is considered acceptable as a "normal" body on a private or public scale becomes increasingly narrow. Correspondingly, the standards that the body has to meet as an object representing a product or an institution become higher. The "criterion for professional employment" that Naomi Wolf (1991) describes applies to both sexes, whereas women are exposed to this to a much larger extent than men. While only in senior positions it becomes important for men to present an attractive body, a perfect body is demanded of women in almost all professions and positions.

An important difference between the sexes also lies in the remarkably uneven relationship between those who are reshapers of bodies and those who seek to have their bodies reshaped: circa 70–80% of those who undergo cosmetic surgery are women, while the majority of surgeons are male. Thus, while an increasing number of women—despite professional success and social acknowledgement—feel "insufficient" and desire to be reshaped by means of "incisive measures", male doctors present themselves as creators of female beauty.

The following discussion will focus on the relationship between the "shaping" male doctor and his female patient.[2] Depending on the theme and setting, doctor and patient take on different roles. At the same time, old roles and self-images of the doctor as artist, creator, priest, magician, psychologist and philanthropist surface which bear a long tradition in the history of the medical profession. In the various modes of dramatically staging the doctor-patient relationship the rituals of surgical cosmetic treatment are performed. Here, apart from the power constellations, the religious implications of the medical actions become transparent as well.

In two ways cosmetic surgery transgresses boundaries. It violates the integrity of the human body

and alters the previous image of the body. Along with the body, the identity is reshaped as well. In this process of reshaping, however, not only the identity of the person undergoing the operation is involved. The analysis of the doctor's self-assessment demonstrates that the operation as a process of creation and shaping is an act in which also the doctor's identity is formed and confirmed—a process of creation and self-creation. In their respective roles as creator and creation, doctor and patient are involved in a dialectic relationship. Without the "deficient" woman, who desires a reshaping of her body, the doctor's (self-)dramatisation, and thus (for his identity constantly necessary) the confirmation of the creative act cannot take place. The "masterpiece", as one cosmetic surgeon termed the result of operations performed on his wife, serves as the continuous representation of the power of cosmetic surgery and bears testimony to the creative identity. "Aesthetic surgery is a love affair", claims cosmetic surgeon Joram Levy (*Stern* 42/1996), thus revealing the intensity and respective dependency of both protagonists within the surgical process of creation.

"Putting it in slightly exaggerated terms, every experienced aesthetic surgeon can say of himself that he has already rejuvenated humanity by a few thousand years."

(Kostek, 1983, p. 177)

When cosmetic surgeons speak about their work, they flirt with the image of God as Creator, who in many cultures is viewed as a "shaping" God and who, in a metaphorical sense, has formed man from clay. They describe their work as an occupation that requires skill and artistic talent, as well as a keen aesthetic sense, a capability for design and a feeling for the harmony of forms. Many doctors emphasise their disposition for art, stressing that aesthetics are of significance in their everyday lives as well, and that earlier on in their career they had desired to become a sculptor or an architect.

"A metamorphosis in the struggle against transience", the "sunken cheeks in crater form", the "pudgy cheeks distinctly bulging out", and the "fatty, thick crease in the throat area that reaches down to the larynx" have disappeared, leaving the face "incredibly rejuvenated". This is how cosmetic surgeon Kostek relates the results of an operation on an eighty-year-old (!) woman.

"Metamorphosis," "rejuvenation" and "rebirth" are frequently used metaphors—both by doctors and former patients—when the effect and significance of an operation in regard to the personality is described. Cosmetic surgery, as an incarnation of ancient fantasies of metamorphosis, rejuvenation and rebirth, reflects a culture in which the creation and presentation of a perfect "surface" is a pivotal value—a society that denies old age, illness and death. Cosmetic surgery is also medicine's answer to the "antiquatedness" of our body, that Günther Anders (1988) has mentioned. The singularity of our body has become a dilemma because, in opposition to the products we manufacture, we are unable to undergo reincarnation or continue existing in successive single parts. Anders speaks of the shame man feels, who, in the face of the products he has created, perceives of himself as a "per se perishable unique specimen". We are abandoned to the singularity of our bodies that confronts us with our fear of death. In view of the traces of life and the decrease in our capacities, we are reminded day to day of the finite nature of our life. Cosmetic surgery is the answer to this "malaise of singularity." The ritual of being reborn by cosmetic surgery, which touches up the bodily traces, nourishes the fantasies aimed at an "ageless" life accompanied by boundless energy.

The cosmetic operation as a ritual of rebirth does not, however, concern solely the woman, who is reborn out of the hands of her creator, but also the doctor, who emerges from this act as creator. First of all, the focus lies on designing the creation, the image of the "new" woman. This is based, on the one hand, on the woman's negative self-image and the ideals regarding a new body that accompany it. On the other hand, and to a usually much higher degree, it is the doctor with his subjective design, who is granted more competence on the grounds of his expertise and his authority. In the course of the operation the new body is created by means of a forming act through the hands of the doctor—a process that both sides refer to as a rebirth. Thus, the cosmetic surgeon sires an image (in his mind) that he gives birth to with the help of his hands. In this sense, the ritual of rebirth in cosmetic surgery is both an act of birth and procreation—the rebirth of the woman through the hands of the man and the self-creation of the doctor as a creator giving birth.[3]

In the history of plastic surgery the tradition of the priest-doctor is particularly obvious: plastic or

restorative operations carried out by a priest-doctor who eliminated the deformations acquired through fate had the character of an absolution (see Schmidt-Tintemann, 1972). Still today, the cosmetic surgeon as priest-doctor—as an initiate with particular knowledge and a special relationship to the higher powers and to fate—celebrates the cosmetic operation as a sacrifice. Here, sins are redeemed and penance is done. Control and discipline, demanded by Christianity of the body, whose drives and weaknesses were to be restrained, continued to be valid within the new medical notion of the world.[4] In our culture, an obese body is considered a sign of a lack of discipline and personal effort. Working on one's beauty, versus the indulgence of one's appetites and the traces of ageing, is a discipline that is still imposed on women to a much higher extent than men. The cosmetic operation as an act of sacrifice and purification begins with the confession that the patient has to make to the priest-doctor. She must disclose her sins, her excesses (regarding eating and other habits) and possibly former operations. Then she has to present herself naked, must reveal her "deficiencies", which the doctor (here in the role of judge as well) appraises, classifies and documents (in writing and with the camera). Following the principle of "do ut des", in the course of the operation the woman offers blood, money, time, fear, physical and mental stress as sacrifices on the altar of beauty. She gives up parts of her body in order to be renewed in a blood sacrifice. As initiate and master of ceremonies, the priest-doctor celebrates the sacrifice; he knows how the transformation is going to take place and what the result is supposed to be. In the process he invokes higher values, such as "beauty", "harmony" or "the aesthetic principle". In his function as mediator between the profane and the sublime, he shapes the woman according to how God should have formed her.[5] On the operating table the "mystery of unification and separation" takes place that, as Streck (1987) claims, lies at the core of all sacrificial cults. By means of parting from a value and through devotion, those who are making sacrifices are to obtain a relationship to God and to the higher powers. The flowing of blood, as a symbol for the source of life, is reminiscent of ancient religious cleansing rituals and the Christian myth of female impurity.

The result of the sacrifice of the cosmetic operation is described by the former patient, if all has gone well and particularly after a significant "incision", as salvation from a long enduring ailment. The Dutch sociologist Kathy Davis (1995), who carried out interviews with women before and after cosmetic surgery, notes that the personal stories relating to cosmetic operations are presented as tales of suffering ("years of terrible suffering") and that the decision to undergo the operation took many years of preparation.

"Cosmetic surgery stories have a before and after," Davis points out. The surgical transformation of the body becomes a biographical turning point: "... a crossroad in the woman's life which divides in a before and after. It becomes the vantage point from which she looks backward at the past to make sense of her decision and forward in order to anticipate what it will mean for her future." (1995, p. 97)

The desire for a cosmetic operation, especially for a facelift, often arises in situations in life which have been preceded by drastic changes, such as a divorce, the death of the partner, or also when incisive changes lie ahead, such as a change of job or profession. Often, the decision to undergo a cosmetic operation is based on the inner motto: "I am becoming active by deciding (externally and internally) on new forms in my life." As a symbol of transition into a different phase in life the incisive step marks a biographical transcendence of boundaries or seals the change. At the same time, the operation functions as a rite of transition. It serves as the ritual conquest of a crisis, opening the entrance into a new phase.

The French writer Benoite Groult described this process in her novel *Leben will ich* (1983), regarding the facelift of her protagonist Louise. The different stages, leading from the decision to undergo the operation to the first phase after the operation show a number of parallels to the various stages of the traditional "rites de passage," following van Gennep (1986). Here, one finds preliminary rites of separation ("rites de seperation"), threshold and transitional rites ("marge"), which accompany the transition, and concluding integrative rites ("agregation").

At a point, when Louise claims to have found her own identity and lives her own life, instead of showing consideration and restraint, as in the past, she feels a desire for a new face. This face is

supposed to indicate her liberation from the old life because the traces of ageing do not match her new experience of life:

"... But the face, compared with the rest of the outer appearance, meanwhile displays an inadmissible protrusion. This double crease on both sides of my mouth, the skin bulging between the furrows, the little flaps of flesh that line my lower jaw like a turkey and, when I lower my head, destroy the outline of my face; these upper lids that have become too long and that always appear to be tucked inwards, this no longer smooth neck ... all these little indications of decay are becoming more clearly visible every day under my incredulous eyes."
(1983, p. 409)

Louise's gaze into the mirror, her taking stock, is like the renunciation of an old belief, an outdated way of life. With those words she is saying farewell to her face, implementing the rites of separation. The visit and consultation in the practice of the cosmetic surgeon also belong to this first stage, and finally the decision to have her face lifted:

"I am treating myself to something that's good for me, and I, who have always been hopelessly honest, am actually beginning to enjoy the prank that I will play on life and people."
(1983, p. 419)

The second stage of the transition with its threshold and transitional rites consists of preparations for the operation, the operation itself and the first few days following the operation. This stage takes place at the clinic, a place, which in our culture is predestined for transition. Here, births and deaths occur and specific physical routines apply; transgressions of intimacy unheard of in everyday life are the rule. During the course of the cosmetic operation as a transitional rite, the doctor takes over the function as leader or priest, who conducts the "rites de passages" in traditional societies and marks the change in status.

After the operation, Louise is transformed—she is wearing a "nun's cornet and the nose of a white clown," feeling "endlessly tired." In this middle stage the initiate is endangered. She must pass trials and sometimes has to remain totally passive, is put into a trance, receives certain drugs or must bear extreme physical pain. This state of emergency is a borderline experience and is also referred to as "depersonalisation" (van Gennep). The anaesthetic, in Louise's case, serves as a threshold ritual that induces temporal unconsciousness and, thus, the transition into another physical state: a passing into another world. In waking up, the initiate returns to life as another woman and is in a special state of consciousness. The operation as a border crossing has lifted the old restrictions, the new ones are still uncertain (scars).

The integrative rites of the third stage serve as an introduction into the new status. In phases, the entry into everyday life takes place. In Louise's transition this concerns the time after her stay at the hospital, which she spends at a girlfriend's home (in a sheltered zone). Further steps include the purchase of new clothes and as the "last great trial" a visit to the hairdresser's.

In opposition to the traditional "rites de passage", which mark progressive transitions from one stage of life to the next, more mature, stage, encompassing the gradual process of ageing, the cosmetic operation is a rite of transition in reverse direction. Here, the traces of ageing, the physical signs of maturity (that in traditional societies are also signs of dignity) are not allowed to be revealed. Additionally, the ritual is not supposed to leave traces. In a culture, in which the traces of ageing are perceived as a sign of weakness and social "uselessness", values and rituals become inverted. The transitional rite of the cosmetic operation does not take place like a traditional ritual of transition in the public sphere, but rather in secret. The scars, as signs of transition, of which traditional initiates are proud, must remain hidden.

In any case, the transitional rite changes the status of the initiate. The significance of the effect of a cosmetic operation as an initiation may also be seen in the case of Louise. After recovering from the ordeal, she decides on a new profession. She wishes to "finally realise her dream and work as a freelance writer," a "stylistic lift in regard to my writing," as she puts it. Thus, she herself becomes the initiator of her new life experience, by acting out her own creativity as a creator.

NOTES

1 As the term "cosmetic operation" is not defined
in medicine, these operations are not statistically
registered. The number of cosmetic operations
quoted in the media fluctuates between 100,000
and 150,000 operations per year. The rapid incre-
ase in cosmetic operations can also be deduced
from the number of patients, who underwent cos-
metic surgery, which between 1985 and 1990 had
already doubled (cf. survey on the situation of cos-
metic surgery in Germany).
2 Participant observation at a consultation for cos-
metic surgery. Interviews with cosmetic surgeons,
the analysis of self-assessments of cosmetic surge-
ons in medicine, and popular-science literature
written by these surgeons, form the basis of the
research extracts presented here.
3 The terms "rebirth" and "new-born" may also
be viewed as metaphors of male birth-fantasies—
the fantasy of the male mind as a uterus, which
gives birth to a woman. The Genesis motif of Eve's
being "born" of Adam, which can be found
throughout Europe since the 11. century, demon-
strates how old the images are concerning a man
giving birth to a woman (cf. Zapperi, 1984).
4 Turner (1984) points out that there are obvious
ties between Christian asceticism and the medical
theories of renunciation. The mingling of pietistic
and medical ideologies of renunciation that both
object to excess and pleasure can be interpreted as
the moral prerequisite for a capitalist economic
system. The duty of being healthy is the obligation
to restraint and self-control. Now, the body is no
longer possessed by God, but by the state or the
employer. The duty of being healthy means being a
disciplined employee.
5 "… which he, so to speak, messed up," as
Dr. Mühlbauer puts it in an interview (Psychologie
Heute, No. 6/1990).

Oliver Sieber, *Kim,* 1995, photography, © Oliver Sieber (ill. p. 229)

ANNEKE IN'T VELD

born 1966 in Capelle aan de IJssel/The Netherlands, lives in Rotterdam

Group Exhibitions (selection)

1998 *Images on Building*, Fotoforum, Amersfoort
1997 *Unbeschreiblich Weiblich*, Noorderlicht Fotofestival, Groningen

Leila, 1996, C-print, Plexiglas, aluminium, 100 x 100 x 3 cm, Courtesy Anneke in't Veld,
with generous support from the Mondrian Foundation and Mama Cash (ill. p. 235)
Fred, 1999, C-print, Plexiglas, aluminium, 100 x 100 x 3 cm, Courtesy Anneke in't Veld,
with generous support from the Mondrian Foundation and Mama Cash (ill. p. 234)
The Working Girls, 1999, C-print, Plexiglas, aluminium, 100 x 100 x 3 cm, Courtesy Anneke
in't Veld, with generous support from the Mondrian Foundation and Mama Cash (ill. p. 237)
Paul, 1999, C-print, Plexiglas, aluminium, 100 x 100 x 3 cm, Courtesy Anneke in't Veld,
with generous support from the Mondrian Foundation and Mama Cash (ill. p. 233)
Libor, 1999, C-print, Plexiglas, aluminium, 100 x 100 x 3 cm, Courtesy Anneke in't Veld,
with generous support from the Mondrian Foundation and Mama Cash (ill. p. 236)
Michael, 1999, C-print, Plexiglas, aluminium, 100 x 100 x 3 cm, Courtesy Anneke in't Veld,
with generous support from the Mondrian Foundation and Mama Cash (ill. p. 232)

The photographic works of Anneke in't Veld focus thematically on people whose main objective it is to achieve perfection and control of their own body. Anneke in't Veld makes photographs of body-builders (male and female), transvestites and transsexuals and puts together selected prints in photo-series, thus establishing references, correspondences, contradictions and confrontations.

The perfection of the self is identified in the case of the above-mentioned groups of people first and foremost with the outer appearance of the body. While, however, in body-building there are certain ideals regarding the manner in which the muscles are to be built up and restructured by means of workout systems and medical compounds, the ideal effect that transvestites strive to achieve is a form of deception or at least irritation, as some transvestites perform their role in an absolutely transparent manner. In their case the aim is not to deceive other people in regard to their actual gender, but rather the immanent satisfaction of a need or desire, an ideal self-gratification. Most transvestites depicted in the pictures of Anneke in't Veld, however, are hardly identifiable as such without having prior knowledge of their actual gender, because their apparel, makeup, hairstyle, posture and overall appearance are so remarkably effective. They are so authentic in their self-confidence and in the conviction of the significance of their role, that the question as to the coherence of their true identity and disposition, must remain unanswered. The body-builders are just as uncompromising in their poses; they know how to present themselves and just how the results of their efforts can be featured to advantage. This is also why they are not at all willing to simply have their picture taken, discussing instead the choice of photos with Anneke in't Veld with which they wish to be represented in the artist's œuvre. This form of co-operation, which goes far beyond the mere willingness to pose in front of the camera, transposes their status as creator to a higher level. Thus, pose and appearance become a constituent element of the act of self-creation.

The relation between factuality and appearance is based upon virtual coexistence, because the fulfilment of perfecting the self lies in the reception of this perfect state which corresponds to a static, affirmative goal, forming a contrast to the processes involved and to the instable variables of motivation and effort. The goal can never be obtained, yet the illusion that, indeed, this is possible is also the incentive to carry on the endeavour, to hold out and to fight. Programmatically channelling one's whole strength is much more than the mere satisfaction of a personal need or inclination, indicating, moreover, an almost messianic concern that is structurally based on belief, hope and salvation. MM

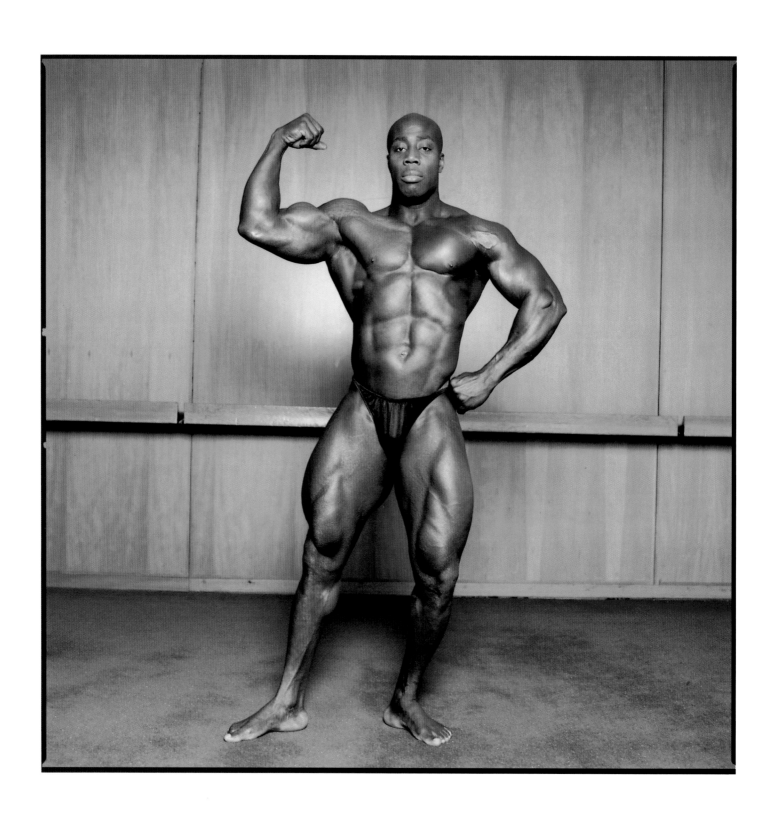

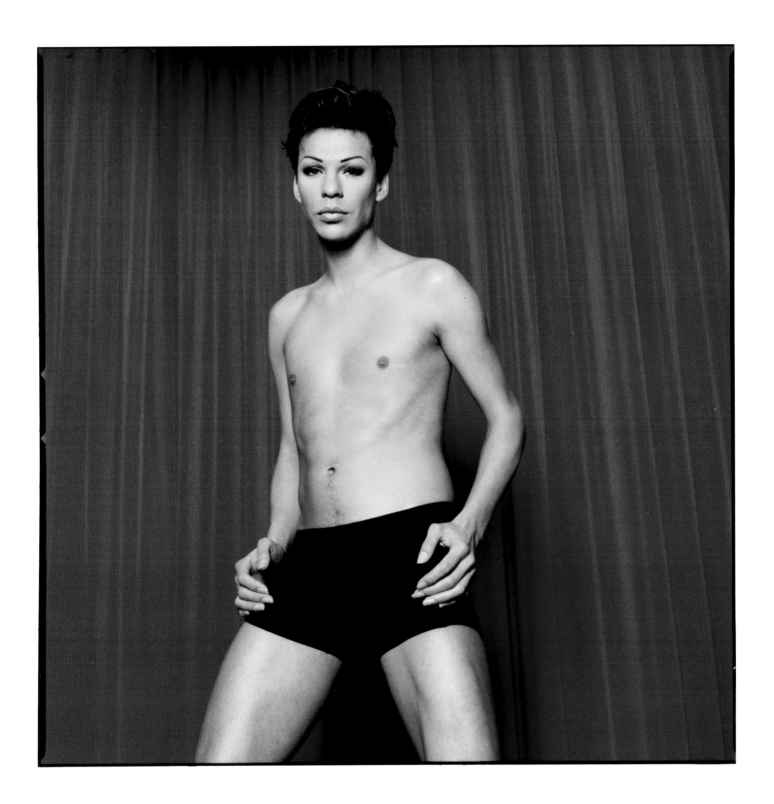

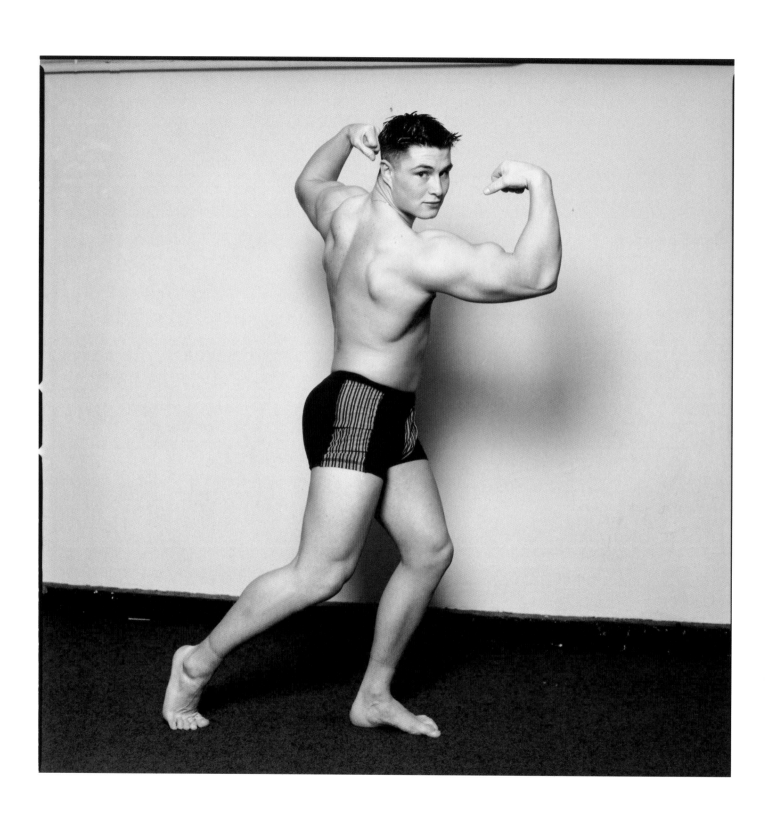

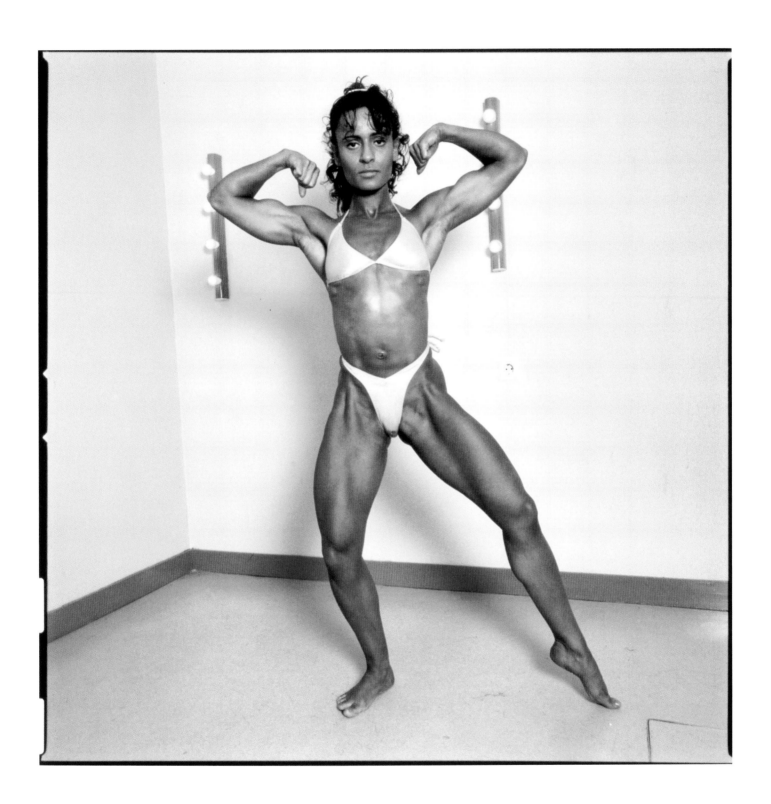

ART STUDIO DEMETZ

represented by Luigi Baggi

founded 1872 in Ortisei/Val Gardena

Sculptures made for the following institutions (selection)

Holy Name Cathedral, Washington D.C.
The Stations of the Cross, Cathedral of Melbourne
All sculptures in the Cathedral of Chicago
St. Patrick's Cathedral, New York
Colle Don Bosco, Italy
The Ressurected Garden Cathedral, Nairobi
St. Franziskuskirche, Koblenz

Lady Diana as a Madonna, 1999, limewood, 176 cm, Courtesy Art Studio Demetz, Selected works
for art by Luigi Baggi, *Representative of premade art,* made by Konrad Piazza (ill. pp. 240/241)

Normally the Art Studio Demetz supplies religious institutions with images of saints and other sacred figures. Demetz is located in Ortisei, a picture-book village with a long tradition in wood carvings of religious figures. Ortisei is abundant with large and small studios which produce sacred images, all run by artisans who are proud of the fact that in a world dominated by mechanisation they uphold the tradition of manufacturing hand-made objects. The people working in Demetz are very much aware of the particular qualities of wood. They are familiar with its capricious characteristics, its nature and its various surface structures and are masters in the technique of wood carving. In spite of the fact that the sculptures are mostly hand-made, customers must order them by catalogue. The images are stereotyped and identified by numbers. They might be viewed as multiples with an individual touch. It is obviously not the purpose here to create original sculptures revealing the hand of the artist, but rather to conserve a collective image.

Because the notion of the 'authentic' work of art does not apply when religious images are discussed as practical objects, the question as to whether they belong in the context of an art exhibition is legitimate. In the eyes of an art lover the authentic artistic expression is what constitutes the value of the work. But to understand the pious experience involved in viewing a sacred image on the basis of these parameters is a profound mistake and a source of discontent. Such images must in the first place be identical. Any notion of authenticity would destroy their purpose. They are produced to reflect the collective memory and a social need, thus nourishing fundamentally practical expectations. This forms a contrast to 'high' art in which the total lack of any practical objective is taken as a value. A work of high art has no purpose or interest apart from its pure existence. Religious art functions in a completely different manner, being made to serve a purpose. It replaces the presence of God. It is a form of grace gaining shape in everyday life and yielding a therapeutic remedy.

Because religious art must be a source of empathy and must fulfil the needs of the devout, individualistic traits must be avoided. Most pious images contain an element of kitsch, to put it mildly; in as far as kitsch holds the promise of a state of perfection, it suits the goals of the religious system, which also holds precisely this same promise. This aspect is among the reasons for its rejection by admirers of high art. As art is increasingly becoming a substitute for religion and religion for art, we are dealing here with two competing systems. The disciple of one system has to disapprove of the adept of the other. The temptation inherent in the emphatic image of Jesus must be banished in favour of a secular and abstract piety. The dyadic relation that the traditional image offers is thus interpreted as an element of kitsch and as such is cast out of the world of good taste. On the whole, the art public consists of a well-to-do class within society. When members of this group lament the fact that in religious art God is reduced to the size of man, they should also remember that for most people, as David Morgan put it in his book *Visual Piety*, it is more important to cope with the miseries of an indifferent world than to fight the world as a whole; and it is against this background that an image which is not of divine authority but of divine grace might be accepted for those in need of it.

It might also be wise to consider kitsch and the abundance of associations it involves in a new light, for exactly in the fields of contemporary art kitsch has ceased to be a conveyor of moralistic issues and is no longer associated with the context of particular values. It has become a legitimate tool, like a brush, or paint, or a line, or even a strategy, beyond any significance for categorisations in regard to taste.

For the exhibition *Heaven* the Art Studio Demetz produced a sculpture of the Princess of Wales represented in her role as a Madonna, one facet of her appeal being her image as the Lady of Mercy. The overlapping of two iconic figures, one drawing upon the other, is another example for the manner in which the religious icon has been transformed into a secular image to meet the demands of our current times.
DLH

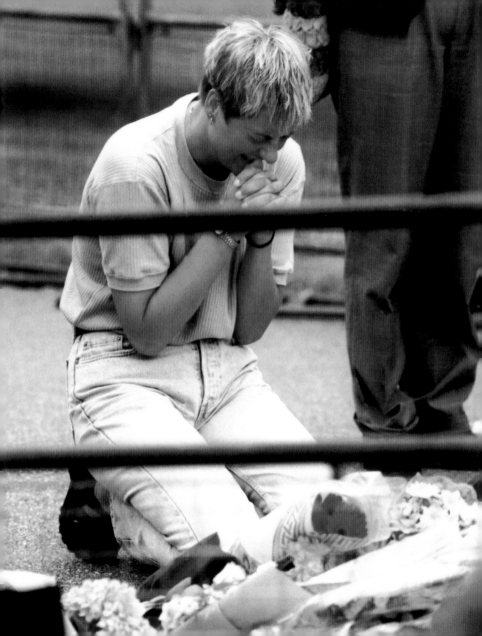

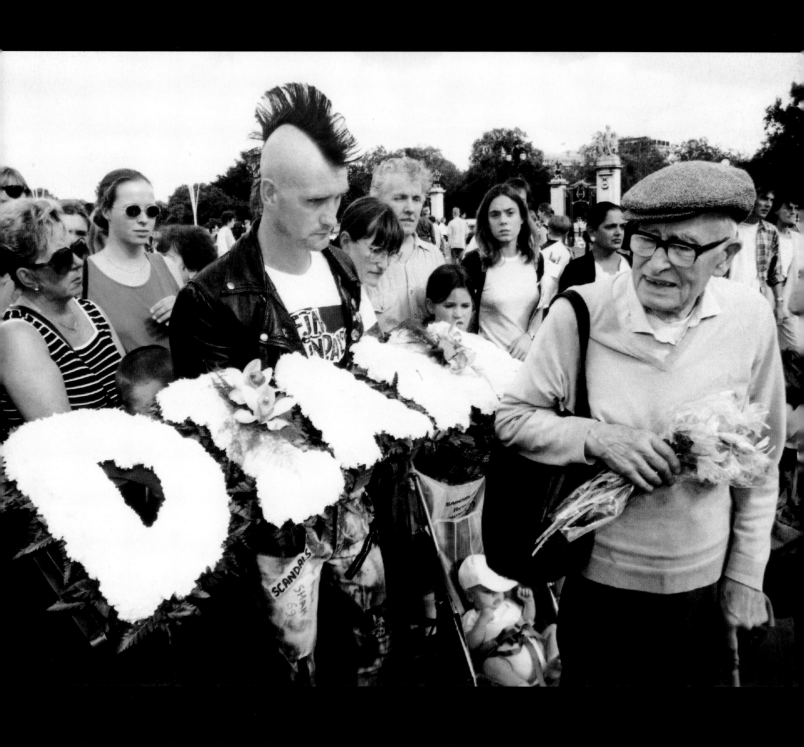

In advertising, texts cannot, as is often erroneously done, be traced back to traditions of referential literature. advertising slogans do not refer to anything. Commercials may be traced back to fashions, prevailing trends, political events, history, etc., but the text—at the moment of its emergence—does not refer to anything beyond it. Instead, the advertising slogan resembles all forms of concise, condensed language compositions that do not tell a story or refer to anything, but rather attempt to identify as closely as possible with their subject matter, becoming one with the content, merging with it. An advertising caption is not intended to narrate the product; it is supposed to be identifiable with the product via its sound, tonality and mood. Its objective is to evoke the product, to serve as an altar and memorial to the product. It is not a document, but rather a monument. We find the tradition of the advertising slogan in psalms and prayers, in the *Merseburg Spells*, in the

Michael Schirner ## AMEN.

works of Meister Eckehart and Angelus Silesius, in modern poetry, for instance in the poems of Baudelaire, Mallarmé, and particularly in those of Paul Valéry, but also in the verses of Stefan George. We find it in the Japanese haiku, in the works of Ezra Pound and in concrete poetry, however, not in the novel, nor in drama, not in the works of Shakespeare, Goethe and Flaubert; we do, however find it, in those of Nietzsche, the Zen-masters and Petrarch.

Thus, the primordial advertising slogan is the short poem, the small rhyme. It is the unconsciously correct reflex of the naïve copywriter in view of the mythical character of the product in modern consumer society. It is there before any rationalisation of the advertisement by means of tests, opinion polls and market research has taken place, and it marks the innocence of a time that today we only know by hearsay. At the beginning of advertising, as we are familiar with it, was the slogan. It

replaces the rapidly worn out speech conventions of the rhyme, employing the terseness of the banal or even the tautological ("Coca Cola is it", "Persil is still Persil"). The idea underlying the slogan is its eternity, its duration. The primordial slogan is "amen." The notion of eternity, however, corresponds to a number of extremely temporal and profane value systems. In identifying the product by means of one sentence or a few words, one wanted to play it safe and therefore relied exclusively on the nerve-racking power of repetition or penetration, as one calls it in advertising today. Furthermore, it was believed then that it was one of the major assets of a product if something was made for eternity, which, given the increasingly fast-moving market, accompanied by the growing prosperity, the dynamics of changing fashions etc., failed to meet the demands.

However, the slogan was ultimately annihilated by the rationalisation and scientific underpinning of advertising that emerged in the sixties. Suddenly—the second world-wide enlightenment in the course of the sixties' movement had also reached the industry—the customers realised something that had never bothered them before, namely that slogans, in the sense of referential languages, do not actually say anything at all: they do not provide explanations, they do not communicate facts,

they do not inform. The industry however, which was in a difficult position because of the general criticism against capitalism, had agreed on the white lie that advertising was product information and was now under pressure to employ accordingly informative, enlightening commercials. Naturally, this was a paradox, since advertising is poetry and not analysis or journalism. Who would expect a chemical analysis in an ode to the Rheinfall of Schaffhausen?

Therefore, nothing of the kind actually came about, but something else superseded the slogan: the headline. This was not meant for eternity, but, instead, designed for a specific occasion. In an allusive way, it fulfilled, or at least seemingly so, the need for an informative appearance but, above all, its great advantage consisted in its vitality and flexibility, and in its ability to arouse curiosity.

It is the nature of the headline to attract attention through verbal effects that rely less on a repetitious and catchy quality than those of the slogan, and which approach the aura of the product by rhetorical means. Permitted and even called for are tricks such as alliterations and internal rhymes, puns, wordplay of all kinds; typical are incomplete sentences, variations on familiar proverbs, aphorisms and the like. A good headline requires the combined creative powers of a tinkerer and an alchemist. Its appearance generated the figure of the advertising poet. There were copywriters, who

sat around in their rooms for weeks, occasionally writing a line, until they suddenly emerged, unshaved—ever since, the unshaved look is an inevitable accessoire of the copywriter—from their retreat, presenting a brilliant Zen-aphorism, which then had to keep for a few months.

This gender of texts had pushed the artistic demands, the poetic-monastic working method so far that it also began spreading the copywriter's disease that is still virulent today: blindness. Each of these headlines was to be so beautiful, lucid and intrinsic that an accompanying image would seem superfluous. Whatever the art director added to the accomplished lines was viewed merely as an illustration, or a nuisance. The lines often did not even arouse curiosity regarding the copy, the image or the product, because they were so self-contained.

Logically, a countermovement also had to arise among copywriters. This is explainable already on the grounds of the diverse temperaments of the copywriters. The tinkerer and condenser, the com-

Heaven on Earth.

Freude am Fahren

pressor and meditator, is faced with his counterpart, the overproducer, the quick, ever-ready pressure cooker, who juts out his lower jaw, letting the words pour out. The latter type invented—so to speak, against the mystical headline—the overly abundant body copy. Here, the headline played a subordinate role; the image was degraded, already for lack of space, to a matter of minor importance; and the copywriters of the school of wafflers and yakkers struggled to attain new freedoms. Following the model of Gossage, who filled the pages of the *New Yorker* with an ad-series for a brand of whiskey, breaking off in the middle of the sentence at the end of the page and referring to the sequel in the next edition, the copywriters devised long, artsy prose pieces, in which they could risk and try out a lot, since hardly anybody ever read their daring verbal ventures anyway.

Thus, as the seventies proceeded, advertising had run through all the extremes in both directions—including everything, from the magic chant to Marcel Proust, that literature had bequested in regard to usable models.

After a time of avid experimentation with texts, a certain helplessness, also noticeable in the field of art, seemed to spread. What was there left to do, after having reached the boundaries of the text? We had a simple solution to the dilemma that put an end to the professional blindness of the copywriters in regard to images and to the dyslexia of the art directors, and not only does justice to the various elements of the advertisement, but also complies with and follows the actual role and function of advertising: the relationship between image and text. To ensure the headlines their pure monumentality and to carry the lack of a reference to the limit, we write lines that state hardly anything at all, and if they are not actually totally void of sense, then, at least, they are very succinct and banal. The same applies to the images—they are basically meaningless. Only by combining image and text in the advertisement a story develops in the mind of the viewer that is neither contained in the image, nor in the text. This means sense is only created through the viewer's mental effort.

We can carry the technique of communicating something imaginary so far that the advertisement also works without the text, like, for instance, in our commercial for the herbal liquor *Jägermeister*, in which the consumer of *Jägermeister* is depicted in the typical pose, and apart from that neither a text nor a product are to be seen—the ad lets the text and product emerge in the mind of the viewer. Even advertisements without a headline or an image are able to communicate. In the most reduced ad in the world we have placed a small word on a white page: *GGK-Anzeige*. We went one step further, relying even more strongly on the mental and imaginative efforts of the viewer, and distanced ourselves further from references to anything external, relating instead to the inner eye of the viewer. This was the case, when we staged a photo-exhibition without the photographs, exhibiting only the captions to the pictures on black panels. Here, nothing but the imagination of the viewer was required anymore, in order to throw light upon the blackness of the panels. This is more or less how I envisage the advertisement of the future: the image must put up with its total disappearance in the imagination of the viewer. The text, and especially the copywriters, will have to do the same.

born 1941 in Chemnitz, lives in Düsseldorf

Group Exhibitions

1992	*Art meets Ads*, Kunsthalle Düsseldorf
1988	*Signaturen*, *22 Maler, Öl auf Leinwand*, Galerie Hans Mayer, Düsseldorf
	Hall of Fame oder Dinge im Kopf, Internationales Design Zentrum, Berlin
1986	*Bilder im Kopf oder die Magie des Gedruckten*, Intermedia-Kongreß, Hamburg
1981	*Werbung als Kunst*, Galerie Hans Mayer, Düsseldorf

Salvation, 1999, sound installation, Courtesy Michael Schirner (ill. pp. 250/251)

Michael Schirner compares the characteristics of religious rites with those of an advertising campaign and finds astounding similarities. Prayers and advertisement slogans have much in common, both promising an elevation to a higher state of (well-)being after certain conditions, namely, those of believing and those of buying, have been fulfilled. Both prayers and ads either express or nourish a desire which is never allowed to be satisfied, temptation being what the one opposes and the other yearns for.

The word "advertisement" is derived from the Latin term *advertere* which means "turning towards", or "drawing one's attention to someone", i.e., consciously creating a connection between two or more entities. Prayers are based upon a structure whose main component is the phrase "if...then", like in the very first "advertisements" dating from as early as the fifteenth century on the portals of churches, called *siquis*. Advertising slogans follow this formula: If (you buy)...then (some particular heaven is open to you). Contrary to some widely spread notions, there is nothing innocent about prayers and certainly there is nothing candid about ads. Both are not "virginal" inasmuch as their objective is to persuade, to influence and to modify patterns of behaviour. They are highly mercantile in character, both offering a form of exchange whose risk is unknown, which is therefore attractive, and which is rooted in the basic notion of any religious system and any successful campaign aimed at making us feel that there is something we are lacking.

In the exhibition HEAVEN Schirner's work is located in the lavatory, where ads are repeated in the manner of priests' sermons, imitating the clerical procedure of prayers. The work bears the title *Salvation*, as this is the declared goal both systems promise. The lavatory is a metaphorical space. Here one goes through a type of cleansing process, ridding oneself of bodily refuse. One also feels better after using it. In relation to a church, lavatories are what the body is to the spirit, a dualism still in search of a mediator. The notion of the toilet as the manifestation of a purifying ritual is only one metaphor among many others; it may also stand for advertisement as such, since both institutions are to a certain extent loathed but needed, if not desired.

Schirner conceives of advertisement as an art form. Purist recipients of art must inevitably be shocked by this notion, because ads are associated – and rightly so – with manipulation and the aim to sell a product. Advertising is not the expression of an artistic force, but rather produced on the grounds of particular interests that are far removed from any romantic notions concerning art and artists. Yet, to claim such a clear distinction between ads and art is to be naïve about the art world. One should remember that propaganda, which is what advertisement is all about, was never missing in high art and was in fact a primary impulse in constituting Modernism. The difference between good art and good advertisement is a moral distinction, not a distinction in regard to quality.

DLH

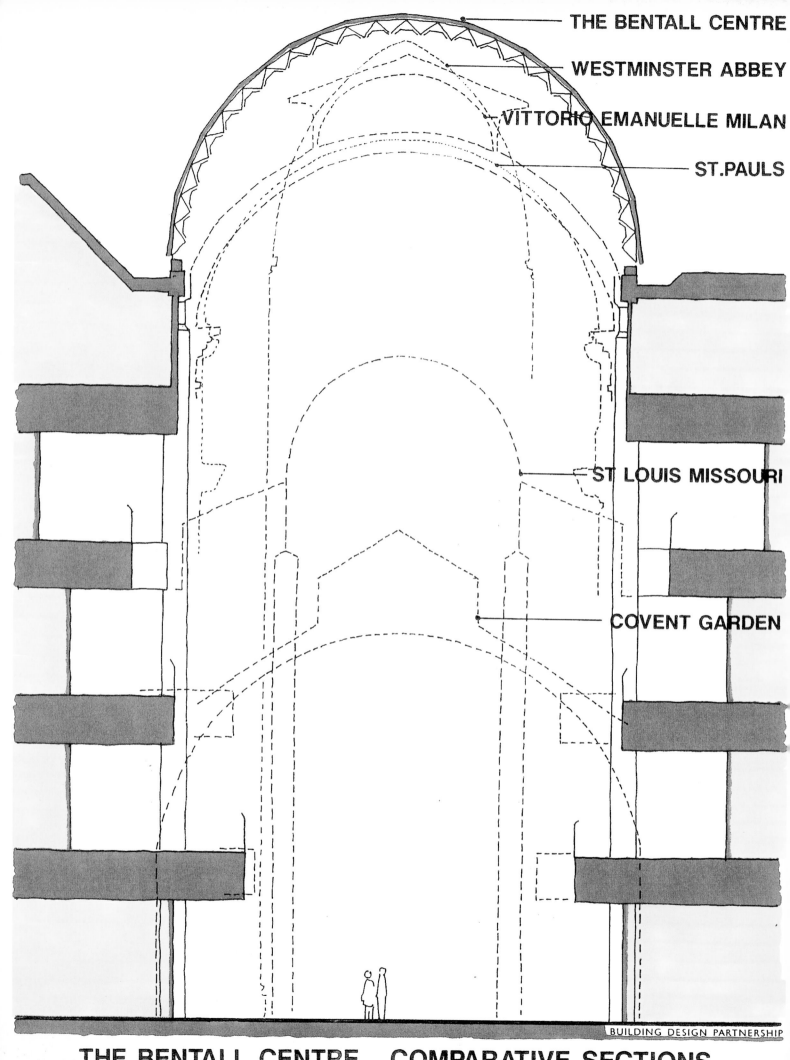

THE BENTALL CENTRE

WESTMINSTER ABBEY

VITTORIO EMANUELLE MILAN

ST.PAULS

ST LOUIS MISSOURI

COVENT GARDEN

BUILDING DESIGN PARTNERSHIP

THE BENTALL CENTRE COMPARATIVE SECTIONS

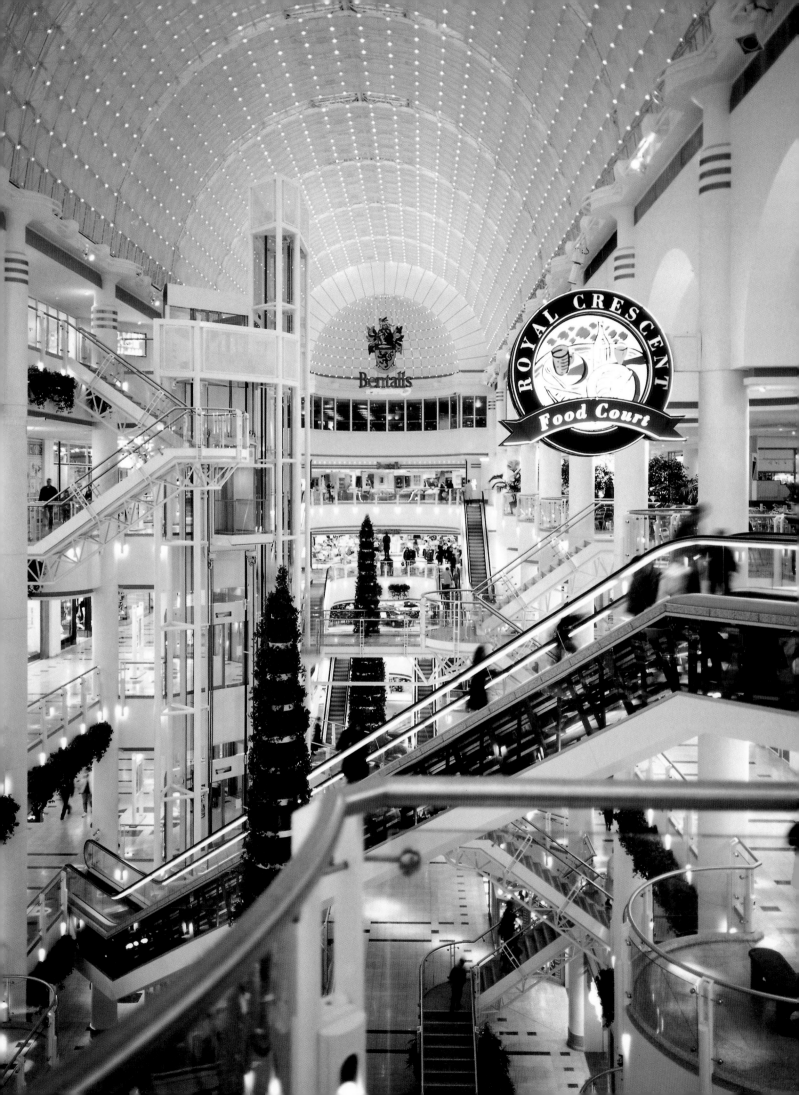

INDEX

CONTENTS

Photo credits: *Madonna – Bustier* worn in *Desperately Seeking Susan*, 1985, autographed on the strap, mixed media, Courtesy Hard Rock Cafe International, © Hard Rock Cafe International (p. 122). *Michael Jackson—Stage Glove* with "Western Costume Co., Hollywood" woven label printed with "Michael Jackson", thought to be worn by him at 1984 Grammy Award Ceremonies, 1984, rhine-stone, Courtesy Copenhagen Hard Rock Cafe, © Hard Rock Cafe International and Christie's Images Ltd. 1999 (p. 123). © Associated Press (p. 242). © Ullstein—Reuters AG (p. 243). Nina Ricci: *L'Air du Temps: Peace on Earth*. 1998, Model: Audrey Marney, agency: Saatchi & Saatchi, © Jean-Baptiste Mondino (p. 244). WEST: *Test It*. 1998, agency: Scholz & Friends, © Michelangelo di Battista (p. 245). René Lezard: *Ziehen Sie sich immer gut an. Denn der Herr sieht alles*, agency: Jung von Matt, © Uwe Düttmann (p. 246). VIVA ZWEI: *Erwachet!* 1999, agency: Boros, © Christian Boros (p. 246). BMW: *Heaven on Earth*, 1998, agency: BBDO © René Jaschke (p. 247). The Bentall Centre, Kingston-upon-Thames, © R. Allen/BDP (p. 254). The Bentall Centre, Kingston-upon-Thames, © Peter Durant/arcblue.com (p. 255)

Exhibition

Curator:	Doreet LeVitte Harten
Project Manager:	Markus Mascher
Architecture:	Projektgruppe HEAVEN: Johannes Fischer, Matthias Gommel, Volker Roos, David Schäfer, Prof. Volker Albus, Staatliche Hochschule für Gestaltung Karlsruhe
Video Installations:	Jochen Saueracker
Technical Set-up:	Jürgen Fritzke, Hans-Jürgen Künzel, Hilmar Sauer, Heinz Stramm and team
Administration:	Michael Bützer, Wolfgang Topel and team
Press and Publicity:	Hiltrud Eichelmann, Bettina Kratzsch, Sabine Krohm-Steinberg, Heike Rosenbaum

Catalogue

Edited by:	Doreet LeVitte Harten
Redaction:	Cornelia Plaas, Markus Mascher
Design:	Konnertz Buchgestaltung Köln
Copy Editing:	Lindsay Taylor, Fiona Elliott, Victoria Pomery, Natalie Rudd
Biographies:	Doreet LeVitte Harten, Markus Mascher
Translations:	Fiona Elliott, Belinda Grace Gardner, Caroline Higgitt, Simon Pleasance, Fronza Woods
Cover Illustration:	Oliver Sieber
Installation Photographs:	Horst Kolberg
Type-setting:	Weyhing digital, Ostfildern
Lithography:	Produktioner Benz, Stuttgart
Printed by:	Dr. Cantz'sche Druckerei, Ostfildern bei Stuttgart

Published by: Hatje Cantz Verlag
Senefelderstrasse 12
73760 Ostfildern-Ruit
Tel. 0711/4405-0
Fax 0711/4405-220
Internet: www. hatjecantz.de
ISBN 3-89322-935-3

Distribution in the US:
DAP, Distributed Art Publishers
155 Avenue of the Americas,
Second Floor
USA-New York, N.Y. 10013
Tel. (001) 212 - 627 19 99
Fax (001) 212 - 627 94 84